# Holding Ground

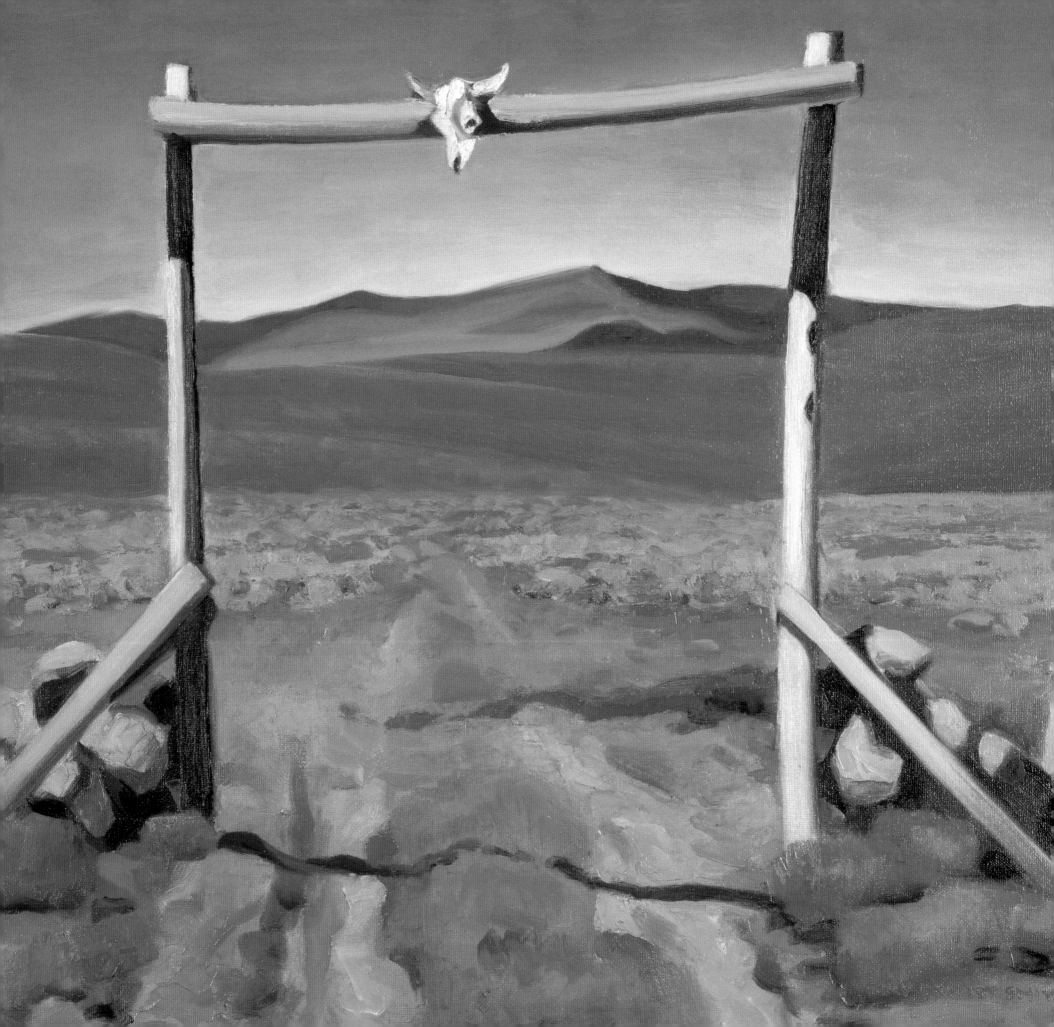

# Holding Ground

*the Art of*

## GARY ERNEST SMITH

*by* DONALD J. HAGERTY

NORTHLAND

PUBLISHING

Cover: *Iowa Cornfield,* oil on linen, 30 x 42, 1997
Back cover: *Figure with Barn,* 48 x 84, 1994
Frontispiece: *Gateway,* 16 x 20, 1990
Page v: *Corn and Shadows,* oil on linen, 16 x 24, 1998
Page vi: *Sage Pastureland,* oil on linen, 24 x 36, 1998
page viii: *Cornfield,* oil on linen, 30 x 42, 1997

Note: All paintings are done in oil on canvas, and belong to private collections, unless otherwise specified. All dimensions are given in inches unless otherwise specified. Paintings are height by width; sculpture is height by width by depth.

The text type was set in Founders Caslon 30 and Founders Caslon 12
The display type was set in Founders Caslon 42
Designed by Jennifer Schaber
Cover and limited edition designed by David Jenney
Edited by Stephanie Bucholz
Production Supervised by Lisa Brownfield

Printed in Hong Kong by Midas Printing Ltd.

www.northlandpub.com

FIRST IMPRESSION
ISBN 0-87358-745-6 (cloth)
ISBN 0-87358-746-4 (limited edition)

Library of Congress Catalog Card Number 99-25186

Library of Congress Cataloging-in-Publication Data
Hagerty, Donald J.
  Holding ground : the art of Gary Ernest Smith / by Donald J.
Hagerty.
    p.  cm.
  Includes bibliographical references and index.
   ISBN 0-87358-745-6 (cloth).—ISBN 0-87358-746-4 (lib. ed.)
   1. Smith, Gary Ernest—Criticism and interpretation.  I. Smith,
Gary Ernest.  II. Title.
N6537.S6163H35  1999
709'.2—dc21                                        99-25186

30/6M/9-99
29/300 ltd./9-99

*for* JUDY.
—G. E. S.

*for* REBECKA, KRISTINA, *and* JAMES.
—D. J. H.

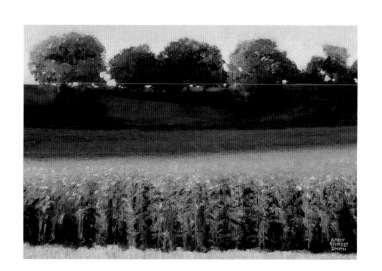

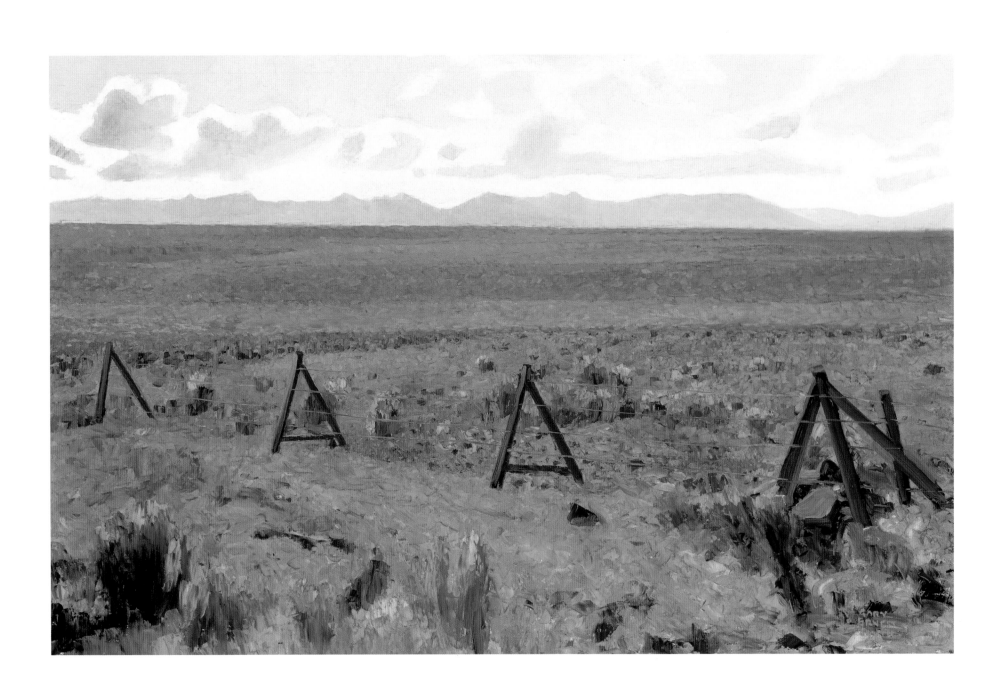

# CONTENTS

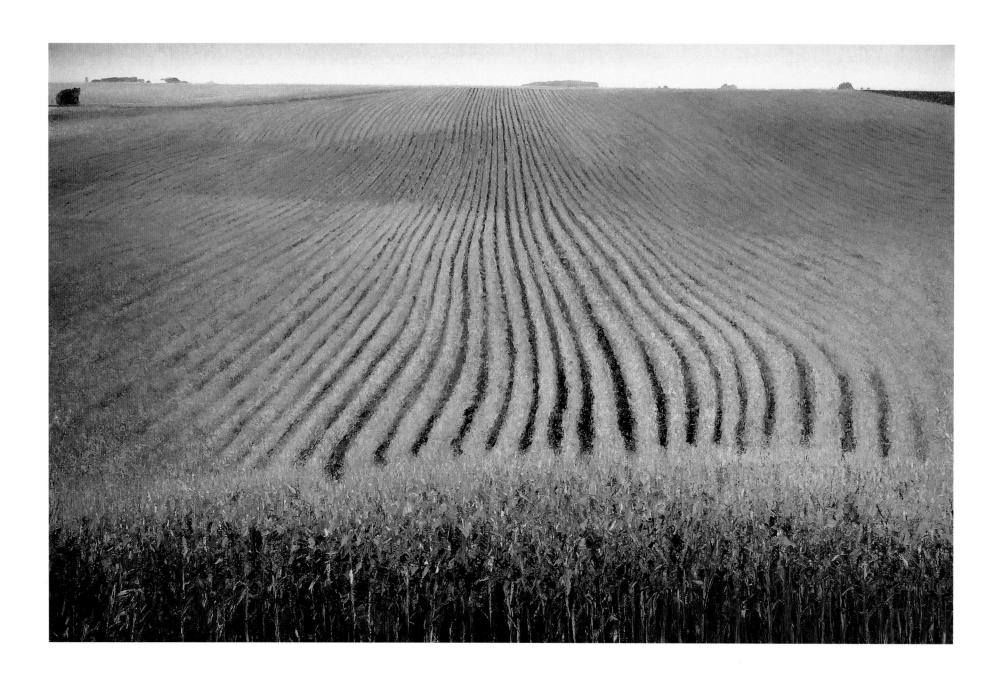

# ACKNOWLEDGMENTS

MANY PEOPLE CAME TOGETHER to shape the creation of this book. Foremost are Gary Ernest Smith and his wife, Judy. On my periodic visits to their Utah home, they stood ready with responses to my questions, provided material, and otherwise allowed me to probe their lives. They are gracious individuals and made every effort to ensure my stays there were productive. Gary and Judy are endowed with abundant spirit, which made me feel much at home.

A special debt of gratitude is owed to Ray E. Johnson and his staff at Overland Gallery: Bradford Shinkle IV, Trudy Hays, Robyn Graca Dill, and Joan Lee, whose individual and collective contributions to the project have been invaluable.

Additional thanks are due to Ernest and Hazel Smith, Ed Mell, Vern Swanson, David Hunt, and Neil Hadlock for their perceptive insights about Smith's life and his art. Thanks too, for the support of publisher David Jenney and the excellent staff at Northland Publishing. My editor, Stephanie Bucholz, should be acknowledged for her insight, editorial skills, and advice. I am grateful for her assistance.

My wife, Rebecka, and our children, Kristina and James, as usual afforded the personal space and enthusiasm needed to write the book. Rebecka, in particular, with

patience and good humor, helped on computer problems, read the manuscript, and offered suggestions. Her presence graces the pages of this book.

—DONALD J. HAGERTY

---

My father told me once when I was young that an artist could draw anything without looking at it. This comment sharpened my eye for drawing. Long hours on horseback and on tractors in extreme weather conditions taught me perseverance, responsibility, and respect for accomplishment. These are the foundations for my art. To this I owe profound thanks to my parents, Ernest and Hazel Smith.

I learned friendship and philosophy in building a career from David Hunt. This was supported by my colleagues and fellow artists; Neil Hadlock, Dennis Smith, Trevor Southey, James Christensen, Mike Reber, Bruce Smith, Clane Graves, Robert Marshall, and Vern Swanson. I want to express my gratitude to Werner Weixler for giving me my first gallery start and for his support over the years.

Painting must have a purpose beyond the commercial, and to make a living one must be presented to the public in the most professional manner. For this I thank my longtime friend and agent, Ray Johnson, along with his wife, Susan. Ray and I have worked together for almost twenty years. Ray believed in me and my ability from the beginning. I am thankful for his humanitarianism, his uncompromising devotion to excellence, and his genius for promotion. He freed me to explore my creativity.

I wish to thank the entire Overland Gallery staff—Trudy Hays, Robyn Graca Dill, Gina Caruso, and Shawn Graca—for their untiring pursuit in supporting and presenting my work, and for our personal relationships. I am grateful to Joan Lee and Keith and Joyce Olsen for their expertise in advertising and promotion. Thanks are also extended to Bill McLemore, Bill Anderson, and Leon Woodward for their fine photography of my artworks. Jerald Jacobs has spent long hours transporting my work around the country. He and his family have offered their support for many years.

I would like to thank Don Hagerty, whose insightful and intelligent writings have broadened my understanding of the American West. He took my work and gave it context, meaning, and perspective.

Thanks also go to Kevin Maag and Brett Wright at Metal Letters in Lehi, Utah, for their expertise in bronze casting. And to David Jenney and his staff at Northland Publishing, I say thanks for their belief in my work.

I want to thank the galleries who carry my work, and the collectors who follow my career. They have given me a high compliment by owning my paintings or bronzes.

Over the years, I learned that real love, support, and purpose make two people grow together with common goals. For this I owe my wife, Judy. Times were tough along the way and all we had in the early years was a dream. She understood and was willing to do what was needed to make it happen. To her, above all, I owe my love and thanks. I would also like to thank my children, Andrea, Christopher, Nathan, and Julia, for the privilege of being their father.

—GARY ERNEST SMITH

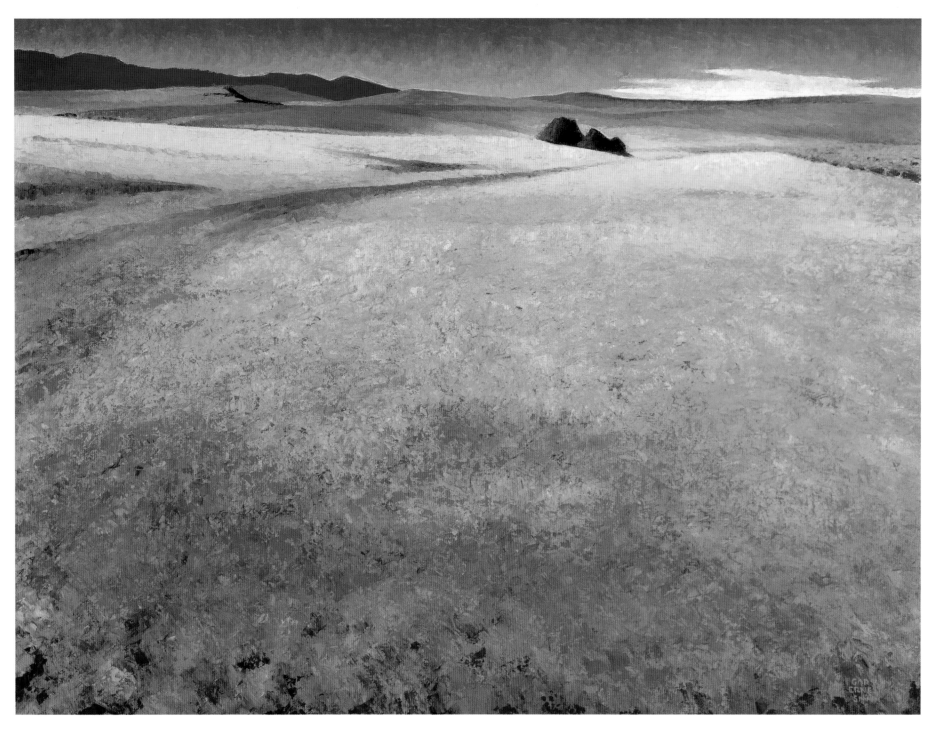

DRY PASTURE, *oil on linen, 30 x 40, 1998*

# TRANSFORMATION *and* TESTIMONY

THE ART OF GARY ERNEST SMITH speaks for landscapes and cultures rarely, if ever, spoken for in contemporary American art. Poet William Carlos Williams felt that in all the arts, there are no ideas but those that reside in familiar things. Painter Andrew Wyeth, in search of his special landscapes, mused that "the commonplace is the thing, but it's hard to find." Both the familiar and the common-place, for Smith, like they were for Williams and for Wyeth, are the overlooked and ordinary, the cultivated landscapes and rural cultures, historic and contemporary, of the West and Midwest. A concept of place and of the people who inhabit particular places loom large in Smith's vision. Everybody comes from some place, and the places we hail from can often affect our lives and work, as it has for Smith.

But these are places and people in jeopardy. The old farm and ranching families are leaving, and cooperative rural life is disappearing. For many places in the West and Midwest, the face of the land, along with the old agriculture-based economy, is being transformed. For most urban Americans, these changes are not apparent. Lucy Lippard, in her insightful book, *Lure of the Local*, writes,

If land is best seen through the eyes of those actually living and working there, our long-standing lens—the small farm—has become clouded. Once the epitome of local, landbased, independent Americanism, the farm (and farmland) is in deep trouble across the country, in areas that few artists know and fewer care to address except when they come to live on former farmlands as agents of rural gentrification.

Only two out of every one hundred people in the United States make a living by farming or ranching at present. And just 6 percent of the nation's farms or ranches made over $100,000 in 1997, yet this 6 percent accounts for half of all farm earnings. Small farming towns continue to disappear or find themselves transformed into extensions of suburbia. In Kansas, people are so scarce in certain areas that more land is classified as "frontier" today than a century ago. And of the 310 incorporated communities in South Dakota, 170 have lost population since 1990. There is a continued exodus from agrarian culture, not solely due to crop or livestock prices or weather losses, but also to the legacy of technology and the juggernaut of an urban-driven America. Increasing economies of scale in agriculture through industrialization and consolidation have turned the idyllic vision of the family farm into an anachronism. When farmers used animals for work and transport, a town existed every six miles or so in the Midwest and upper Plains states. When tractors and trucks replaced horses and mules, farms increased in size, the farmers decreased in number, and small farm towns began to fall off the map.

Richard Critchfield's book, *Trees, Why Do You Wait?*, is a lament for the trees and shelterbelts of the Midwest, with little left to protect when farm buildings are allowed to fall down or are demolished after the owners depart, so as not to be taxed. Critchfield is

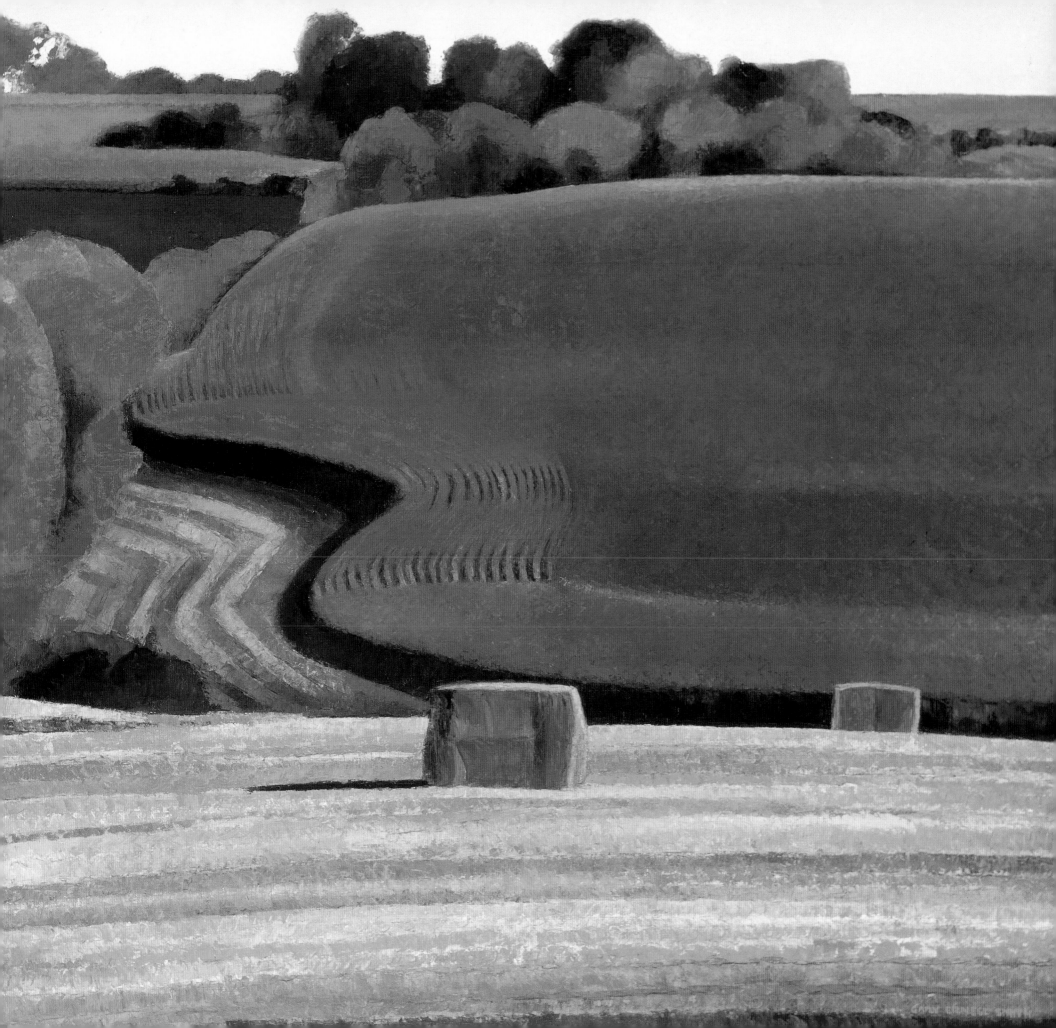

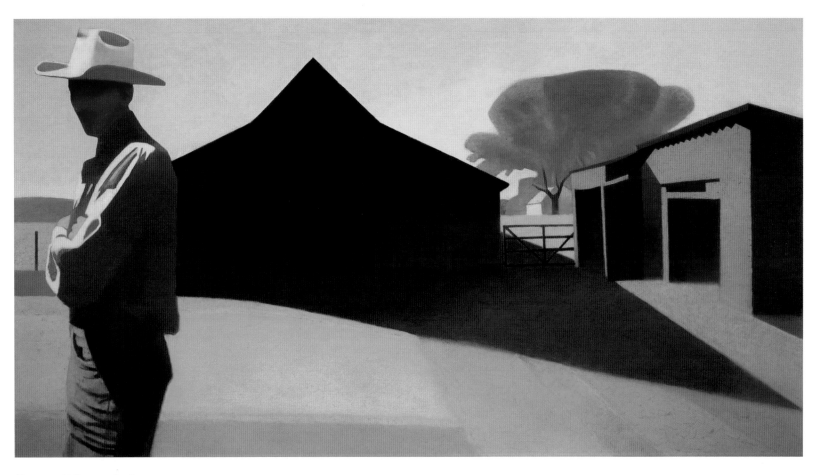

FIGURE *with* BARN, *48 x 84, 1994*

concerned that the exodus of rural people has led to the breakdown of the agricultural moral code that was at one time the heart of American culture. He believes the moral code of rural America has direct bearing on the overall morality of urban life and is bothered that the kind of urban culture we will have in America is going to depend on how many Americans continue to farm. Jonathan Raban, investigating the past and current effects of homesteading and farming conditions out on the high plains of eastern Montana for his book, *Bad Land*, found implications of the forces now at work on agrarian society:

For every surviving ranch, I passed a dozen ruined houses. The prairie was dotted about with wrecks. Their windows, empty of glass, were full of sky. Strips of ice-blue showed between their rafters. Some had lost their footing and tumbled into their cellars. All were buckled by the drifting tonnage of Montana's winter snows, their joists and roofbeams warped into violin curves. . . .

It took me a while to see the little hilltop graveyards. I had mistaken them for cattle pens. Fenced with barbed wire and juniper posts, each held ten or twelve rotting wooden crosses, with, here and there, a professionally chiseled undertaker's headstone. . . . Save for the odd empty jam jar, the individual graves were untended, but someone kept the fences up and the grass neatly cut. I supposed for farmers here it came with the territory, the job looking after the dead strangers on your land.

The continuity of farm life in parts of the Plains states has been disrupted or displaced and cannot sustain itself. In recognition of this development, a controversial proposal has been floated in recent years by two professors at Rutgers University, Frank and Deborah Popper. Called the "buffalo commons," it envisions the conversion of about 140,000 square miles in ten states, or about a fourth of the area, into the world's largest natural preserve. In other words, the territory would be allowed to revert to an earlier ecosystem, before settlers started to transform the landscape. Of course, this proposal has generated furious controversy and alarm among the inhabitants of the area, particularly the farmers and ranchers, who sense the danger of losing generations-held land.

In the 1990s more people have moved into rural counties in certain states than have left them. But the paradox here is that the people flocking into these rural areas are not farmers or ranchers; they are escapees from the pressures of urban life who long for pastoral surroundings, but need the amenities and convenience offered by urban life. They yearn for a simpler life, but only as long as it is no more than an hour's drive from a metropolitan area. Quiet farm towns are now planned bedroom communities. One of them, Brentwood, in California's Contra Costa County, was the fastest growing city in the state in 1997.

Lippard writes that when farmland is sold for development, a suburban veneer is laid over the existing design; thus urban expectations confront and clash with the realities of rural life. "Rural suburbs" is a contradiction in terms, having neither the feel of the city nor of the country, perpetuating a false rural environment. Today in the West, Midwest, and for that matter, most of the United States, stubborn farm holdouts often find themselves squeezed between megamalls, industrial parks, expensive homes, and parking lots. The new furrows on the landscape are the yellow or white parallel lines painted on the asphalt of those parking lots.

The geometry of agricultural fields is commonly seen along the West's network of interstate highways, silent, secret places that mask their resplendence from passing travelers isolated in their vehicles. From Red Bluff to Bakersfield along Interstate 5 in California's Sacramento and San Joaquin Valleys, adjacent to the Snake River plain through Idaho on Interstate 84, and south from Salt Lake City beside Interstate 15 are large tracts of fertile ground.

But this agricultural land is increasingly imperiled today, as is land throughout the United States, its quiet, unmomentous presence overwhelmed by the invasion of sub-

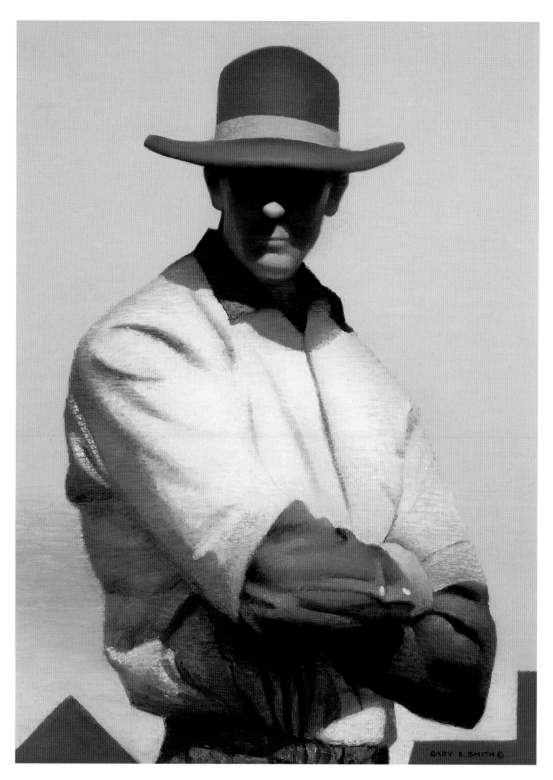

SYMBOL *of* AMERICA, *40 x 30, 1987*

MAN *in* RED, *60 x 48, 1994*

divisions, town-busting strip malls, gated communities, golf courses, and high-technology business centers. For many areas, cultivated fields are living on borrowed time. In 1987, for example, California's Contra Costa County had 43,000 acres of orchards under cultivation. Today, only 3,000 acres remain. In fact, it has been estimated by the federal government that over four square miles of prime farmland is being transformed by development every day. It is forecast that the Sacramento Valley could lose nearly one million acres of farmland, or 15 percent, by the year 2040 due to increasing suburban sprawl and the rise of megacities. Here, and elsewhere, cities and farmers are locked in conflict over the "edge," where subdivisions end and farming begins. Prime farmland, prized for its soils, are desirable places as cities expand like concentric circles radiating outward, that best land swallowed by relentless sprawl. Housing, it seems, is the new cash crop, and landscape gardeners the new farmers. The set of a surveyor's tripod in the fields announces the arrival of a New West, the face of suburbanization forces. Nowhere does this seem more apparent to Smith than in the places adjacent to his Utah home, fields he once walked over, now destined for housing tracts and other developments that accompany growth.

The art of Gary Ernest Smith celebrates what we once had; it is a lament for vanishing places and farm-based culture, its emotional roots, and what we still have of all that, now endangered. First and foremost, Smith is a painter and sculptor of rural subjects: the quiet beauty of domesticated landscapes and the stewards of that land, farmers and

ranchers. Smith goes against the grain; he paints for himself. He is not concerned with the "fashionable," nor the desire to be "in." He abhors stagnation, and over the years has conceived of and produced with technical skill and creative thought several series of topics in his work, each a departure from the others. Intersections of land, culture, and history inform his art. Like the work of poet Gary Snyder, Smith's art says, "I am here."

Among these topics or themes are those found in his paintings of agricultural fields scattered throughout the West and Midwest: humble yet fertile places, transformed earth where human presence is palpable but not explicit, where crops have thrived and died and await the chance to be reborn again through seasonal planting cycles. Gretel Ehrlich once mused that we should "look" into the earth. Smith has—through his paintings of cultivated fields. Though they are drawn from places in Utah, Oregon, Minnesota, Iowa, Idaho, Arizona, or other locations, these paintings represent everywhere and anywhere. They represent America's imperiled places—agricultural fields—their greatest enemies concrete and asphalt, the face of development fueled by combat between expanding population and a finite expanse of land.

Human life is most harmonious when close to the soil, when there is that symbiotic relationship between nature and an agrarian way of life. The "Field Paintings," an epic series of paintings Smith started in the mid-1990s, focus on that most precious of commodities, soil, and the seasons which shape its productivity. Though they depict that most ordinary element in the landscape, Smith endows these canvases with poetry. While literal on the surface, the paintings venture beyond their images, meditations created from some mirror of Smith's imagination. In his book, *The Unsettling of America,* Wendell Berry states that it is impossible to contemplate the life of soil without seeing it as comparable to the life of the human spirit.

The son of ranchers, Smith has looked at, understands, and portrays with emotion the tiller and tender of these lands, the small farmer and rancher. Through the use of sparse narrative, strong color, and heroic forms in his figure paintings, he projects the universals of individual and family values: strength, solitude, compassion, hard work, struggle in the face of adversity, frugality, and practicality. Smith sees these paintings as symbols or icons that transcend the here and now. Furthermore, the inseparability of family in daily work lives and how those lives fit in the crucible of the landscape is crucial in his work.

Formal and distanced, filtered through memories, the figure paintings, along with Smith's sculpture, capture moments of self-awareness, the daily fragments that make up our lives. The figures center around the cherished and enduring symbols of the yeoman farmer, cultivator of the soil who draws strength from the earth itself. That symbolism—timelessness, the universality of man at work with nature, and the dignity of physical labor—resides in these works. With their large, bold shapes and minimal detail, they explore the attitude of the rural lifestyle, endurance, and the mystical intimacy with the soil that farming without much reliance on technology entails.

There is little doubt that the venerable traditions of rural life, as Smith celebrates them, are drawing to a close. Smith's paintings and bronzes portray people and places belonging to a certain period of time not too far in the past, but one played out against present-day reality as those images probe deeper in search of an almost existential mood.

Where it all begins for Smith is the spare, meditative landscape he first knew as a boy growing up on the family ranch near Baker City, in northeastern Oregon. Smith's paintings of the region explore the distant horizon, emblems of cattle ranches such as gates

and fences, and the vast sagebrush ocean that rolls away across a land shaped by aridity and volcanic activity. Much as artist Maynard Dixon did, Smith finds solace in landscapes created by the action of water, wind, hot summers, sub-zero winters, and a people molded by austerity.

Northeastern Oregon is a tough, unyielding land of contradictions, and Smith examines it with a sympathy that, translated to his art, inspires understanding and respect. For Smith, this process considers the region's landscape and culture not as fixed entities, but as paths that unwind before his eyes, under his feet. Smith has found in northeastern Oregon a place that does not reveal everything, but where truth lies within the stark plain cover. As such, this native ground has helped shape the responses and direction his art has traveled for over two decades.

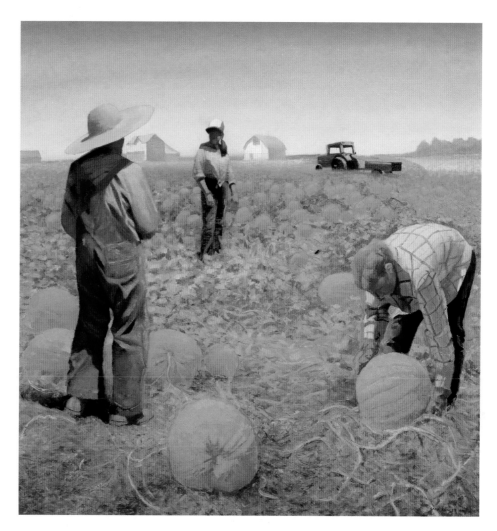

THREE WOMEN GATHERING PUMPKINS, *78 x 78, 1994, courtesy of The Butler Institute of American Art, Youngstown, Ohio*

Born in Oregon, now living in Utah, Gary Ernest Smith is a westerner. His art draws inspiration from several western states, primarily northeastern Oregon, Utah, Idaho, and Arizona, with a few forays to Minnesota and Iowa. Should he then be considered in the context of what is termed "Western art"? Often, contemporary Western art suggests a place and time, a rupture between the past and present, and a lament for loss, and is staffed with an array of characters, often cowboys and Indians. But artists who embrace

this genre focus on pristine, heroic landscapes, romantic ranch life, cultural myths of the Old West, and the allure of simplicity in continuing long-held perceptions about the West. Much of the art produced by western artists has a romantic cast, narrative and escapist, about it and a selective vision toward the subject matter. It omits much to include a little. There are others, such as Smith, who envision the American West as complex and multifaceted, harboring many points of view. Their art can often transcend a narrow parochialism and offer alternative visions to the old fictions.

American mainstream art has always borrowed from imagery rooted in the local or regional, such as Western art, as well as from the ideas generated by mass cultures. All of American art is, of course, in some fashion, local and regional, even though contemporary modernist art sometimes ignores those original voices emanating from various regions. And there is art that explores the meanings of localized landscapes, like cultivated fields, and rural-based cultures, but that art has global application. According to Lippard:

> If art is defined as "universal," and form is routinely favored over content, then artists are encouraged to transcend their immediate locales. But if content is considered the prime component of art, and lived experience is seen as a prime material, then regionalism is not a limitation but an advantage, a welcome base that need not exclude outside influences but sifts them through a local filter. Good regional art has both roots and reach.

Smith's art is grounded by a deep sense of tradition, based on his memories of an agrarian childhood, shaped by experience and the presence of place. Most of his subjects—cultivated fields, rural men and women—are about the processes of agriculture.

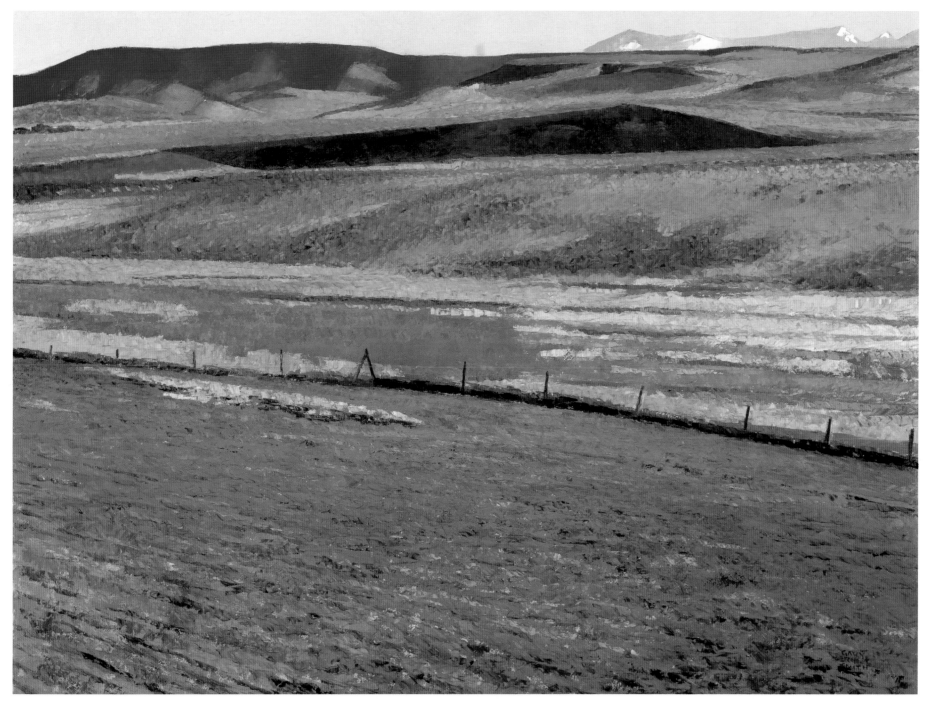

FIELDS, HILLS *and* MOUNTAINS, *oil on linen, 36 x 48, 1998*

KEEPER *of the* GARDEN
*24 x 36, 1984*

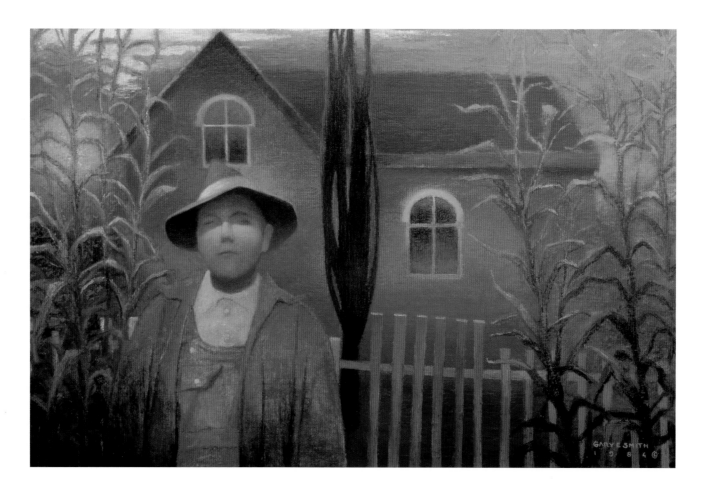

But agriculture, for Smith, is much more about ideas than it is about the implications of food production and the technology used to produce it. The virtues of a landscape worked in harmony with nature, and people who respectfully create that environment, are the concepts that drive his work. A strong dose of nostalgia is embedded in Smith's art, prompted by looking back at his own history. No doubt there is regret for what has been lost through changes in the rural traditions of America as played out in the West or the Midwest. Without much romantic sentiment, Smith's paintings are evocations of both the unsung aspects of rural culture and the new realities that confront it.

In recent years, Smith turned from the artistic terrain of farmers and ranchers to a close scrutiny of the landscape itself. The intrusion of man still resides there, but it is grounded in the present, whether in the geometry of a recently plowed field, or a fence that bisects a sagebrush plain. He sees two landscapes: two realities imposed by the natural and human worlds. Wallace Stegner thought no place could be called a place until it has a poet. Or, in this case, maybe it is an artist like Gary Ernest Smith. His art, his places, are not just about cultivated landscapes, but about the beliefs and activities of people that come to characterize their places. "Untold land is unknown land," reflects Lippard.

———————————————————

In the exploration of the ordinary, the commonplace, the overlooked, and the familiar, Smith has uncovered not only beauty, but enduring symbols. Smith's art and his choice of rural people and cultivated terrain bring fresh insight to an ignored part of American life and little-known places, helping us view them with new eyes and deeper appreciation. As rural culture slowly disappears, the concern of Richard Critchfield and others about the effect of that disappearance on the larger landscape of American values gains advocacy through Smith's art. The joining of places with people—their presence or absence—offers opportunities to ponder different layers of meaning and perception. All artists receive tangible and intangible rewards from their chosen subjects. In return, they, as Smith does, offer the concept that his art helps us to look at people and places we might otherwise ignore. Through what Smith sees, what he remembers, and what he invents, his art allows us to view important, but often unseen aspects of American culture. We see more clearly, and understand more.

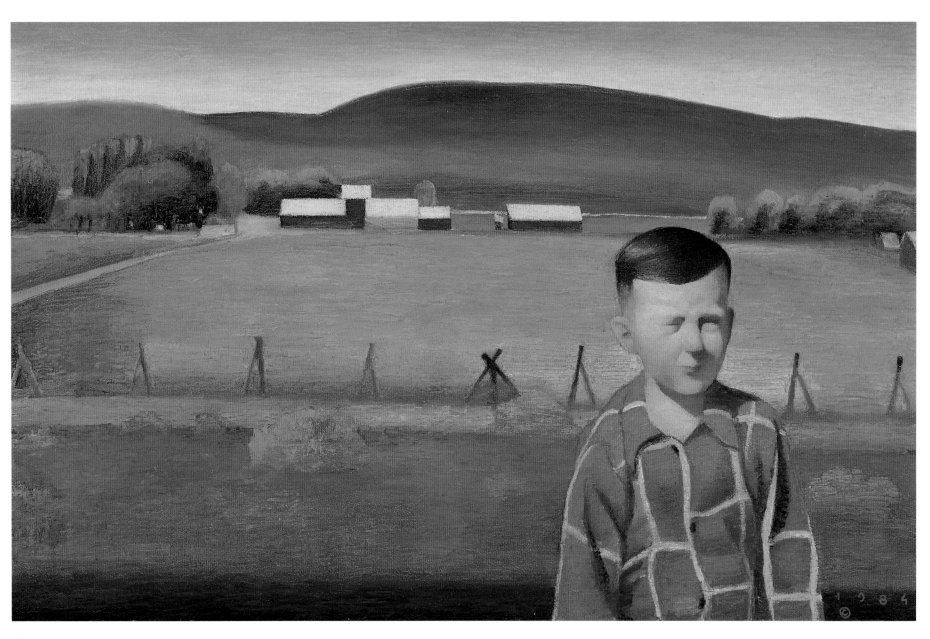

MEMORIES *of* HOME, *24 x 36, 1984*

# FOUNDATIONS *of* LIFE *and* ART

S MITH'S HOME LIES AT THE BASE OF THE WASATCH RANGE in the commu-
nity of Highland, Utah. The Bull River, which tumbles out of the nearby
mountains, flows past his house, then meanders southwest to empty into Utah
Lake. To the southeast a few miles looms 12,000-foot-high Mount Timpanogos, graced
with sheer cliffs and jagged edges. A highway nearby leads into American Fork Canyon
and the narrow, twisting mountain road to Robert Redford's Sundance resort.

Nestled on two acres astride the lush riparian habitat of the Bull River, Smith and
his family have called this place home since 1978. Box elder, chokecherry, Gambol oak,
wild plum, and hawthorn crowd around the house with chaotic growth. Songbirds chat
among the trees while quail strut along the driveway. Four levels, starting with Smith's
studio, then bedrooms, an office, a music room, and finally, the kitchen, dining room,
and family room, descend down a hillside from the street. Where the house ends, care-
fully tended flower and vegetable gardens march toward the river. Various rooms
throughout the house offer glimpses of Smith's paintings, along with works by other
artists such as Maynard Dixon. One room is crammed with an impressive collection of
early cartoon art: *Krazy Kat, Alley Oop, Prince Valiant, Little Nemo in Slumberland, Red*

Cow
*colored markers on paper, 7 5/8 x 10, 1948,*
*collection of the artist. Drawn at age six.*

*Ryder,* and others. Often, the sound of classical music fills the house, when Smith's wife, Judy, first clarinetist with the Utah Valley Symphony, practices in the music room.

On the uppermost level is Smith's large light-drenched studio, stripped-down, clean, functional, and orderly. "The Thinking Place," he calls it. With white walls and maple floor, the studio has both north- and west-facing light from windows and three skylights. Two leather sofas face each other in a nook. In the opposite corner is Smith's easel and painting materials. Perhaps as many as a dozen paintings—mostly landscapes—some finished, others in various stages of work, are hung on the walls. Stacked against one wall are several of his large paintings of agricultural fields. A painted bronze of Superman, the model for a large sculpture commissioned by Metropolis, Illinois, sits on a table, ready, it seems, to leap into the air.

Although in his mid-fifties, Smith appears youthful and vigorous as he works on a painting. Dressed in jeans, a loose, short-sleeved shirt, and loafers, Smith is not quite six feet tall, has a slender build, salt-and-pepper hair, a well-trimmed mustache, and eyes the color of blue denim. There is an air of immediate friendliness and calm reasonableness about him as he talks about the image in front of him. Sometimes the serious face breaks into a quiet smile as he gazes out of a studio window as if to reaffirm the rural landscape around his home.

---

East of Oregon's Cascade Mountains, the land empties out: towns are compact, the intervals between them long, and the landscape is marked by far-flung distance. In the Snake River–Columbia Plateau of northeastern Oregon's high desert country, enclosed valleys burrow here and there. Baker City lies in one of them. Named in 1863 for Edward D. Baker, a friend of Abraham Lincoln who was killed in one of the Civil War's early

battles, the town arose when gold was discovered in the vicinity. The gold never amounted

to much, but when the Oregon Short Line Railroad came through in the early 1880s,

Baker City became the center of flourishing ranch, farm, and lumber enterprises.

Here Garold Ernest Smith was born June 29, 1942, the first son of Ernest and Hazel

Smith, who came to Baker County in 1937. Two other sons, Dallas and Larry, followed at

three-year intervals. The family home was a large
ranch some twenty-five miles northeast of Baker
City. Located in Big Creek Valley, tucked in the
foothills of the Wallowa Mountains, the ranch was
bought by Smith's grandfather in 1916 when he came
from the Willamette Valley, one of several in the
vicinity he eventually obtained for his five daughters
and their husbands. To the east rise the Wallowa
Mountains, spiritual homeland of the Nez Perce.
Westward lay the pine-covered outlines of the Blue
Mountains. Rolling sagebrush-covered hills stretch
in all directions as far as the eye can see. Adjacent to
the ranch was Pondosa, a lumber town that began in
1927 and closed in 1957, the name adapted from the
Ponderosa pine that flourishes in the high mountains.

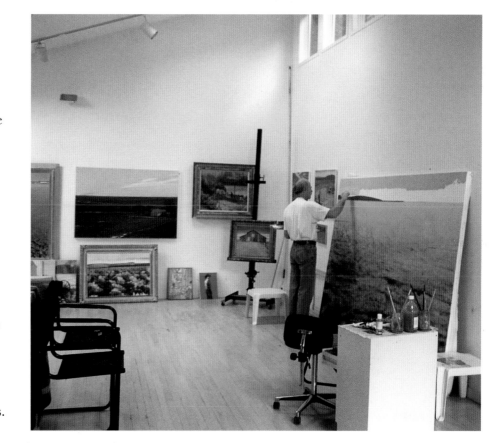

*Gary Ernest Smith in his studio, 1998.*

During World War II, Smith's father worked at
the lumber mill making ammunition boxes for the army. At the war's conclusion he and

his wife assumed the responsibility for the family ranch. The property sprawled over

6,000 acres with another 100,000 acres, known as the Big Creek allotment, leased from

*Nine-year-old Gary Smith and his father going to ride for cattle, 1950.*

the Wallowa-Whitman National Forest. Smith still remembers the work—stacking hay; growing wheat, alfalfa, and barley; milking cows; irrigating; feeding chickens—hard, full days. Over five hundred head of cattle roamed over the ranch, and Smith spent countless hours in the saddle, becoming an accomplished horseman. During early winters, tracks had to be pushed through the snow in the mountains for the cattle to move down into the valleys, an effort which often entailed long days in northeastern Oregon's subzero temperatures. These impressions of a limitless landscape, the work ethic of family and neighbors, and the closeness of people to the earth had a profound impact on young Smith, memories he still retains.

Early in life, Smith knew he wanted to become an artist, and he began to express himself with visual art at a young age. His parents still retain drawings done when he was three years old. Whenever time from ranch chores allowed, he drew animals, farm scenes, and the landscape. His first introduction to art was cartoons in the local newspaper, such as *Alley Oop*, *Red Ryder*, and *Freckles and His Friends*. Sunday mornings brought a section of comics that he would peruse for hours. "I liked the concept of sequential art and telling a story," Smith recalls. Eventually he started to design his own comic books and to draw Western scenes.

Smith's parents realized he possessed a special gift and whenever possible encouraged his artistic efforts. His mother enrolled him in a private art school in Baker City before high school, but her son's talent had already surpassed the instructor's. By the time he

began high school, Smith had earned a local reputation as an artist, particularly with watercolor, securing commissions for paintings of landscapes and portraits. In Baker High School, his self-taught ability furthered the notoriety and added to his confidence. While still a teenager, Smith discovered an advertisement from the Famous Artists correspondence art course in an issue of *The Saturday Evening Post*, the head of a girl with the caption, "Draw Me." He did, then submitted the image for consideration. Shortly thereafter a representative from the correspondence school drove out to the ranch and enrolled him. Driven by his passionate interest in art, Smith completed a cartoon course in one year, and credits this experience with furthering his interest in pursuing an art career.

In 1957, and again in 1958, Smith spent the summers with his great-aunt in Lincoln City on the Oregon coast. She taught art courses and managed a gallery that exhibited the work of local and regional artists, and often invited them to present lectures. One artist was Robert Banister, head of the public school art programs in Riverside, California. A noted watercolorist, at one time head of the U.S. Army arts and crafts program, Banister helped mentor Smith. Eventually, Banister told Smith that he would hire Smith to teach in California if he would attend college and obtain an art degree.

Smith worked on the family ranch for two years after graduating from Baker High School in 1960. Through an agreement with his father, he spent a half-day on chores, then the other half drawing and painting. In 1963 he entered Eastern Oregon College, located fifty miles north in LaGrande. While Smith attended classes, he lived in Baker City, commuting the hundred-mile round-trip each day with his close friend, David Hunt. Most evenings he worked in a Baker City Chevrolet garage.

*Three-year-old Gary at his Oregon ranch home in 1945.*

After Hunt transferred to Brigham Young University in Provo, Utah, he urged Smith to follow. In 1964 Smith enrolled in the College of Fine Arts at the university as an art major, his goal a BFA. His art abilities, particularly drawing, well above average for an undergraduate, prompted several instructors to select him as an assistant in their classes. After six months, Smith started to teach his own classes through a teaching assistantship.

Although this was the first time he encountered competition, Smith found Brigham Young University's environment supportive of his interests. While he considered himself technically proficient, he knew he needed to address the historical foundations of art. Consequently, Smith immersed himself in the study of various art movements, from symbolism and abstract expressionism to impressionism,

WEST EAGLE
*tempera on paper, 24 x 30, 1957,*
*courtesy of Ernest and Hazel Smith*

and of how artists conceived their work. "I went through every style and trend because I wanted to understand and incorporate certain aspects into my own work," he says. Through his years at Brigham Young University, he ate, slept, and dreamed art, and still retains the passion. The Fauve painters, especially Andre Derain and Maurice de Vlaminck, were strong influences. Smith, first working in acrylic, then oil, progressed through a series of styles in his painting, from realism to abstraction, then back to realism.

These attempts helped establish the roots of Smith's current art and his beginnings as a colorist. "I did them all, and experienced them as a part of my growing phase," he says. "I also realized," he continues, "the greatest advantage an artist has is not in school or in the system of teaching, but in his colleagues." This belief was inspired by rigorous critiques from his fellow students, many of whom became close friends as well as noted artists in their own right.

In December 1967, Smith married Judy Asay, a music student and clarinetist in the University Symphony. Six months later, on the verge of graduation, he found himself drafted at the height of the Vietnam War and sent to Fort Lewis, Washington, for basic training. Afterwards, he received orders to report to Fort McClellan, Alabama. For over a year, Smith taught noncommissioned officers English and training management. Another course he led was Quick Kill, an instinctive shooting program that teaches one to shoot when there is no time to aim. Smith became so proficient that he could knock an aspirin out of the air with a BB gun.

With six months left on his tour of duty, Smith received orders for Vietnam, but they were changed the next day, and he found himself in Korea, assigned to the Eighth Army Support Depot. While there, he produced a large quantity of art, including studies of military life such as fellow soldiers and posts, some of it part of the Army's illustration program.

Smith learned an important lesson while in Korea that he feels has helped his technical skills. He fashioned his own sketchbooks from surplus military paper, and started drawing with a ball-point pen. Smith believed that learning to draw with a ball-point and not relying on the crutch of an eraser to make changes would better train his eye. He carried the sketchbooks everywhere and filled them with candid, on-the-spot portraits

*In the Smith family backyard, 1956. Hazel and Ernest Smith and the boys, left to right: Larry, 8; Dallas, 11; and Gary, 14.*

of military places and people. Now, whenever Smith searches for inspiration in the field, a sketchbook is close at hand.

When Smith received his discharge from the Army in 1970, he returned to Brigham Young University to complete his degree. Judy was pregnant when he left for Korea, and their first child, Andrea, was born in 1969. Three other children followed: Christopher in 1972, Nathan in 1975, and Julia in 1979. Smith quickly completed the remaining requirements for the BFA in late 1970, then decided to pursue graduate work, his goal a teaching career at a college or university. Besides teaching several undergraduate courses in the early 1970s, he was appointed director of the university's art gallery.

By 1971, Smith's art embraced not only landscapes and figurative work, including a series of anxious-looking self-portraits, but also metaphysical, introverted images, as he continued to explore his personal style. That year he began showing some of this work at the Weixler Gallery in Salt Lake City. In the late 1960s and early 1970s, Smith explored the art forms of ancient Egypt, which led him to an increased use of dynamic symmetry—a mathematical system of composition based on the relationship of the diagonal to the side of a rectangle—and symbol in his paintings. At one point, he even used a coded symbolic alphabet on his canvases as an explanation of the image's enigmatic meanings.

Smith's intense fascination with art history led him further into studies on impressionism, expressionism, the Fauvists, color symbolists, even surrealism. Artists like Piero della Francesca, Emil Nolde, Edvard Munch, Henri Matisse, Stanley Spencer, Paul Gauguin, and above all, Maynard Dixon, helped influence the gradual evolution of simple, direct statements in his paintings. When he saw an exhibition of Dixon's work at Brigham Young University, Smith was intrigued with how this artist captured the essence of an image in a simplified, reductive manner. The use of bold color and minimal shapes by

NUDE
*pencil on paper, 17 x 14, 1965*

BEGINNING
*16 x 18, 1967*

Dixon and these other artists intrigued him and his work moved further toward a more concrete use of form and color, anchored by an abstract realism.

In 1972, the New York artist Joseph Hirsch, invited to Brigham Young University for a series of teaching workshops, praised Smith's technical skills but also urged him to consider what direction he should take with his art. Smith, who had thought he might relocate to New York or another major art center, pondered Hirsch's advice. In effect, Hirsch told Smith to be true to what he believed in, and not be swayed by the art marketplace.

SELF-PORTRAIT
*ball-point pen on paper, 4 x 4, 1971*

Smith decided that his gallery contacts and commissions would allow him to pursue his own interests, so he left Brigham Young University in 1973 and embarked on the path of an independent artist. "We struggled in the beginning with an income of two to three thousand dollars a year, but we lived in a small rented house in the country, which helped, and our needs were not great," he says.

From 1973 through 1982, Smith worked on paintings as well as mural commissions. During this period he often explored commercial buildings for their mural possibilities, or talked to local architects about potential sites. After his research was completed, he would approach the owners with a proposal for a mural. Most of the mural projects dealt with Mormon history and historical events in Utah. One of his first commissions was to create thirty panels, each of them twenty by twenty-five feet, for a recreational center in Upland, California. Working twelve to fourteen hours a day for three months, Smith used a combination of brush and spray gun to create the panels, incorporating specific themes drawn from Western history such as outlaws, Indians, frontier towns, and the desert.

Many of Smith's historical murals were destined for banks in and around Salt Lake City, such as American Fork Bank, Copper State Bank, Deseret Bank, Murray First Thrift, Brighton State Bank, and the Dixie State Bank in St. George, Utah. The murals were based on ideas prompted by images in early photographs and were done using imaginative colors that Smith felt expressed those earlier times. "Old photographs were important," he says, "but they failed to show the color and feel of the early era. While the paintings are historically accurate, I wanted to convey a cultural and emotional point of view in these murals." Ultimately, Smith completed fifteen significant murals between 1973 and 1982.

By 1974, Smith had moved to Alpine, Utah, and with sev-
eral artist friends, established an artists cooperative. Among
his projects at that time were six large-scale paintings detail-
ing important events in Mormon pioneer life in and around
Navuoo, Illinois, commissioned by a group of Salt Lake City
businessmen. These took eight months to complete. A more
unusual project involved the painting of a four-by-eight-foot
canvas showing Salt Lake Valley as it might have appeared in
1847, background for a film about Brigham Young. Smith fin-
ished the painting at his studio in two and a half weeks.

During 1977, Smith experienced a severe illness—which
he suspected might be paint poisoning—causing a serious
allergic reaction and severely curtailing his painting that year.
After his recovery the following year, he and his family moved to Highland, Utah, and
started construction on their present home. Along with several other artists Smith
worked to establish the North Mountain Artists Cooperative as a nonprofit, loosely knit
art community scattered along the Bull River. Smith and the others—painters, sculptors,
graphic designers—each purchased two acres and constructed contemporary-style
homes along the wooded stream. Serving as his own contractor, Smith built his house
from the foundation up, finally completing it in 1979.

While he now considered himself successful as an artist, Smith nonetheless pon-
dered his future. After almost a decade of commissioned work, he decided to follow
another trail. "Something inside me was screaming to get out," Smith recalls. After

THE WAITING ROOM
*42 x 54, 1972*

POINT *of the* MOUNTAIN, UTAH, *24 x 32, 1973, courtesy of Springville Museum of Art, Springville, Utah*

lengthy reflection and discussions with Judy, he embarked on an exploration of his historical roots. He canceled most of his present and future commissions and secured a second mortgage on his home. Then, drawn by the call of half-buried perceptions and emotions, he returned to Baker City, Oregon, for several weeks.

There he roamed the familiar sagebrush-covered hills during the days, then in the evenings pored through old family photograph albums and talked with his parents about memories. The feel of hot summers and cold winters, the weathered faces and callused hands of people who tilled and tended the earth, sweat and dust, the seasonal rhythms of a demanding land confronted him. "Somehow I saw myself trying to capture all of that," Smith recalls. "Perhaps it was nostalgia, or the dignity of the lifestyle," he reflects, "yet there was an intuitive response to what I saw and remembered."

When Smith returned to Utah, he started painting eight to fourteen hours a day, six days a week. The emotional images from his boyhood Oregon emerged on canvas as artistic statements encompassing a style and subject uniquely his own. The subject matter centered around the private life, and the order, in moments of deep-rooted habit and intimacy drawn from a nurturing land, the benchmarks of rural life. "When I was young, my father told me a good artist could draw anything without looking at it," Smith recalls. "So, from the time I was very young I have been visually memorizing how these things were. Now I began to use those mental sketches to portray images from a certain viewpoint and time, impressions of the past played against present-day reality."

During the time Smith was pondering the visions in his mind, he was offered a commission from Red Ryder Enterprises in Tampa, Florida, to resurrect for syndication the Western comic heroes from the 1940s, *Red Ryder* and *Little Beaver*. Driven by his love for the characters, he finished an illustrated story in six weeks and submitted it to the

HANDCART PIONEERS
*44 x 48, 1978*

contractor. Pleased, they forwarded the drawings to King Features in New York. But King Features informed Smith that the *Red Ryder* project had been terminated. "The timing was off," Smith reflects, since public interest in space adventures had overtaken western adventure stories. He considered this development rather fortuitous, though, for it allowed him to concentrate on his painting.

After he returned from Baker City, Smith continued to explore the string of memories from his rural past, formulating ideas in his mind for images he would create in the

future. In 1981 he received a commission from the Church of Jesus Christ of Latter Day Saints for travel to Israel and the Middle East to find subjects for historical paintings, followed by an extended tour of Europe to visit museums and study art. But throughout these travels, ever since the 1979 visit to Oregon, shadowy images in his mind confronted his esthetic senses.

Those images finally revealed themselves, their inspiration wide and varied: a gesture, the way a shadow strikes a face, an image in an old family photograph, or the memory of a past experience. They emerged in 1983 when Smith created the precursors to what became known as the "Solitary Man" series, symbols of rural farmers and ranchers, memories extracted from the historical past and from his own experiences. Leonardo da Vinci once declared, "Every man paints himself." Smith took his own introspective thoughts, added the recollections of rural life, and transformed them into personal visions executed with paint.

With his sketchbook in hand, Smith started to document what he had seen and remembered. His paintings stressed an emphasis on bold shapes and expressive colors, and a switch to the palette knife brought out their power. Paintings of ranch hands, pumpkin farmers, and others characteristic of agrarian life illustrated a generation of people, and their spirit of frugality, hard work, responsibility, individual reliance, and dignity. Some of the first paintings were loose, impressionistic, their subjects drawn through the imprecise lens of history. But the Solitary Man paintings that followed are a radical departure. More contemporary in execution, the figures in them are big-boned, muscular, and marked with a geometric severity of line and form, their shadowed faces lending mystery and poignancy.

MEN *and* MACHINES
*50 x 70, 1982*

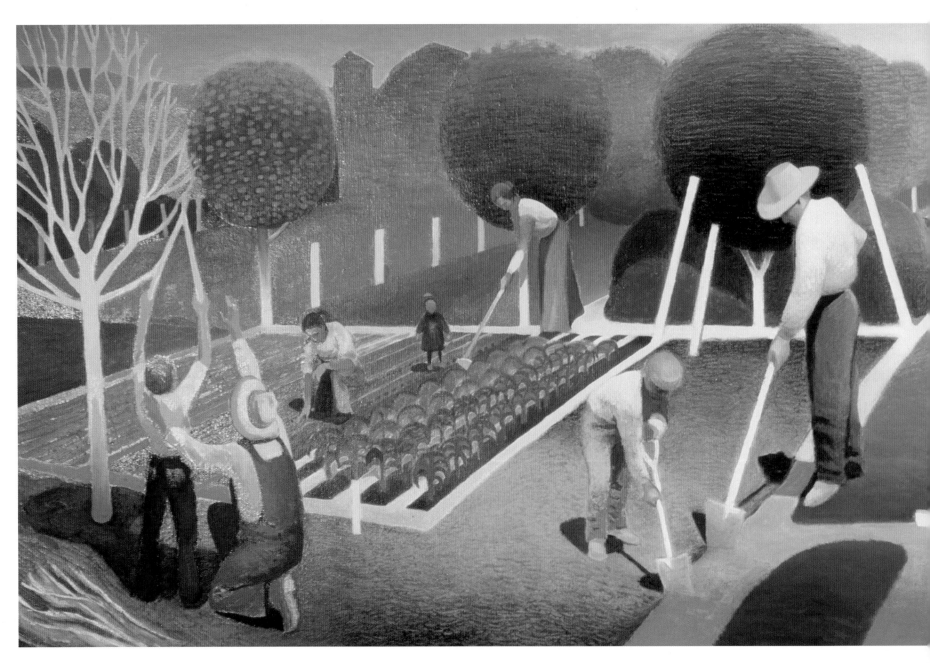

HARVEST *of* SOULS, *18 x 54, 1984*

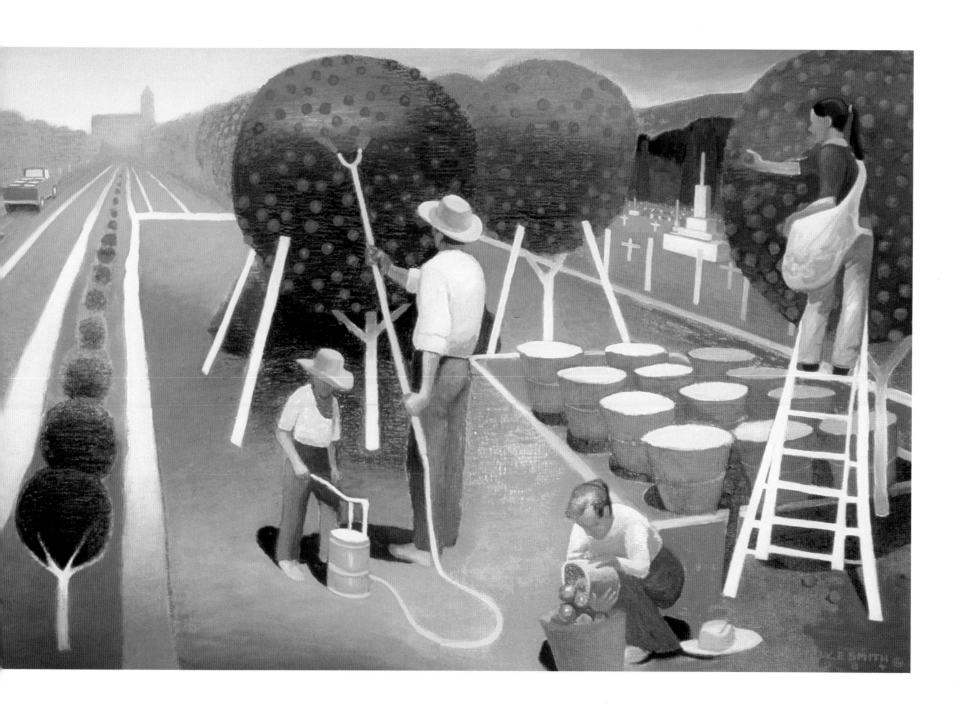

An abstract, dreamlike quality resides in them, the formal, distanced figures symbolic participants in Smith's vision of a rural Eden.

Smith's paintings of rural culture proved compelling, for when he held a special exhibition of them at Brigham Young University in 1983, all sixty works in the show sold. Other exhibitions of the new paintings included one with a group of leading Utah painters at the Nora Eccles Harrison Museum in Logan, Utah. Perhaps the year's most significant event was when Ray E. Johnson, the owner of Overland Gallery of Fine Art in Bloomington, Minnesota, and Scottsdale, Arizona, several Wooden Bird Gallery locations, and the Hadley Companies, producers of limited edition lithographs, contacted Smith.

Johnson and his wife, Susan, were visiting Salt Lake City in December 1983 when they encountered Smith's work at a gallery. The gallery owner provided them with Smith's number and the Johnsons called for an appointment to meet him at his studio. They came out, viewed his paintings, and talked to him at length. "I always look for paint quality, and I saw Smith could handle paint," recalls Johnson. "Besides, they had that rural feel which has always attracted me." The Johnsons purchased several works for their personal collection. Some time later, Ray Johnson asked to represent Smith, to which he quickly agreed, beginning what has proved a productive, long-term relationship. "I saw in Smith potential that did not have an end," says Johnson.

In August 1984, *Southwest Art* featured Smith's paintings in an article written by Vern Swanson, director of the Springville Museum of Art in Springville, Utah. By 1985, Smith saw his paintings of rural subject matter exposed to wider audiences, fostered by another solo exhibition at Brigham Young University, a group show of Utah painters at the Sundance Institute and, in 1986, his first one-artist exhibition at Ray Johnson's

Overland Gallery in Scottsdale, Arizona. That same year three of Smith's works were selected for inclusion in the Third Western States Traveling Exhibition organized by the Brooklyn Museum of Art.

Another visit to Oregon in 1988 prompted a realization about important visual patterns of the American West—gateways, fencelines, isolated barns—that could be translated as symbols onto canvas. So in June of 1989, Smith returned to the Baker City area, his car loaded with canvases, paint, brushes, sketchbooks, cameras, and film. Smith traveled the back roads for a month in search of his images: watertanks, ranchers, windmills, the skeleton of a deer hung on a barbed-wire fence, the red volcanic earth, and the gray-green of a sagebrush sea. Days were filled with sketching and photography. An agreement with a film development store in Baker City allowed Smith to have his photographs ready the day after he dropped them off.

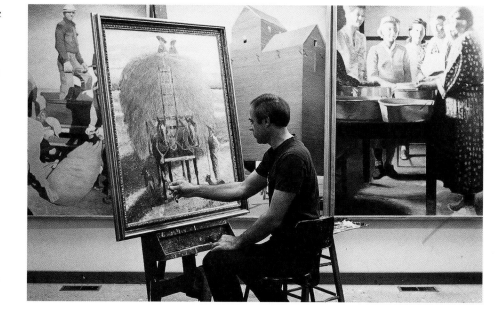

*Gary in his studio, 1982.*

Armed with the field sketches and photographs, he worked in a makeshift studio set up in his parents' basement, where he painted long hours every night. Nearly thirty paintings, some as large as four by six feet, were completed during or shortly after the month he explored northeastern Oregon's distinct topography. Then, one afternoon in early July, Smith hosted an impromptu exhibit of the paintings at his parents' home. Large numbers of people from around the area stopped by to view them, and the local newspaper printed an enthusiastic article about Smith and his paintings. Smith remembers, "This artistic quest opened strange and wonderful gateways in the mind. Beckoning

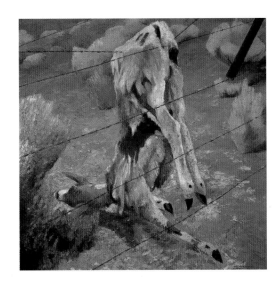

WINTER KILL
*48 x 48, 1989*

paths weaved and stretched far beyond the horizon. I became immersed in a spiritual odyssey to rediscover visual fragments long hidden in my memory."

The paintings include symbolic constructions such as cow or elk skulls nailed to the top of a square-arched gate, perhaps a caution against arrogant assumptions of human dominance over nature. Mummified carcasses of deer or cattle draped over wire fences after a hard winter recognize death as part of life's cycle. The spindly legs of a windmill or the sharp outline of a thistle punctuate the broad sweep of hard-baked earth and horizon in other paintings. The ranchers portrayed in several canvases project that universal image of people whose strength derives from working a difficult, uncompromising land. Through the medium of paint they are endowed with the virtues of hard work and self-reliance in the tradition of Emerson and Thoreau, facial features shadowed beneath cowboy hats and John Deere caps, the everyman of the rural American West.

By now the status and role of women had undergone significant change in the rural West, Smith knew, and it prompted him to paint a portrait series of local women ranchers in Baker and adjacent Union counties during the summer of 1990. In these canvases Smith projects the self-reliance and ability of women at work outdoors in various roles handling cattle, milking cows, cutting wood, or caring for the land. He completed eighteen paintings, each an identifiable portrait of a specific woman. As Smith considered the portraits more personal than commercial, he donated two of them and sales proceeds of a catalog to the Oregon Trail Regional Museum in Baker City.

In September 1989, when Smith completed the last of his Oregon paintings, the Springville Museum of Art in Utah organized an exhibition of them titled *Journey in Search of Lost Images*. When the exhibition closed, the paintings went on tour to twenty-two museums throughout the United States from 1991 through 1992.

Since Smith worked with bold forms and shapes in his paintings, it seemed natural he would begin to explore sculpture. Sometime in late 1989, neighbor and fellow artist Neil Hadlock, owner of Wasatch Bronzeworks, brought a prepared armature and clay to Smith's studio with a challenge: "Here is the clay; here is the armature. Do it!" The subject of Smith's first sculpture was one of the most popular images in his painting genre: a man with a scythe over his shoulder. The image translated well into the bronze medium, and the edition of fifteen soon sold out. This was followed by a second bronze, a farmer lifting a sack of potatoes, in an edition of three eight-foot-tall sculptures. Eventually Smith crafted additional bronzes drawn from examples of rural life. Other sculptures reflect his interest in cartoon characters, such as Krazy Kat and Alley Oop, and western historical figures like Billy the Kid. Sculpture, Smith discovered, was not just a natural outgrowth from his painting, but a mechanism that allowed him to recharge his vision.

An unusual challenge for Smith arrived in 1993 when the community of Metropolis, Illinois, decided to commission a giant statue of that man of steel, Superman, for the town square. Barron Walton, a Utah company serving as project manager for the sculpture, knew of Smith's interest in cartoon and comic characters. The company approached him and helped arrange the contract. Smith soon discovered that the addition of a third dimension to a character heretofore known in two dimensions was challenging. "My goal was to make Superman more than just a statue," Smith says. "I have great love for the character, which began when I was a boy and continued into adulthood. My dream was to make the statue something the entire country could be proud of."

Smith commenced the sculpture process with a small clay model, then enlarged proportions to the needed height of fifteen feet. The image evolved from discussions between the city of Metropolis, DC Comics, representatives from Barron Walton, and

Smith, and from the engineering limitations posed by the design of such a large sculpture. As envisioned by Smith, Superman's facial expression eventually stood between innocent pleasure and a worldly-wise scowl.

Guided by the model, two assistants blocked the sculpture out in clay while Smith refined detail work on the face, hands, belt, and other formal parts of the figure. It might take twelve months or more to complete a sculpture this size, but with help from his assistants, Smith completed the statue in a little over six months. Once final approval arrived from DC Comics, a rubber-and-plaster mold was fabricated, and then cut into sections and moved to Metal Letters in Lehi, Utah, for bronzing.

When the over-two-ton statue was completed and the red, blue, and yellow paints applied, the foundry held an open house for one day. An estimated one thousand people stopped by to get a glimpse of the superhero before it would be loaded on a flatbed truck for the journey to its permanent home. The visitors enjoyed Superman in all his glory: hands on hips, the flared red cape flowing out, the letter "S" on his chest, a look of determination on his face. Finally, the statue was shipped to Metropolis in June 1993, where it was unveiled in Superman Square, set on a granite base engraved with "Truth, Justice, and the American Way."

As the Soviet Union began to crumble in the early 1990s rumors circulated of artistic treasures created by Russian and Soviet impressionists and realist painters during the Soviet period between 1930 and the early 1970s. Soon exciting stories of an impressive body of work by these artists filtered out of Russia. Ray Johnson, who had already been to Russia to assess the work, invited Smith and Vern Swanson to accompany him on

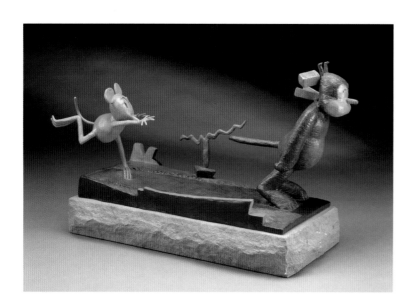

KRAZY KAT
*bronze and polychrome,*
*8 3/4 x 15 x 6, 1992*

OPPOSITE
SUPERMAN
*bronze, height 15 ft., 1993,*
*City of Metropolis, Illinois*

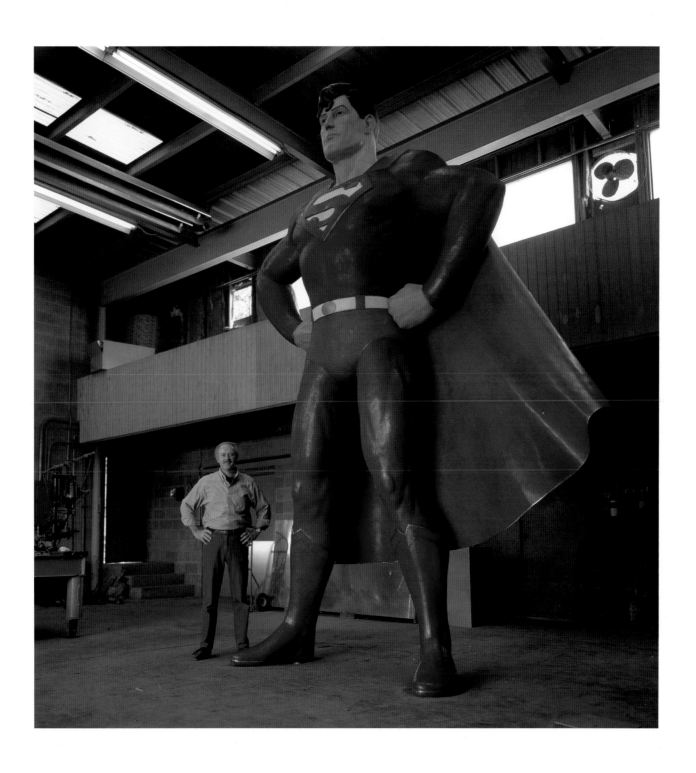

another trip, to locate, purchase, and bring to the United States the best examples of this long-hidden art. "I needed people like Smith and Swanson who could tell me whether or not an artist and his paintings had potential," he says. Johnson, Smith, and Swanson traveled throughout Russia, visiting museums and artists in their homes and studios. Eventually, Smith returned to Russia several times with Johnson and Swanson. Smith credits these visits to observe artists who painted Russia's rural life with strengthening his resolve to continue with similar subjects.

There have always been certain periods in Gary Ernest Smith's life when he recognized the need to self-impose a new direction for his art. One of these periods arrived in 1994 when the landscape recalibrated itself in his paintings. For many years, landscapes served as backdrops in his figurative work, connecting the human shapes with the earth. Now he saw the familiar landscapes of northeastern Oregon and the agricultural fields scattered throughout Iowa, Minnesota, Utah, Idaho, and Arizona with fresh eyes. The resulting landscape or field paintings became personal records of sensations drawn from novel and singular spaces, something more powerful than the human experience.

In his landscape paintings, Smith uncovered beauty in the less obvious—perhaps the solitude of a sagebrush-littered plain, or grain stubble in a field with intriguing patterns. These paintings depart from traditional landscape renderings, for they invoke the overlooked and ordinary in the land. They are more literal than any of his previous paintings, although they are created in the same way: landscape fragments collected through photographs, field sketches, and memory. Smith pried away the layers of earth, looked inside, discovered more than surface beauty, then created something new and different. Through this insight he has revealed the complicated, the familiar, the inconsistent, the noncomforming, the solitary and the spectacular, all characteristics of place.

*Gary and Judy Smith at the Overland Gallery in 1997 with Ray and Susan Johnson.*

Furthermore, these paintings elaborate upon man's cultural occupancy of the land: perhaps how a fence follows a slope over the horizon, or the shape of a contoured field, the resultant mosaic a refashioned landscape, temporal expression of time's passage. Most importantly, through Smith's vision, this action thrust upon the land is not viewed as disruptive, but rather as a harmonious link between human life and the natural environment. He found that the serpentine line of a contoured field or the march of a fence toward the far distance measures both humanity and nature.

Smith ventured further with these paintings, his goal a complete redefinition as an artist. "Seeing these broad, beautiful fields converted into subdivisions or shopping malls provided inspiration for me to explore ways I could preserve those fields on canvas," Smith remarks. The minimalism of plowed earth pointed the way to bold new statements in a series of monumental field paintings through the seasonal cycles. They were mostly six by eight feet but included one heroic six-by-sixteen-foot, mural-like canvas. Unlike his color-saturated, boldly structured figure paintings, these images rely on texture and perspective, strong horizontal lines, and an array of colors that border on monochromatic. The field paintings stress the here-and-now, and are reflective of seasonal shifts, basic as life itself. Smith's feet have always been planted on the soil, and these paintings, windows to the lives of fields, do not elaborate upon the act of painting alone, but speculate on spiritual rapport with the land.

Sixteen of the field paintings and ten studies were first exhibited at the Springville Museum of Art in December 1995. In the fall of 1997, the Museum of Art at Brigham

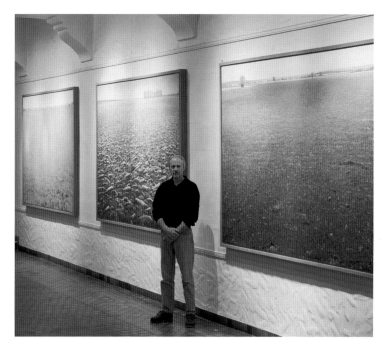

*Gary at the Springville Museum show in 1997.*

OPPOSITE
FIELD OF BALES
*30 x 40, 1998*

Young University organized another exhibition of the paintings. As part of this exhibit, a load of dirt was brought in to create a modest field in the center of the exhibition area. Another exhibition occurred at the Eiteljorg Museum in Indianapolis, Indiana, in October 1999, which included not only the original paintings but some recent canvases.

While Smith continues to pursue the exploration of landscape concepts in his painting, he will oscillate back and forth with special commissions and monumental sculpture. Through the efforts of Ray Johnson, Smith received numerous commissions to paint or sculpt famous country music personalities. Recently he commenced work on a larger-than-life bronze sculpture of Owen Bradley, a legendary figure in Nashville's music industry, destined for installation in a city park named after Bradley.

Whatever Smith does in the future, though, his drive and vision no doubt will be fueled by what he calls his "pilot light." "There is something always flickering, a spark that keeps pointing me toward that elusive imagery out there," he says. "My art is a constant struggle for new insight, for the more effective technique." A thorough craftsman, someone whose techniques have come through years of labor, Smith's work is a reflection, not only of his own nature, but of a people and land with whom he is closely allied. Wendell Berry might call Smith a "placed person," rooted to memories of the terrain and cultures that penetrate his life. Smith is an artist still in mid-flight, with over twenty-five years of productive work behind him. He has become someone who no longer needs to search for the how, but for the why, that intersection between memory and observation, self and idea. There are new avenues, new visions yet to be explored.

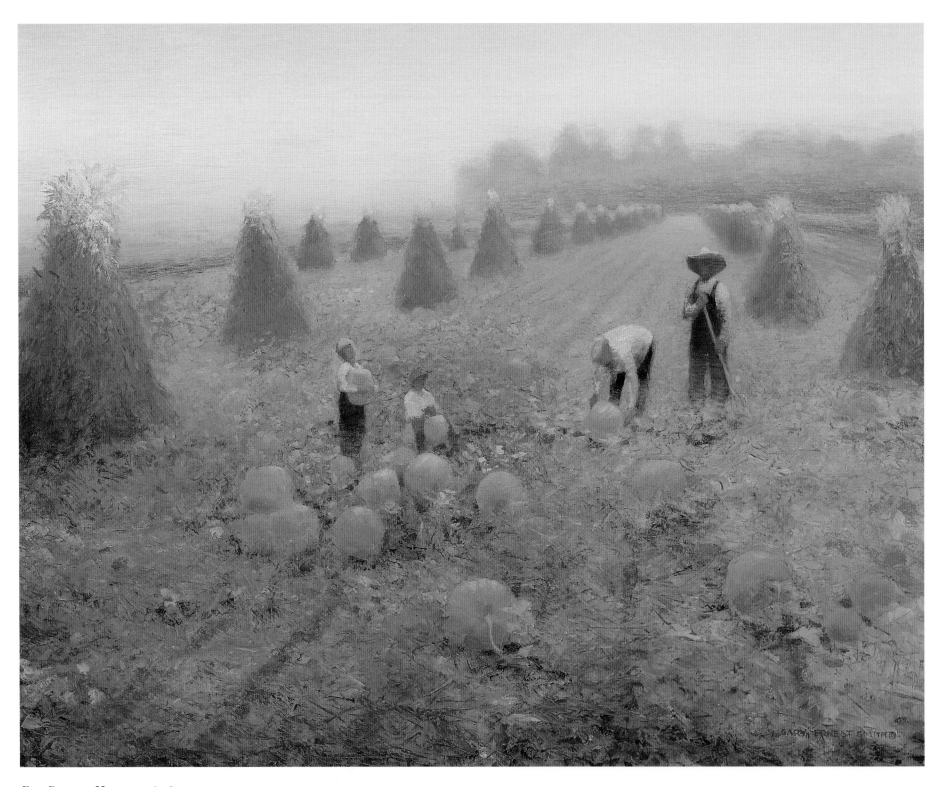

FALL PUMPKIN HARVEST, *48 x 60, 1990*

# SYMBOLS *of* AGRARIAN LIFE

GARY ERNEST SMITH'S FIRST MEANINGFUL LESSON IN LIFE came as a result of contact with the land. By participating in the cycle of growth and harvest as a boy on his parents' Oregon ranch, he learned that much of what one gets out of life has a direct correlation to what one puts into it. When, in 1980, he severed connections to his mural commissions, this began his search for a more personal expression in his art, something uniquely his own. Judy understood his ambition and encouraged him to pursue the quest.

Smith headed to his boyhood home in northeastern Oregon. There, he thought, may lie the answers to his questions. Walks through the bony landscape, discussions with his parents about their lives, and time spent sifting through old family photograph albums unleashed a flood of memories and images. "Among the pictures was one of my grandfather sitting on an old steam engine," Smith recalls. "Others included me out working in the fields with my relatives: the color of harvest, the smell of freshly cut hay, the feel of relentless heat and sweat dripping off my sore muscles and the dignity of hard labor. I suppose it was nostalgia, but suddenly I wanted to capture that way of life, a way of life that has vanished forever." Now, he would not only begin to see more in these memories

*Gary Smith feeding cattle on his parents' Oregon farm, 1966.*

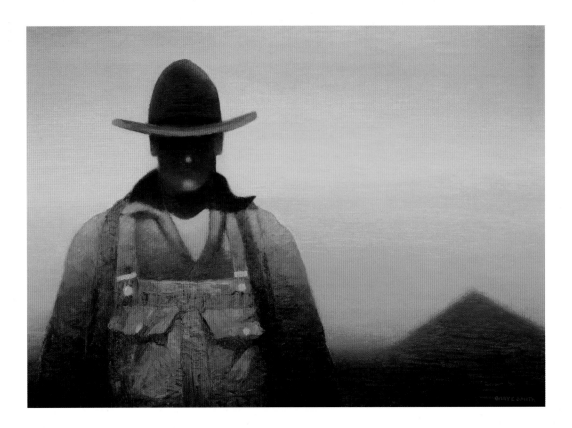

but would create them with a distinctive approach in his painting.

When Smith returned to his studio, he established a rigorous schedule, painting long hours every day, six days a week. He emerged with an art embedded in a personal iconography, drawn from an era when people lived close to nature, in touch with the earth, and had order and continuity in their lives. "The foundation of all my painting is the rural experience, because that is who I am," Smith explains.

For over a year, Smith continued to paint furiously, rarely taking a day off. The images eventually created became a series centered around what he believes are universal values: the dignity of the physical labor of individual farmers and ranchers close to the earth, rendered from either historical or contemporary perspectives. Self-reliance,

DUSK
*60 x 50, 1985*

*Almost monochromatic in color and with the absence of any buildings as background, this painting celebrates the close ties between man and nature. The farmer has a firm, solid grip on the pitchfork as if to express his tenacity in his way of life. The close of day, when the horizon and sky begin to merge, seem to put him in an elusive mood.*

OPPOSITE
RURAL ICON
*24 x 36, 1987*

*In this painting, Smith has achieved a classically balanced representation devoid of specificity. With the emphasis on the figure and only the hint of a man-made structure in the background, this image stands as the quintessential Solitary Man painting. Embodying all the elements Smith intends to portray with the series, it is a testimony to the individual strength and fortitude of the American farmer. "Of the main themes I deal with in the creative process," says Smith, "productivity and self-reliance seem to reoccur. In the rural people I paint, I attempt to portray something of the struggles and triumphs of those who work with a sometimes friendly, sometimes harsh land."*

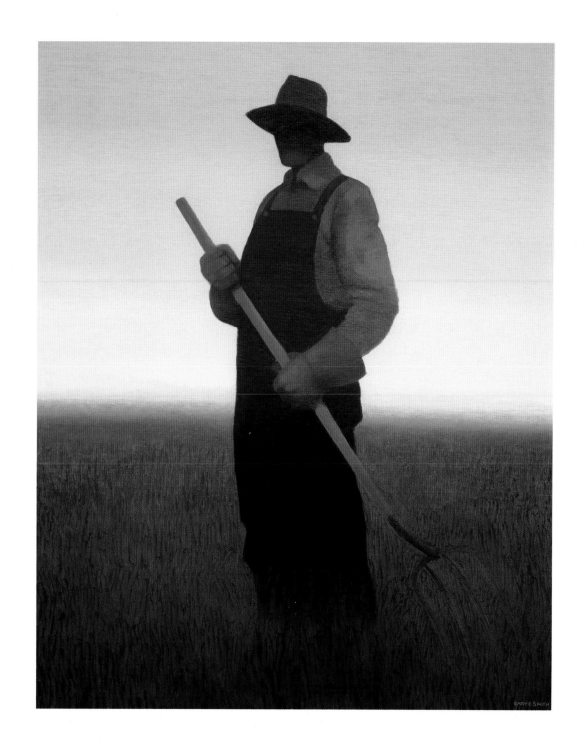

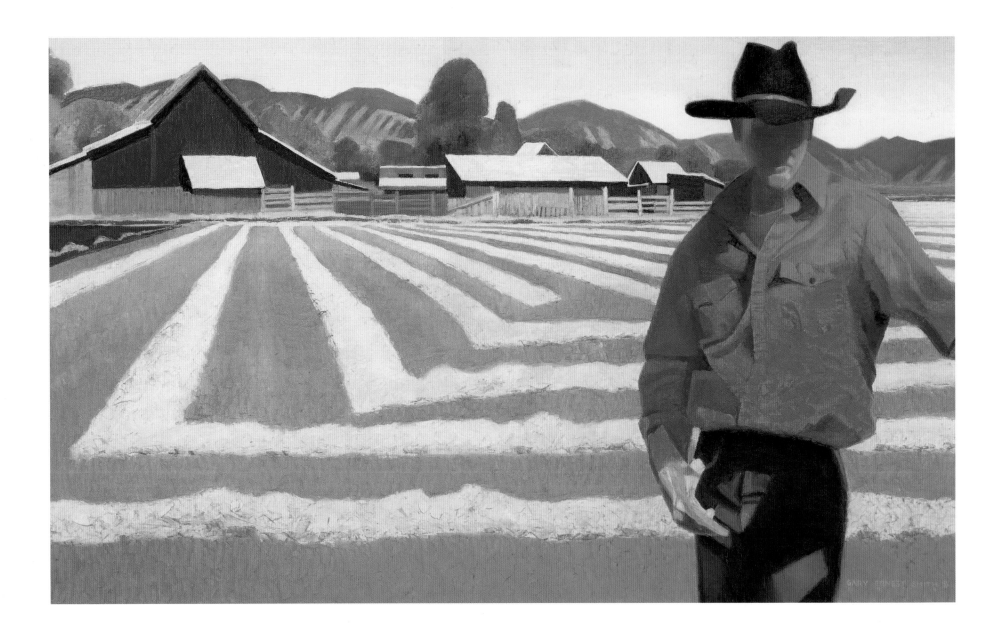

self-respect, and self-worth emerge from the agricultural experience, Smith believes, values that are becoming lost, along with sustaining a job with sweat and hard work and taking it through to completion. "Often, the most daring and challenging time in an artist's career is when he embarks on new territory," says Smith. "Expression and creativity demand growth. The very nature of art is to seek out the new, then push the boundaries." In time, these new paintings became known as the "Solitary Man" series.

At first, autobiographical undertones found their way into these paintings of human figures: personal memories from Smith's early life on the Oregon ranch, with its particular social surroundings. Recently, though, contemporary images, ideas drawn from sources outside of the painter's mind, now play an increased role in the paintings he wants to create. Whether historic or contemporary, the people and objects in his paintings—a solitary figure in a field, fences, ranch gates—serve as symbols that invite the viewer to search for meaning under the paint's surface. Smith's paintings are never illustrative, and are never about mere depiction or description; they are mechanisms for him to explore the subjective world of ideas that inspire him. Beyond the human forms and landscapes in Smith's work, there is always something else, something in the gravity of the lonely figure of a rancher or a cattle skull nailed to the top of a ranch gate. "All great art carries within it layers of meaning encoded in a symbolic message," reflects Smith. The symbolism Smith employed first in his figurative paintings, and more recently in his landscape work, reflect universal themes.

Figures, people engaged in the act of labor or in repose in the rural environment, constituted one of the first symbols important to Smith. The faces hint at a basic countenance, with little trace of a particular personality. According to Vern Swanson, it is this choice of subject matter—faceless figures created with almost metaphysical overtones—

OPPOSITE

FIELD COMPOSITION *with* FIGURE
*36 x 60, 1994*

*This image, in contrast to* Relics of Time, *(page 54), shows the figure of a youthful farmer or field hand in a moment of less ponderous reflection. His bright red shirt dominates the composition and cuts across the windrows that he likely helped to create. The background cluster of buildings is more elaborate than in most of Smith's paintings, and the figure is separated from this world by the field, in which he seems at ease. The "field composition," or windrow configuration, designed to control the flow of water for utmost efficiency, reveals Smith's bold technique with the palette knife.*

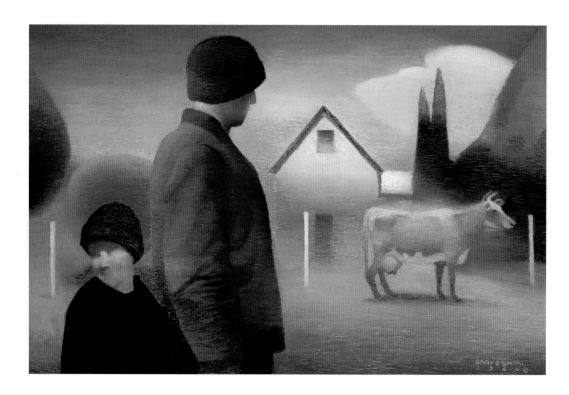

that separates Smith from the other artists who depict the West or Midwest.

When Smith begins a painting, he strives to reduce an image's message to its elemental characteristics. It is handled as a composition first, which means shapes and colors must be related. He strives for simplicity, imaginative colors, and bold forms that are emotionally provocative. The subject must communicate fundamental truth rather than objective reality. The artist Paul Klee once declared that painting is not the replication of reality, but in fact the invention of reality. Smith's technique of stripping faces of recognizable identity, and in many paintings merging foreground and background, are, for him, similar to the concept of invention as envisioned by Klee.

"The subject is important, but I approach my work abstractly, in search of its underlying meaning," Smith says. "My wife, who loves to garden, was an ongoing catalyst to

GRANDFATHER *and* GRANDSON
*with* SHEEP
*30 x 24, 1987*

*The inspiration for this painting came from a photograph of Ray Johnson and his grandfather. Smith positions the figures in front of a barn to emphasize the contrast, as in* Father and Son with Cow, *between the natural shapes of people and animals and the angular shapes of man-made structures. The barn fills the frame of the painting on three sides, emphasizing the importance of structures built to help sustain life on the land.*

OPPOSITE

FATHER *and* SON *with* COW
*24 x 36, 1985*

*The importance of rural life is stressed in this painting in a sort of family monogram. The composition is devoid of extraneous details and reduced to a few colors, and the figures contemplate the environment with indeterminate emotion. The roundness of the trees, repeated in the figures' caps, and the soft, amorphous edges of the living subjects seem to suggest a connectedness between them versus the sharp, angular shape of the artificial structure.*

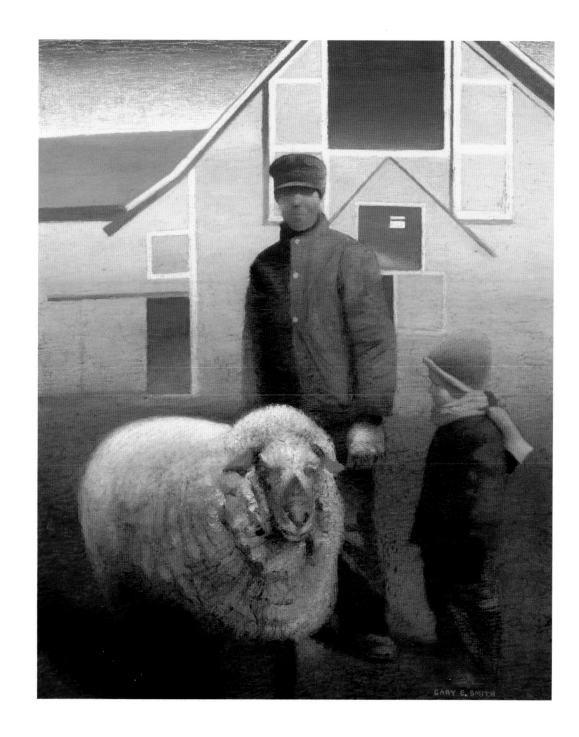

DRY FARM

*oil on linen, 36 x 40, 1994*

*"I see the individual as an important symbol, and that importance in this painting comes from being anonymous, rather than too specific," says Smith. The road leads the eye toward the horizon, while the tree and its shadow lying across the road offer balance to the farmer's figure on the right. This image is an example of Smith's use of cropping; only the upper torso of the figure is portrayed. The figure's facial features are schematized, perhaps representing the rural everyman of the West and Midwest.*

place my figures' faces in shadow," says Smith. "Watching her work, I was intrigued by the way shadows obscured her face underneath the hat. In addition, for many years I observed people in bright sunlight, noticing their identity was often obscured by head-gear. So over time I realized this was a perfect metaphor and universal symbol for every-man and woman." Theodore F. Wolff, of the Christian Science Monitor, wrote:

> Smith is a shaper of icons, not of the devotional sort, but of the kind that draws attention to and celebrates the dignity and worth of his fellow men and women and of what they do. Just as important, he wants and needs to com-municate with the rest of his kind. Smith is a rural artist, not an urban one. His interests lie with individuals and families interacting patiently and philo-sophically with the land. The people in his paintings are at peace with them-selves and with their world—and when they're not, they accept their fate with quiet dignity.

Thomas Hart Benton, Grant Wood, and John Steuart Curry are credited with inventing, in the late 1920s and early 1930s, the symbolism of rural American culture. They were leaders in a movement called "regionalism," an appeal for the preservation of American values and a response to the agonies of the Depression. When we think of rural America's past, these are the painters who often come to mind. In fact, they are the yardstick by which all painters of rural or agricultural subjects are often judged. Robert Hughes, art critic for *Time* magazine, believes regionalism was a search for a lost Eden, for people and places that did not exist.

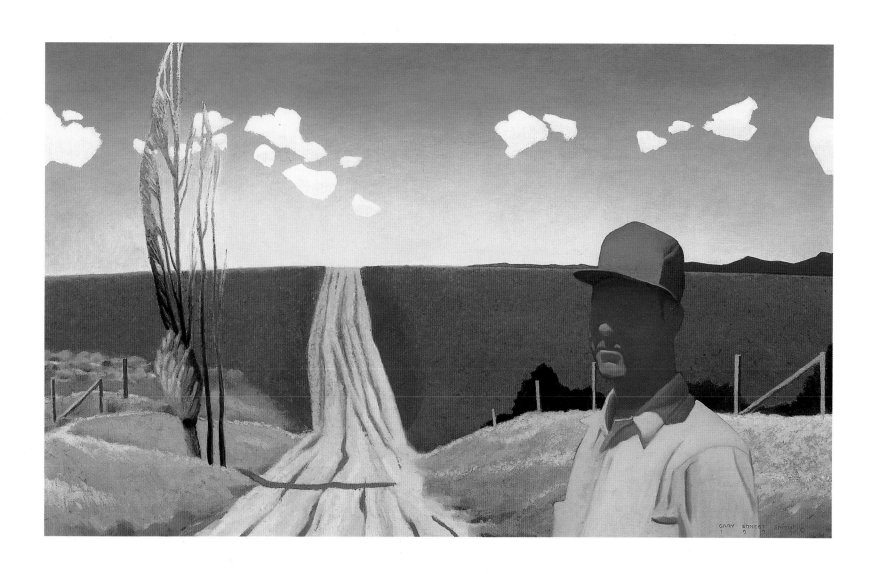

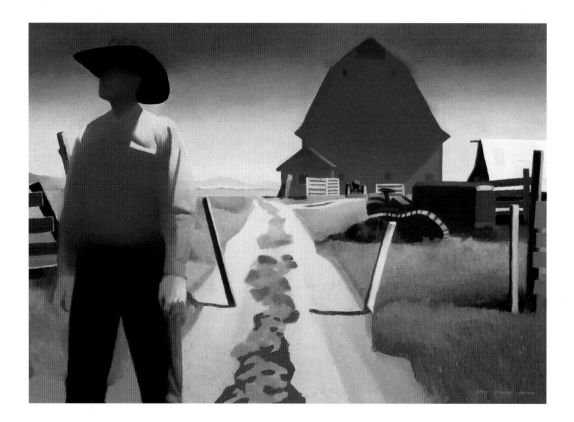

Benton's expressive works were satiric social commentaries, his most famous being murals painted in the Mexican mural tradition. Grant Wood depicted Iowa as the land of plenty: lush, fantasy landscapes in a stylized realism employing flat-patterned design. Wood's fame, of course, rests on the iconic *American Gothic*. Of the three, John Steuart Curry, the son of a Kansas rancher, was the most attuned to nuances of agrarian life. Curry's art tried to express the rural Midwestern landscape in terms of social and spiritual values. His depiction of the Midwest attempted to reveal national characteristics, such as the strength of the cultivated landscape, community, simplicity, and religious faith, although the subjects of his paintings are mostly disasters—floods, twisters—and religious fanatics. These artists extracted their concepts of art from the Midwest's land and people, but none remained as close to their foundations as has Smith.

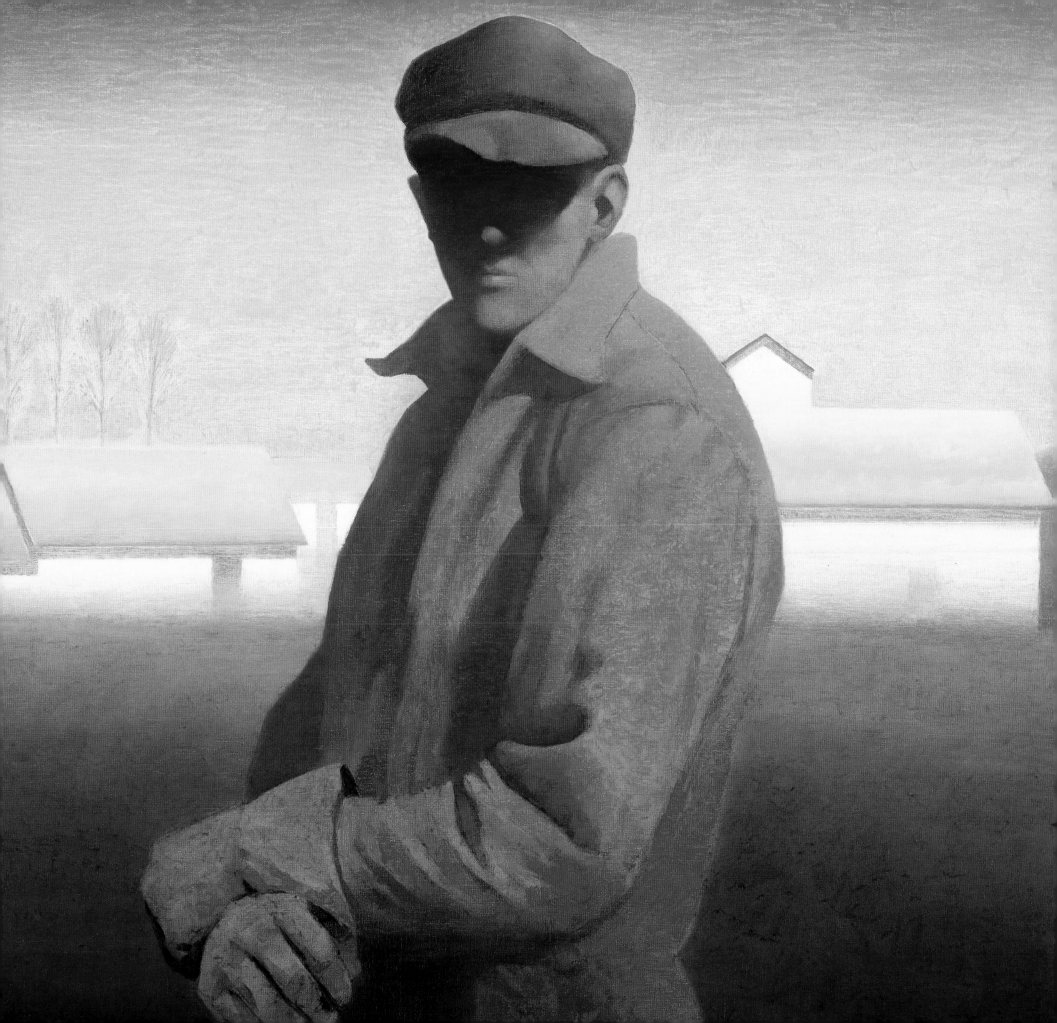

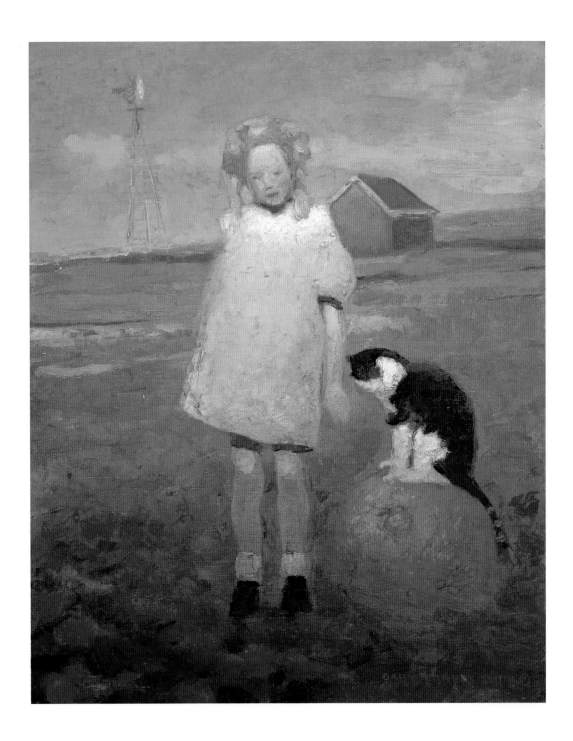

GIRL *with* CAT *and* PUMPKIN
*20 x 16, 1994*

*There is a sense of emotion residing in this impressionistic image of a young girl standing next to her black cat perched on a large pumpkin. The innocence of the child is revealed in the lighthearted, uneven posture of the little girl and the resulting tilt of her skirt, and appears to be pushed further by the dreamlike foundation on which she is standing. Her innocence seems to exist in direct dramatic contrast to the bareness of the farm behind the girl—the skeletal presence of a windmill and a single, simple building—and ultimately to the potentially harsh realities of farm life.*

Norwegian artist Edvard Munch, whose work was the leading exponent of symbolism in the late 1890s, is a painter Smith much admires. In Munch's work symbol and subject matter are intertwined, particularly in his paintings of people. He had a gift, in Smith's mind, of infusing his images with emotion through the use of symbolism. Melancholy, for example, often permeates Munch's paintings, as it does some of Smith's images. "He did these haunting images, and I wanted, not to replicate this feeling, but to endow my figures with mystery. Furthermore, there was something about the way he froze the figures in the images that has intrigued me," says Smith.

Critics have often suggested a similarity between Smith's solitary figure paintings and the work of Edward Hopper. Hopper, along with Charles Burchfield, was acknowledged as a pioneer of the American scene. He primarily depicted the social realities of urban America as he saw them, a vision of the city as a bleak, almost forbidding place where loneliness, alienation, and unease rule among its inhabitants. His paintings project a cold, bright light, and a concentrated and intense reality.

The figures of Smith's men, women, and children are similar to those in Hopper's urban paintings, the subjects distant and remote, endowed with stern immobility and blank visages. Like Hopper, Smith distills and consolidates what he views and experiences to heighten sentiment or clarify a thought. Overall, though, Smith's palette is warmer and has a greater interplay of color. In contrast to Hopper, Smith's people do not project a sense of alienation. Though detached, they seem in balance and attuned with their environment. Many of Smith's subjects are portrayed as if caught unawares, like quick snapshots taken in moments of deep reflection. Emotions are kept in check, and stillness and calm rule.

BOY *with* SCARF
*30 x 24, 1987*

*This image came from a photograph of a young Ray Johnson dressed in knit cap and scarf. Smith creates a nonspecific background, the figure of the boy blending into it through the brushstroke technique that blurs his edges. Serene and contemplative, the boy seems to belong—and seems to feel that he belongs—to his surroundings.*

RURAL HOME
*16 x 20, 1994*

*Inspired by old buildings located not far from Smith's home,* Rural Home *and* Pioneer Stone Home *are vestiges of earlier rural lifeways. In* Rural Home, *indistinct figures seem to wait casually, unaware of the viewer, on the front step of the house—perhaps they are not inhabitants but visitors here.*

OPPOSITE
PIONEER STONE HOME
*18 x 24, 1994*

Pioneer Stone Home *is an example of Smith's technique of scraping a painting's surface. The human connection is portrayed by the placement of a man, woman, and dog in front of the building in a style reminiscent of an old photograph. The building towers over the figures, its endurance surpassing theirs.*

Like Hopper's urban residents, the agrarian workers in Smith's paintings are somber and quiet, encouraging viewers to consider what their thoughts might contain. No overt political statements or strident social issues are evoked. "In these works, nothing is explained or laid out for you," says Neil Hadlock. This art, the solitary human figure, is a personal philosophy for Smith, his way of connecting with a complex world, his goal to endow it with meaning. Through these paintings, he celebrates man's relationship to the land.

With little doubt, Maynard Dixon is Smith's primary inspiration. For over half a century, Dixon celebrated the transcendent spirit of the American West through drawings, paintings, and murals. Smith's figures are comparable to Dixon's paintings of Native Americans and, in particular, his Depression-era views of the "Forgotten Man," haunting images of individuals uprooted by economic and social forces. Smith, like Dixon, organizes his human forms with strong shapes and often places them in silhouette, empowering the figures with greater force. The individuals in Smith's paintings stand straight, with the simple dignity of a people who lean against the wind, work in the sun and rain, and own their own land.

An important category of symbolism for Smith's art is the sense of family bonds. His paintings of domestic scenes are the result of growing up with people who experienced pride and order in their everyday lives. "In a sense, I celebrate the influence of those who, both yesterday and today, have touched my life," says Smith. He notes that throughout contemporary American art, most critics and artists avoid the concept of nostalgia. "But," he argues, "it is not so much the subject painted as the intent, sensibility, and skill manifested by the artist that elevates it out of sentimentality." Nostalgia, whose root is

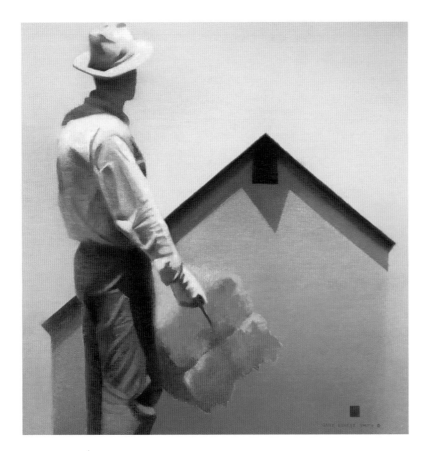

FIGURE *with* HAY BALE
*48 x 48, 1995*

*In contrast to the figure in* Stacking Hay,
*(page 66) this farmer is captured in what is*
*for Smith a more typical depiction of move-*
*ment: He seems to be pausing as if in thought*
*or because something has caught his eye. From*
*the left, pervasive light illuminates his solid*
*shape as he lifts a hay bale, its squareness*
*suggesting a modern farm setting.*

the Greek word *return*, suits Smith's concepts of drawing upon memories for inspiration in his art. It is the peg on which he often hangs his art of rural life. To Vern Swanson, however, Smith's most effective work lies less with nostalgia and more with the contemporary agrarian scene. "Smith has a journalist's eye in the monumental sense, and as an artist of the West, there seems to be more gravity in his contemporary work."

Barns are also intriguing symbols for Smith. Visible testaments to a way of life, they were once a place of sanctuary, refuge for animal and man alike, the repository of seasonal crop cycles, or playhouses for children. Probably there are a few resident ghosts, too. The elaborate wooden barns erected in the late nineteenth century into the 1940s are rapidly disappearing, remodeled into upscale homes, or razed when old age and gravity bring them down, to be replaced with metal sheds. Sometimes whole barns migrate, when they are picked up and moved elsewhere by new owners. "Turn-of-the-century barns are quickly disappearing," says Smith. "Only a few in the West still remain intact. They stand today as symbols of a quieter time. I love their strength and purpose."

The bold forms and simplicity of the rural figure paintings eventually led Smith to sculpture. In 1989, after reflection about prospective subjects, Smith selected one of the most popular images in his paintings, *Sweat of the Brow*, a figure with a scythe slung over one shoulder. The sculpture proved popular and the initial edition sold quickly. The illusion of the subject's life and movement is accomplished through careful orchestration

of mass and volume, along with the play of light and shadow on the figure. "Gary Ernest Smith's sculptures show restraint, and are most successful when they are least narrative," says Neil Hadlock. Smith's second bronze, *Man Lifting Sack*, is also drawn from his figure painting, the facial features modeled loosely and simplified. Besides an edition of fifteen casts, three sculptures were executed in monumental, eight-foot tall proportions. One of these greets visitors outside the Springville Museum of Art; a second is located at the Hadley Companies in Bloomington, Minnesota. Another sculpture, *Potato Man*, an image of a farmer wrestling a sack of potatoes, was prompted by an individual Smith saw laboring in a potato field. To him, these sculptures, in fact all his sculptures, are a natural extension of the bold shapes in his paintings. Like the paintings, the sculptures venture beyond their basic forms and shapes to celebrate the lives and importance of rural people.

In search of the same symbolism that marks his paintings, Smith usually makes a drawing of a prospective sculpture, but sometimes proceeds to work directly on a model. Once the ideas are pulled together in the studio, he builds an armature, then forms the subject with malleable clay. When the preliminary sculpture is completed to his satisfaction, it is taken to a foundry for the construction of a mold, then cast in bronze. "No two of any sculptures are exactly the same," says Smith. "Each of them has some finishing needed, perhaps grinding or welding a small piece of bronze somewhere on the sculpture.

SWEAT *of the* BROW
*bronze, 19 x 5 x 7 1/2, 1989*

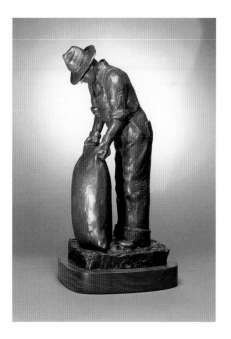

MAN LIFTING SACK
*bronze, 17 x 5 1/2 x 5 1/2, 1990*

When you examine the bronzes closely, there are many variations, so each one is considered a unique work of art."

The enigmatic figures in Smith's paintings and sculptures do not farm or ranch through the windshield of a pickup or the air-conditioned cab of a John Deere tractor. As he has portrayed them, these people belong to the land, and love it as the living entity that it is. This is the message of Smith's art. As William Kittredge writes in *Owning It All:*

> Agriculture is often envisioned as an art, and it can be. Of course there is always survival, and bank notes, and all that. But your basic bottom line on the farm is again and again some notion of how life should be lived. The majority of agricultural people, if you press them hard enough, even though most of them despise sentimental abstraction, will admit they are trying to create a good place, and to live as part of that goodness, in the kind of connection which with fine reason we call rootness.

Gary Ernest Smith knows this linkage, this rootness to place, has weakened. He knows our perceptions of it are now receding, our connections to it walled off by the passage of time and the changes transforming the rural landscape. Through his meditations in painting and sculpture, he creates a vision, an epitaph for vanishing moments in the agricultural history of this country. Whether he is inspired by historic or contemporary subjects, however, Smith continues reinventing himself through his art, considering, through the mediums of paint and bronze, basic themes in art: man's harmonious connection to the fertile soil and the work done upon the land to make it productive.

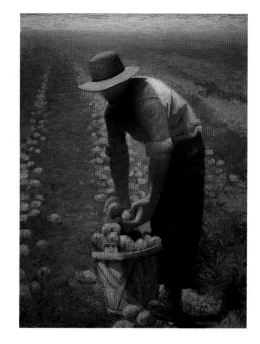

POTATO FIELD
*40 x 30, 1988*

*Here, a figure bent over to collect potatoes emphasizes the repetitive work needed to harvest potatoes without mechanical means. But the potatoes are small in his hands, pointing to the idea that, little by little, large tasks are overcome.*

OPPOSITE
CELEBRATION *of* LIFE
*48 x 60, 1996*

*The spiritual connections of humans to the earth is expressed as a farmer commemorates a successful harvest with a tune on his fiddle. With this image, Smith returns to a naturalistic approach, but with heft and power created through thick, heavily worked paint.*

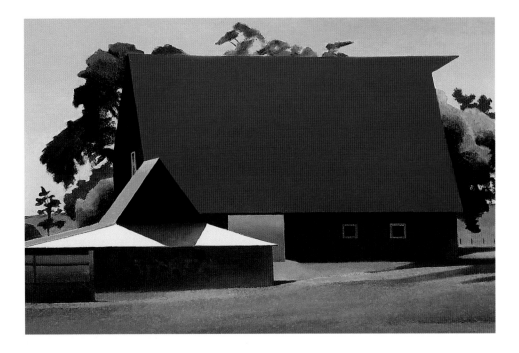

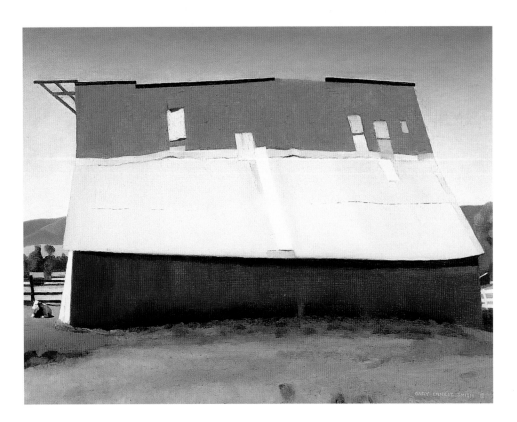

BARN DESIGN
*oil on linen, 40 x 60, 1996*

BARN COMPOSITION
*oil on linen, 30 x 40, 1996*

*Intrigued by how this man-made object, a combination of the aesthetic and pragmatic design, relates to the adjacent landscape, Smith attempts to fashion the shape and color of the structure in harmony with the surroundings.*

*In* Barn Design, *Smith has organized sharp-edged planes and blocks of solid color with an almost architectonic treatment. He will also show how changes can affect the look of barns, as in* Barn Composition, *the original wood shingles on the structure replaced with a corrugated metal roof.*

OPPOSITE
PURPLE BARN
*oil on linen, 48 x 48, 1994*

*An elegantly configured structure, the subject for* Purple Barn *is a well-known landmark in Utah's Cache Valley. Towering with haughty but faded majesty over a modern tractor parked in front, it is now an indicator of the uneasy confrontation between past and present. Once, horses provided the muscle for working in the fields, and the barn served as their home for shelter and feed. The presence of the tractor is a sad reminder of the barn's obsolescence and its lack of usefulness. Like many surviving barns in the Pacific Northwest, Rocky Mountain, and Plains states, this one has a gambrel roof, sometimes termed a hip roof, designed to create more usable space over the floor area.*

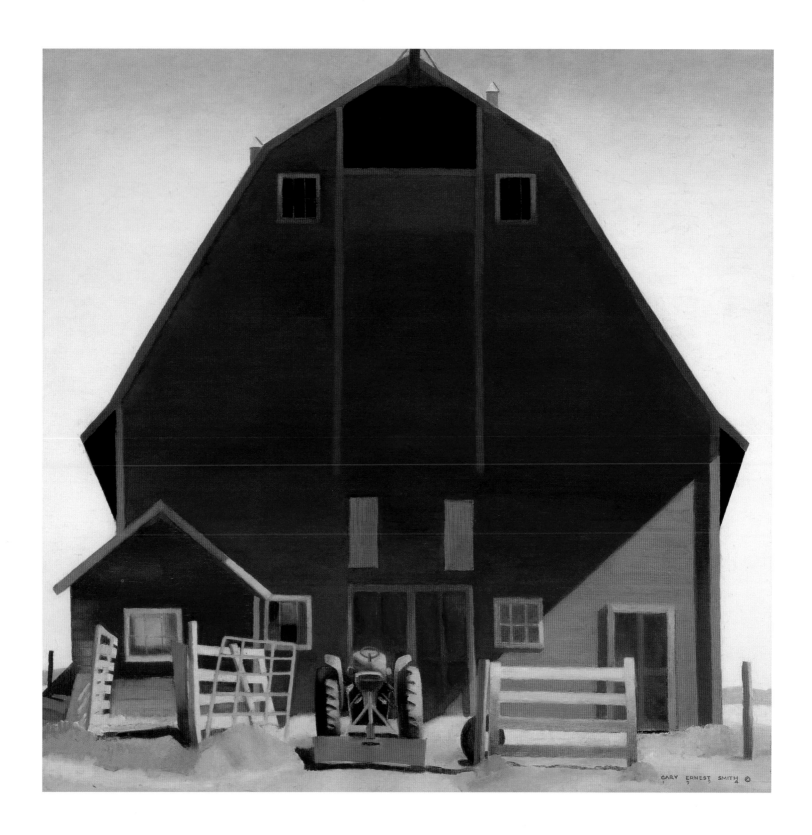

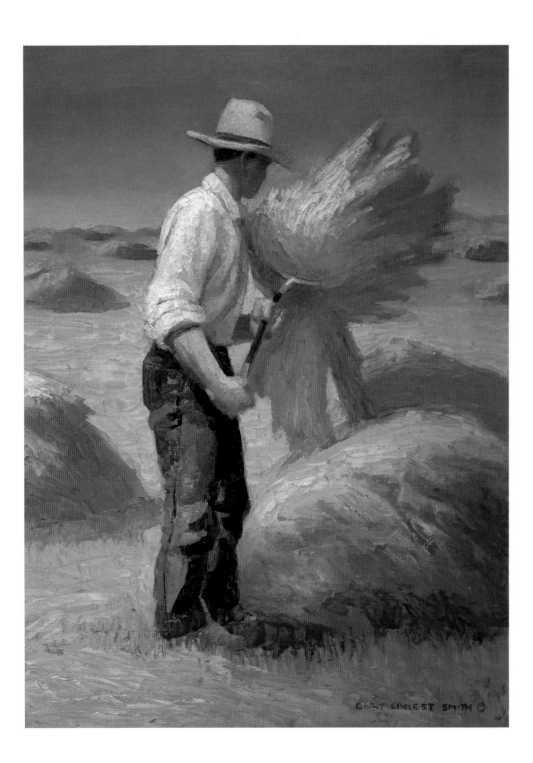

STACKING HAY
*24 x 18, 1990*

*In an unusually bold portrayal of movement, the strong central figure in this painting faces away from the viewer as he lifts the hay into piles. The foreshortened pitchfork seems insubstantial, a simple tool, yet it yields a large amount of hay in the hands of the farmer, symbolizing his ability to draw a living from the land by his own muscle, without dependence on machinery. Again, Smith has created the feel of work performed under the extreme conditions of a midday sun. The necessity of this work is clear: The farm animals' survival in the coming winter depends on these efforts.*

OPPOSITE

A CLEAR JUNE DAY
*36 x 48, 1993*

*With this painting, Smith has depicted the gathering of hay before the advent of modern technology. Almost documentary in nature, it represents the intensive labor needed to bring in the harvest. To the right, in the middle part of the image, a horse-drawn haycutter is at work. The hint of farm buildings in the background reminds us of the home life that is, at the moment, distant in thought and perspective. In the immediate foreground, an individual forks the newly cut hay into piles. The viewer seems to be standing on a nearby haystack, looking down at the figure, taking in the scene with the detached and rudimentary understanding of the outsider.*

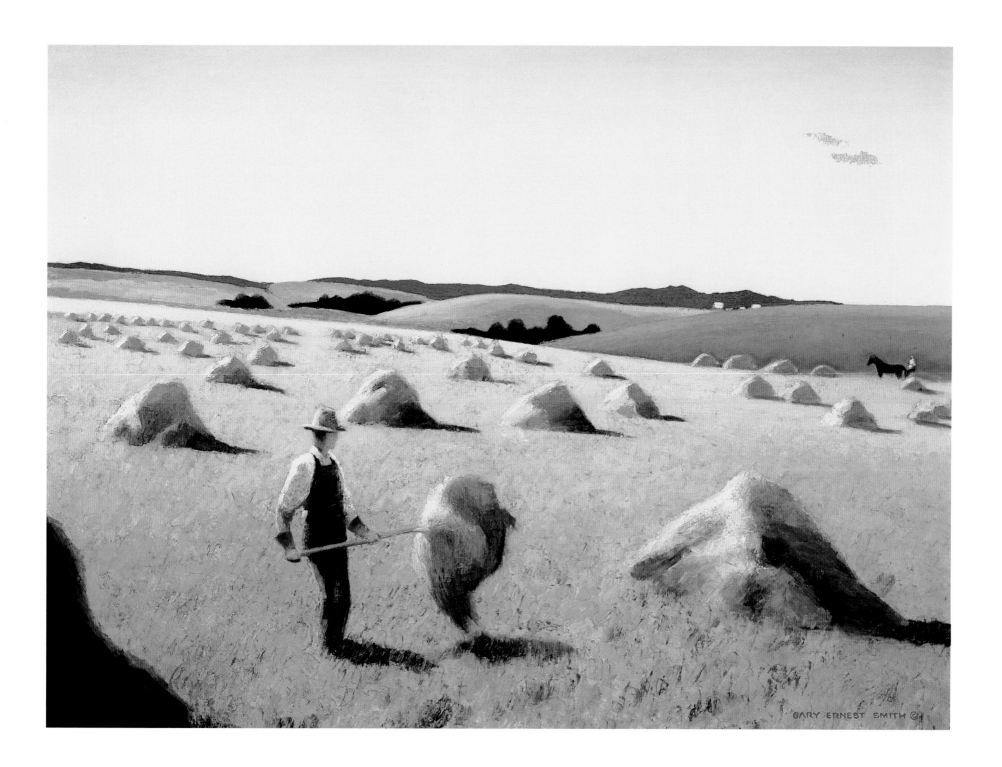

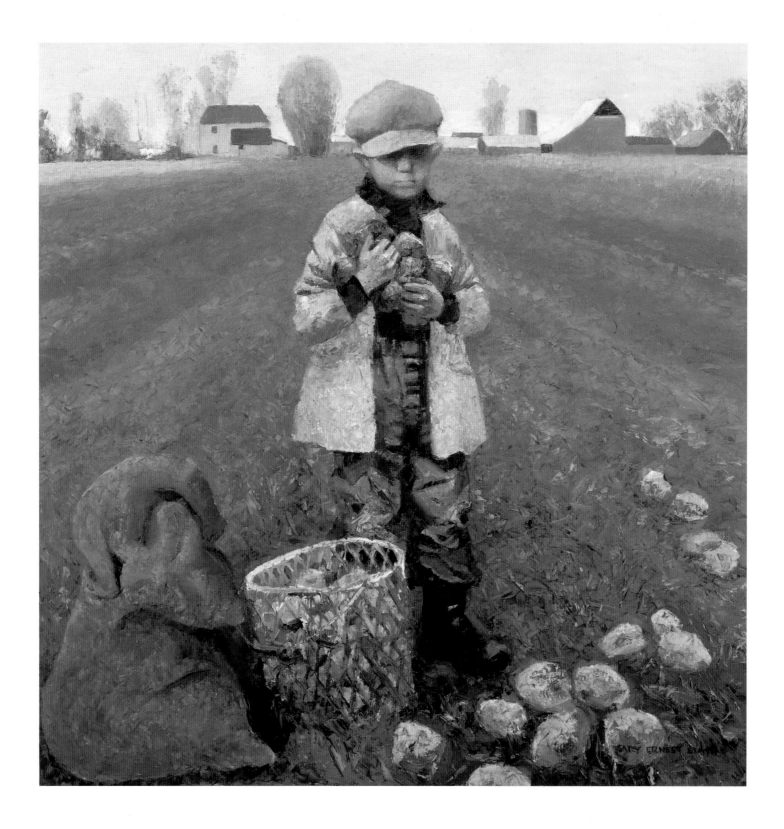

YOUNG FIELD HAND
*oil on linen, 40 x 40, 1996*

*Work, people tackling everyday tasks throughout the patterns of seasons, their hands joined to the soil, is a common thread that runs through Smith's work. Here, he has portrayed a boy in the process of harvesting potatoes from a field. Less stylized in execution than some, this figure's expression reflects the melancholy sometimes inherent in life extracted from the land. At the same time there is a stoicism in the young boy already learned from hard work at an early age.*

OPPOSITE

WOMAN *with* HEAD *of* CABBAGE
*40 x 30, 1989*

*In this composition, the figure of a woman is the center of attention, and central in importance. The cabbage in the woman's hand, as well as those in the basket and nearest her, are realistic and well defined, while the cabbages behind her disappear into a cloudlike mosaic of violet hues. Furthermore, her old-fashioned clothing blends with the colors of her crop, so that in her quiet gathering she merges with the product of the land. Compare this to the contrast between the young man's red shirt and the muted browns of earth in* Field Composition with Figure *(page 48), a figure that represents bold manipulation of the land.*

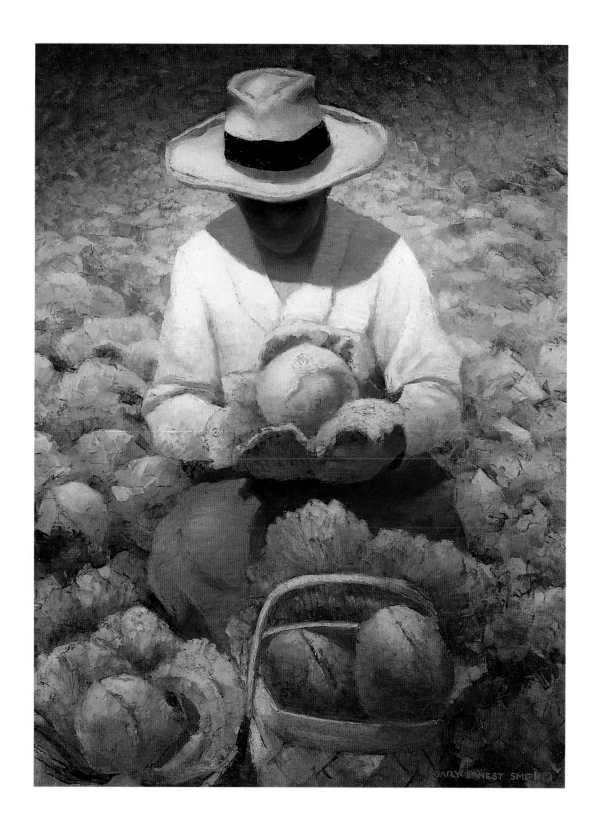

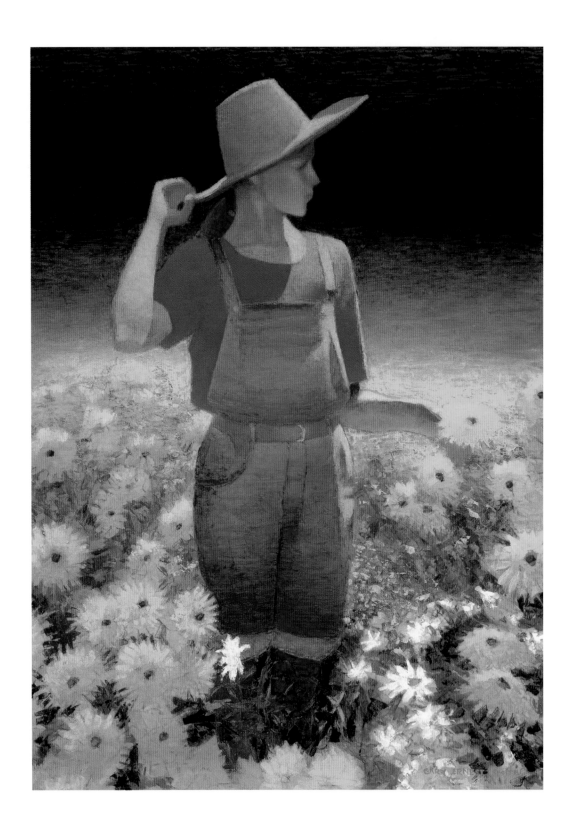

WOMAN *in* POPPY FIELD
*40 x 30, 1992*

*This painting was inspired by a figure Smith saw in a northeastern Oregon field. The woman is collecting flowers in a sun-drenched field for enjoyment as opposed to harvesting for subsistence, yet she does not appear care-free, only peaceful in a way that shows accept-ance of her world. Here Smith revels in the play of the red and blue of the flowers, among which she seems to grow.*

OPPOSITE

GARDEN YOUTH
*40 x 30, 1993*

*Smith's daughter Julia at work in the family garden was the inspiration for this painting, her figure placed among a riot of blooming flowers. The girl's youth is emphasized by the carelessness of her gestures—one hand on the hat, the other reaching for a flower, the quin-tessential symbol of innocence—adult hands are usually shown at rest on a tool or are busy with work. Again, Smith has explored the freedom of color, the yellow flowers in stark contrast to the red, blue, and tan hues of the clothing worn by Julia. The dark back-ground above the horizon contrasts with the flowers as if she is, for now, in an innocent place in the world. It is a fine summer day, and everything seems in perfect harmony.*

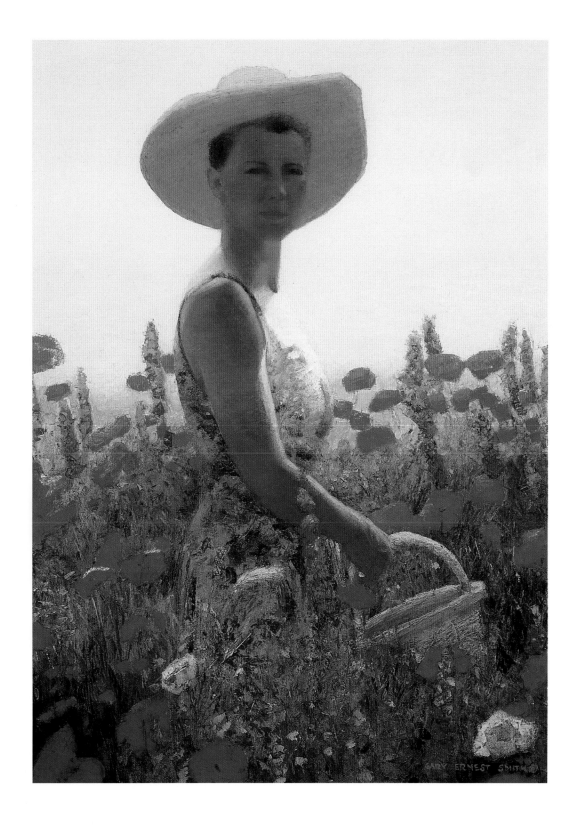

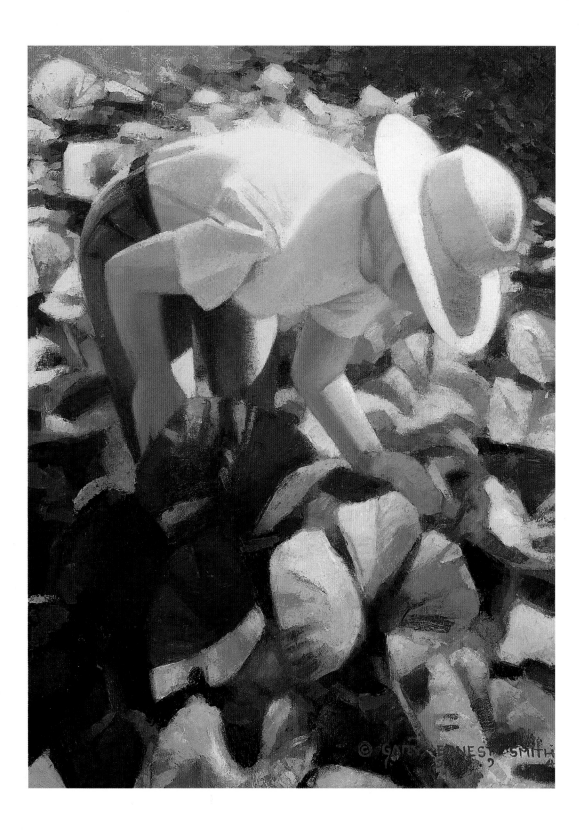

PUMPKIN PATCH
*24 x 18, 1994*

*In this painting a woman, her blouse explosive
with brilliant yellow, bends down to check on
a pumpkin hidden beneath the enormous
leaves. The work is not strenuous; she is
checking on the progress of the crop as opposed
to performing the more demanding and time-
dependent tasks of planting or harvesting: one
hand rests on her knee as the other parts the
leaves for inspection.*

OPPOSITE

JUDY'S GARDEN
*48 x 48, 1988*

*In this painting Smith celebrates family bonds
and the bounty of flowers and vegetables
behind his house. Brilliant light is cast around
the garden as his wife lovingly tends her
cherished creation, the unusual number of
detailed elements underscoring the recognition
of abundance at this thriving home. The
crouching action of the figure brings her close
to the object of her labor, suggesting a famil-
iarity with the earth and its produce, a delib-
erately built and satisfying relationship. Just
above the middle of the canvas is the Bull
River, and across the stream a neighbor's home.*

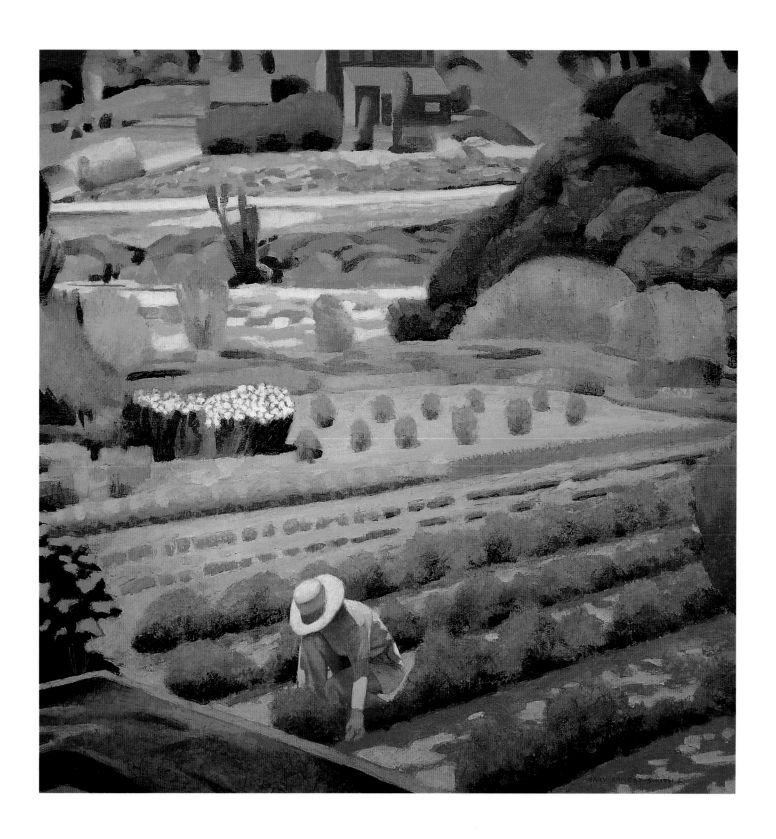

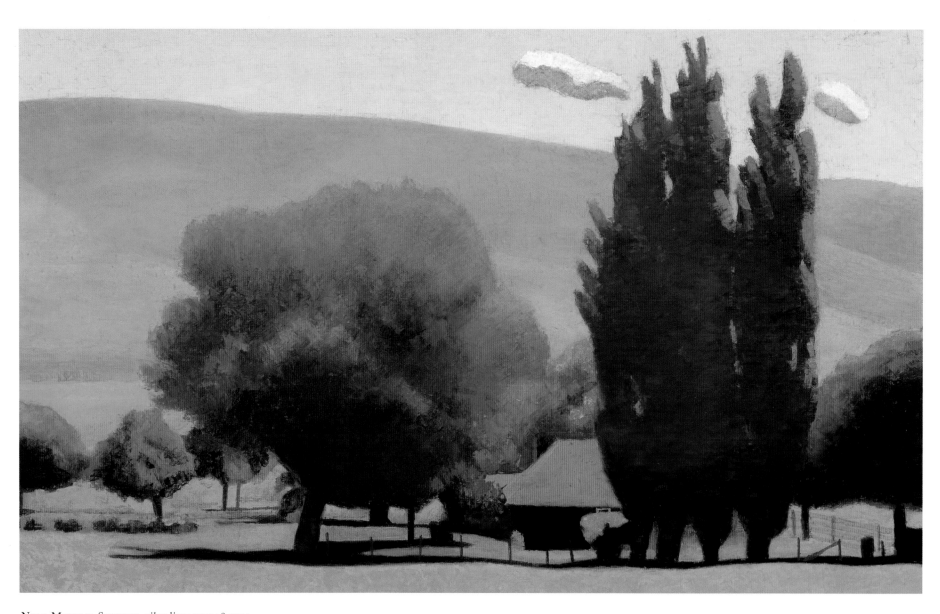

Near Medical Springs, *oil on linen, 30 x 48, 1995*

# | 4 |

---

# FAMILIAR TERRAIN

WHEN GARY SMITH HEARS HIS INNER VOICE, his response is calm, measured, and deliberate. Time is allotted for meditation upon the implications. So when he again began to feel the tug of memories from the place that molded his existence, he determined to plan a second pilgrimage to northeastern Oregon in search of visual fragments that, though once so familiar, had nearly receded from his memory. "At times like this, an idea or image in my mind may be incomplete as a concept, but it is the genesis of something that will play out in my art over time," says Smith. Northeastern Oregon is a region connected to pioneer and agrarian legacies, a place where identity is still molded by geography and history to a large extent. But this is an immediate past, not far removed from the present. And the present is changing.

In one of the essays in *Lasso the Wind*, Timothy Egan takes a look at changes confronting the town of Joseph in Oregon's Wallowa County, northeast and adjacent to Baker County. This is an area almost the size of Delaware, where cattle raising is still important, yet the county supports less than fifty ranchers. Furthermore, this area has

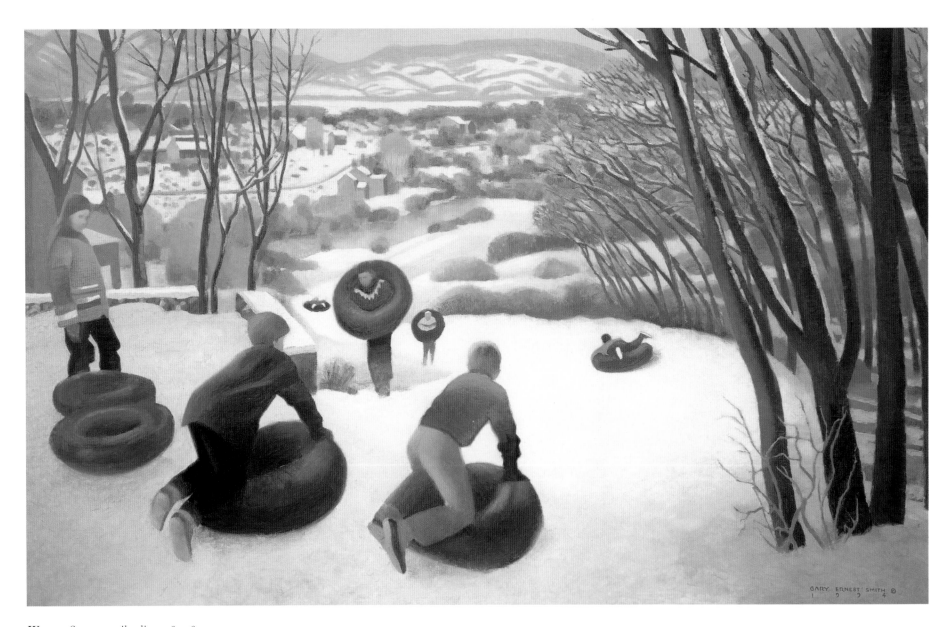

WINTER SLIDING, *oil on linen, 48 x 78, 1995*

lost two-thirds of its population during the past half-century, although the numbers have stabilized in recent years. Residents are looking at alternatives to declining cattle and timber industries, including the establishment of a Nez Perce historical center, which would celebrate the region's earliest and most famous inhabitants.

Like Wallowa County, Baker County has seen the traditional culture of an agricultural-based economy wane. In 1930, nearly 17,000 people lived there. Now only about 10,000 people live in the county, and most reside in or near Baker City. As the extractive industries of cattle raising and logging slowly decline, Baker County, like Wallowa County and other rural regions of the West, has embraced tourism as economic salvation, particularly "heritage tourism," since the Oregon Trail passes through the area.

Still, there are ranchers and farmers who cling to their cherished way of life. Some years are good financially: others bring declining beef or grain prices coupled with high operating debt. As Ralph Beer observes in *Big Sky Journal:*

TUBING
*11 x 13 1/4, pencil on paper, 1990*

> Calves that ought to be a source of pride seem hardly worth the effort, while every machine on the ranch needs new tires. Our old-timers are dying off, and the young people have left for jobs in town or worse. So much land, so many barns . . . all those pasture fences and sets of corrals, each and every refinement part of a distinctive landscape, the consummation of somebody's sweat-soaked vision, and all of it—land and dreams together—up for sale.

Ranchers and farmers once believed their offspring would continue to work their ranches and farms, but this expectation is increasingly unfulfilled due to social and economic impermanence. Children of ranchers and farmers are forced to seek employment

*Gary Smith sketching in a plowed field, 1997.*

OPPOSITE
EVENING FARM
*oil on linen, 24 x 30, 1997*

*In the quiet serenity of this farm environment,
the buildings seem to blend into the shapes and
colors of the hills as if they were a part of them.
Still, at this particular moment, the difference
between the two worlds seems significant in
the contrast of the hill's dark shadow versus
the bath of light on the pasture floor.*

in their local communities or migrate elsewhere, perhaps to Portland or Seattle. If they choose to remain, jobs might be found in the new service economy—microbrew pubs, coffee houses, food marts, video stores, or art galleries. The riptides of change have surged through the rural West, and throughout the country have pushed aside old agrarian traditions like flotsam and jetsam. Smith knew that the landscape of northeastern Oregon he experienced as a boy, and what remained in that landscape, needed a chronicler to exemplify the changes confronting it.

So he again left his Utah home and drove the eight-hour stretch to Baker City, this time planning to stay through the month of June at his parents' home. Each morning he packed his camera and sketchbooks and explored the lonely stretches along the back roads of Baker County. Often he would park his car and stroll for miles over austere landscapes, places where he could let his mind wander and observe. His sketchbooks were quickly filled with subjects—windmills, gateways, fences, weathered barns, and the dramatic landscape. Smith also stopped to chat with and sketch the local ranchers, those strong, resilient individuals who wrestle a living from this stubborn land.

Gary Ernest Smith is not the first artist to interpret the singular beauty of eastern Oregon's high desert country. In 1901, Maynard Dixon undertook a trip by horseback from Oakland, California, the prospective destination Montana. When Dixon and his companion, friend and fellow artist Edward Borein, reached southeastern Oregon, they paused for two months to explore the isolated cattle ranches scattered along the ramparts of the Steen and Alvord Mountains, places like the P Ranch, the Buena Vista Ranch, and the Harper Ranch. During that time Dixon created numerous sketches on aspects of range life—working cowboys, fences, ranch buildings, and the brooding rimrock landscape. When Dixon and Borein resumed their trip, they headed north to Vale,

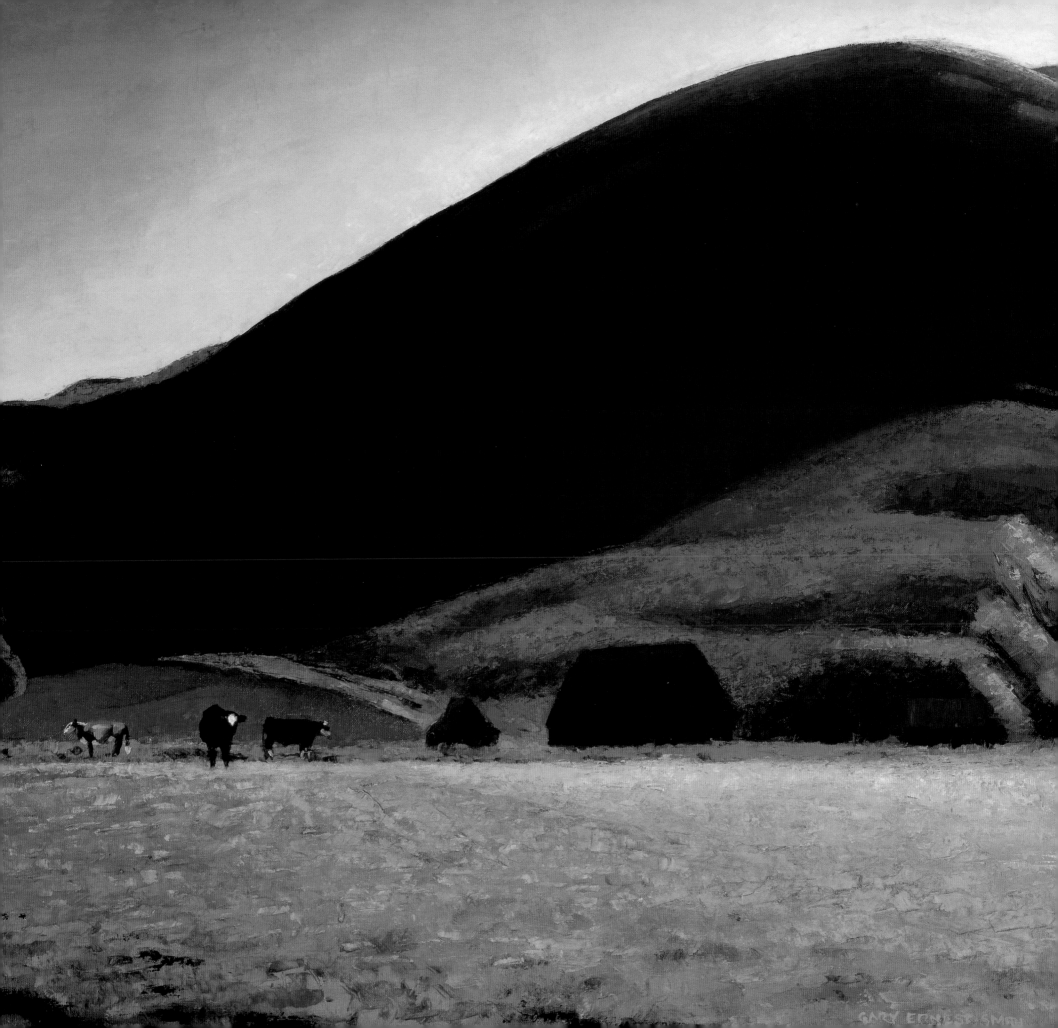

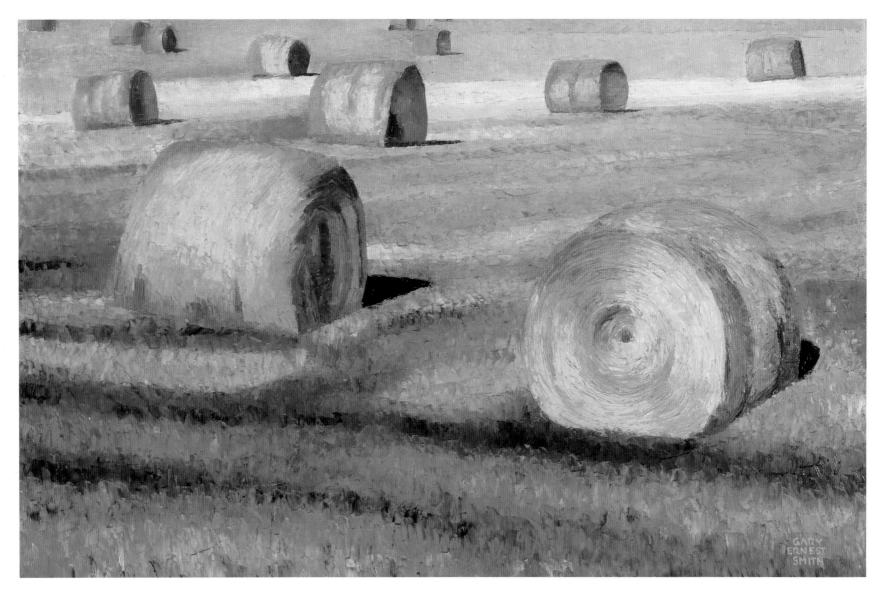

ROUND BALES, *30 x 40, oil on linen, 1998*

Oregon, some sixty miles southeast of Baker City, then turned east into Idaho, finally arriving in Boise where, tired and broke, they stopped and headed back to California. "The results of the trip," Dixon later wrote Charles F. Lummis, "were plenty of sketches, no oils, new knowledge of Indians and cowboy and range life in a tough country, and greater respect for the facts."

FIELD *of* BALES
*8 1/2 x 12, charcoal on paper, 1997*

During his initial 1989 exploration and subsequent but short visits thereafter, Smith, like Dixon, uncovered an array of possibilities in his quest. For him, northeastern Oregon serves as the equivalent of Paul Cezanne's *Mount St. Victorie* or Claude Monet's *Giverney*. He now staked out new artistic territory for his art. As new subjects—gates, fences, and the ubiquitous sagebrush flowing over the hills—revealed themselves, Smith's journeys through this familiar terrain became like benedictions, visual transcripts that excite his imagination. These journeys had a profound effect on the direction of his art. Henry David Thoreau claimed, "If you would find yourself, look to the land you came from and to which you go."

Throughout his career, Smith has equipped himself with sketchbooks. When he returned to northeastern Oregon in search of the essence of rural life, the sketchbooks became even more important. In them he captures images to fix a scene and the sensations it produced. "Nothing can substitute for personal observation," says Smith. He sketches figures or fragments of the landscape with graphite, crayon, charcoal, or ball-point pen. Some of the sketches are rapid notations executed on yellow-lined notebook paper, others are more realized drawings on high-grade paper. The sketches are initial impressions, research upon which his paintings rest. To Smith, what he leaves out of a sketch, what is not needed, is as important as what is included. Though he uses photographs, he does

FIELD WASH
*oil on linen, 36 x 48, 1997*

*The power of water, wind, and gravity upon an arid terrain inhabits* Field Wash. *Erosion forces have, over time, corkscrewed a twisting channel in the earth, the sediments of an ancient sea and past volcanic activity exposing the geologic history like pages of a book on the canvas.*

OPPOSITE
DRY HILLS
*oil on linen, 24 x 36, 1998*

*As Smith shifts from figurative to landscape painting, he continues to search for instants of revelation whenever he ventures back to northeastern Oregon. Some of these insights inspired* Dry Hills, *the sparse landscape reflective of its bone-like structure without pretense, like an act of meditation.*

not rely on them the way he relies on the drawings to resolve the structure in a painting. The transition of a field sketch to a painting involves a focus on simplification and choices about shapes and color.

By the time of his return to northeastern Oregon, Smith was alternating between paintings drawn from his memories of youth and observations of contemporary farm and ranch life. What he encountered in northeastern Oregon moved him further toward selecting images from the region's present-day reality and strengthened his painting technique. The concept of a painting is now visualized in Smith's mind before he ever reaches for the palette knife or brush. "Although I am inspired by nature, I prefer to paint in my studio where I can control the process and let my own sense of composition and color dominate. I find when I paint on location—for example, northeastern Oregon—I will be influenced by what I see rather than what I feel," says Smith. But in his studio he sees an image in his head exactly the way it will be done. "I probably spend more time thinking about a painting than actually doing it." Once Smith decides on that image, there is no indecision and he works quickly. "I try not to think philosophically or technically as I paint, but to work from emotion and react only to the process," he says.

Smith carefully designs the composition in each painting, addressing the image so any negative spaces are as important as positive ones, ensuring they relate and complement one another. Value, color, and space relationships develop simultaneously as he paints. Part of this approach is based on the roots of his earlier studies of dynamic symmetry and the golden section, but mostly now it is based on intuition from years of experience. Structure is always paramount in a painting and he strives to erect the

scaffolding for the paint through shape and line. His way of handling realism involves paring away extraneous detail to distill the image to its core essence. Human forms are often merged with architectural shapes—like a barn or other farm structure—and natural surroundings to create what he calls a fusion of disparate elements. Strong color relationships in his paintings are important and he often creates many different feelings in his subjects by selecting unusual choices of color combinations.

Sometimes he jumps right to the canvas with a design, without the guide of a preliminary sketch. Then paint application will proceed rapidly, with little need to rework or make any changes in the composition. "The Russian artists I met are like fencers, dancing back and forth in front of the painting, making quick jabs," says Ray Johnson. "But Gary Ernest Smith, on the other hand, stays at arm's length and locks the image in." Rarely now does Smith destroy a painting because something did not work in the composition.

A tireless worker, Smith will start a canvas early in the morning and continue working on it with intense concentration until it is completed. "He is such a prolific worker, and is overwhelmed by the need to be in the studio," observes Vern Swanson. Discipline, order, and a balanced approach to life are important for Smith to concentrate on his work. "Gary likes to work alone in the field or in the studio," says Judy Smith. "He is a solitary person by nature. When we got married, I told him he would be married to art first."

Smith is always in touch with the body of paint on a canvas through emphatic gestures with a palette knife, which he adopted after lengthy study of the work of French painter Georges Rouault. The palette knife brings out the clarity of color and the dramatic interplay of bold, geometric shapes, which a brush alone cannot accomplish. From time to time, Smith uses a combination of palette knife and brush and, more rarely, a brush

alone. "To me, Gary Ernest Smith is one of the few painters who can handle a palette knife effectively," says artist Ed Mell.

Large paintings, either figure or landscape, are painted wet on wet, which requires rigorous discipline. Smith layers the canvas with paint, then paints into that wet paint, his objective to emphasize the strength of the subject and certain illusions of light. "A palette knife allows one to paint wet into wet without muddying up the canvas, while at the same time fostering a unity of color values, which solidifies the work," explains Smith.

Primary colors are used directly from the tube—cadmium red light, cadmium yellow light, ultramarine blue, burnt sienna, burnt umber, white, sometimes yellow ochre. But Smith feels he obtains purer color through mixing, often directly on the canvas. Frequently, he will apply four or five colors, let them dry, then scrape some of the paint off, varying the layers and creating a glaze. "One of the things that attracts me to Gary Smith's paintings is his ability to create a final surface with deep texture," comments Johnson. This wiping off of the surface before the paint completely dries leaves pigment remaining in the pockets of the canvas, creating new textures and nuances, and an added dimension for the interaction of color and light. The scale of a painting also plays an important role. "Sometimes the size of the canvas dictates an emphasis on texture through building layer upon layer of paint over a period of time," adds Smith. Vern Swanson thinks Smith's use of the palette knife and his glazing technique make his work stand out in the history of Western American art.

One of Smith's painting characteristics is the expression of heat through the use of color. Much like painter Paul Gauguin, Smith will push his colors toward a more radiant

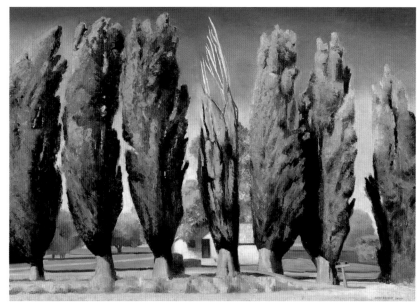

POPLARS
*oil on linen, 36 x 50, 1998*

*Another inspiration for Smith arrived through the classical shapes of trees as in* Poplars, *elegant Lombardy poplars lined up rank-and-file like soldiers forming a fortress around the house. Throughout the western United States, these trees have been commonly planted in rows or squares to serve as protective windbreaks. The house seems small in its natural setting, yet protected by it. Lombardy poplars mark locations of human habitation and, in the arid West, especially the Great Basin, their erect candle-like forms are vertical landmarks in an otherwise empty horizon.*

palette, manipulating their hues and exaggerating color beyond reality to make a forceful statement on the canvas. "The oranges and yellows used in my paintings, particularly the earlier ones, came from the feeling of being a boy out in those northeastern Oregon fields, and how terribly hot and sweaty it could become," Smith explains. "I wanted to replicate that, the feel of sweat, even the uncomfortable brilliance of bright sun. By using the palette knife and certain colors in some of the earlier historical or religious works I discovered a system of layering paint with short horizontal strokes that made it seem as if heat was rising out of the ground."

The harsh residue of northeastern Oregon's hard winters now found its way as a new theme into Smith's vision of the region. Among some of the paintings exploring this theme are *Winter Kill* (page 36), in which the hind legs of a deer are snagged by the barbed wire as it struggled to leap over a fence in heavy snow, and *Cow Carcass with Sagebrush*, a common scene in cattle country. Smith remembers these brutal realities of ranch life: going out in the spring to fix fences and untangling the remains of deer from the barbed wire. When he returned to the area in 1989, Smith approached the local ranchers on his explorations and made inquires about places where he could find deceased livestock or wild animals. "An animal carcass is a familiar sight to the rancher in this area," Smith says. "These works are not painted to be sensational but to touch a chord of truth that recognizes death as an integral part of life cycles."

Water, of course, is a paramount requisite for survival in this arid region, and the windmills that punctuate the horizon are used to coax life-giving liquid from reliable sources. Smith created the simple geometric shapes of the daisy-petaled windmill and watertank against a minimal sky in *Watering Hole,* (page 90) to represent a metaphor for a lighthouse or beacon in the parched desert, an oasis for cattle and man alike.

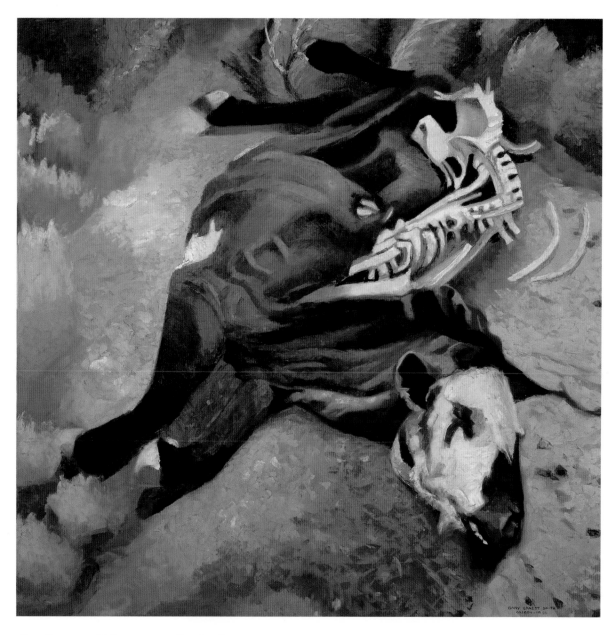

Cow Carcass *with* Sagebrush, *48 x 48, 1989*

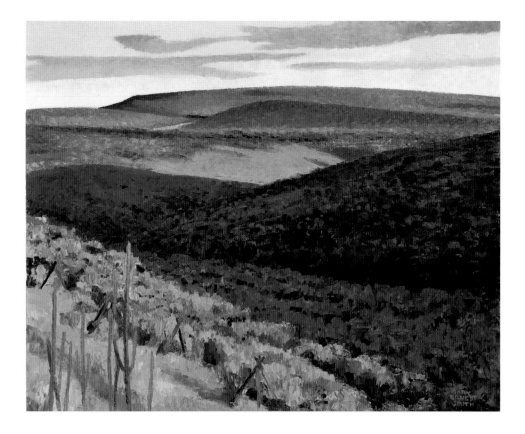

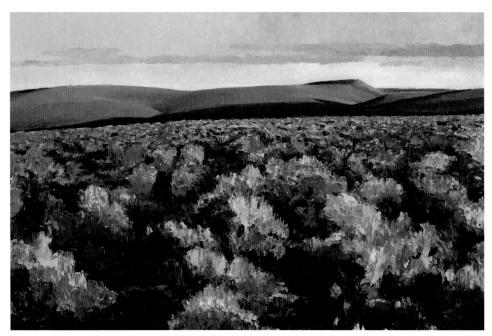

SAGE *and* SHADOWS
*oil on linen, 24 x 30, 1998*

WESTERN SAGE
*oil on linen, 24 x 36, 1998*

OPPOSITE
SAGE VISTA
*oil on linen, 36 x 48, 1998*

*In* Sage and Shadows, *late afternoon light creates dynamic shadows that dot the landscape and come together to form a large shadow through the middle of the image. The gray-green sagebrush of* Sage Vista, *undulating over the hills like a comfortable blanket, is a young, summer sagebrush. The low hills and distant mountain ranges contribute to the impression of a virtually infinite expanse of uninhabited land.* Western Sage, *with its older, larger, and drier sagebrush plants, and brown, dry hills, represents a more intimate piece of land in the fall season. Through the use of the palette knife, Smith has created each painting with fidelity to the scene, yet both images are examples of his technique of abstracting from the literal perception.*

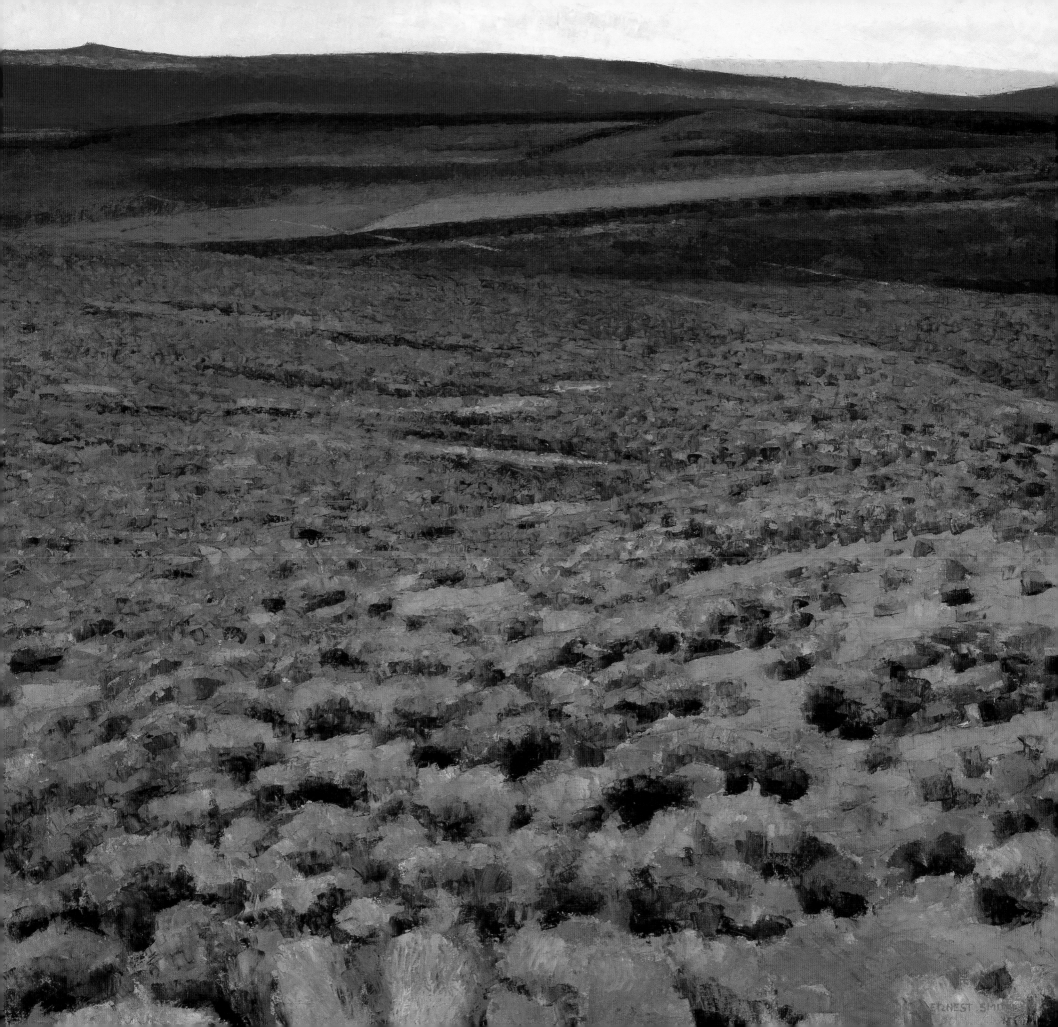

As a boy, Smith grew up surrounded by the rolls and breaks of sagebrush, rode horseback through it, and, as he remembers, "Picked ticks off myself afterwards." But not until recently did he realize the implications of its quiet, simple beauty. Now, wherever Smith ventures about this land, and in whatever direction, he sees the uninterrupted, untended gardens of sagebrush rolling over the hills in a new perspective. "Now I see how it creates beautiful textures and colors in different light across the rolling hills," he says. The aromatic scent of sagebrush, brushed with wind and dust, sometimes shining with moisture from rain or snow, was so familiar, so ordinary, so prolific to Smith that it no longer registered until

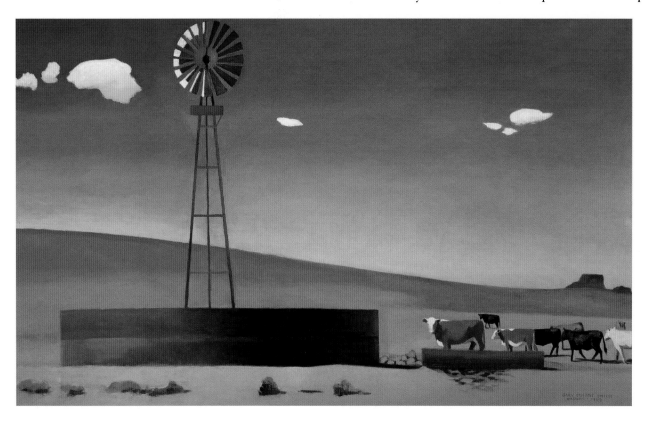

WATERING HOLE, *48 x 78, 1989*

he left the country and missed it. One result is *Sage and Shadows,* (page 88) where late afternoon light creates a dynamic shadow that slashes through the middle of the image. The elegant outline of the Blue Mountains frame the horizon above endless sagebrush in his painting, *Sage Pastureland* (page vi). This sagebrush landscape is important to Smith, but also important to his vision is the idea that the human presence resides there, as evidenced by the fence.

In *Roughing It,* Mark Twain wrote about the plant, "Imagine a gnarled and venerable live-oak tree reduced to a little shrub two feet high, with its rough bark, its foliage, its twisted boughs, all complete. . . . It is an imposing monarch of the forest in exquisite miniature." Like a complex and dynamic sea, sagebrush reigns supreme in the American West, including the Snake River–Columbia Plateau region.

The early ranchers in northeastern Oregon quickly learned that tall sage indicated arable land, and low sage or none in a certain area suggested that crops would not grow there, as sagebrush cannot tolerate high alkalinity. Knowing this, ranchers would strip certain areas of sagebrush, then plant alfalfa or other crops. This process is illustrated in *Fields, Hills and Mountains* (page 13), an image of a plowed field located in bottomland and separated from adjacent sagebrush by a fence. In this canvas, Smith has utilized sequential horizontal lines to create the feel of distance between the foreground and the far-off snow-capped peaks of the Wallowa Mountains.

Stalwart ranchers still clinging to remnants of a disappearing rural lifestyle in north-eastern Oregon often appear as subjects in Smith's paintings. Among these is *Farmer,* (page 93), a painting of Smith's father. As Smith recalls:

> The strong form and extreme value contrasts moved me to create this paint-ing as he stood silhouetted against the sky. This image of my father is much like some of the Solitary Man figures. He is a productive, hard-working indi-vidual who was able to accomplish a lot in his life because of his dedication and tenacity. He stands as a representation of the sort of person in northeast-ern Oregon who understands and responds to the demands of ranching.

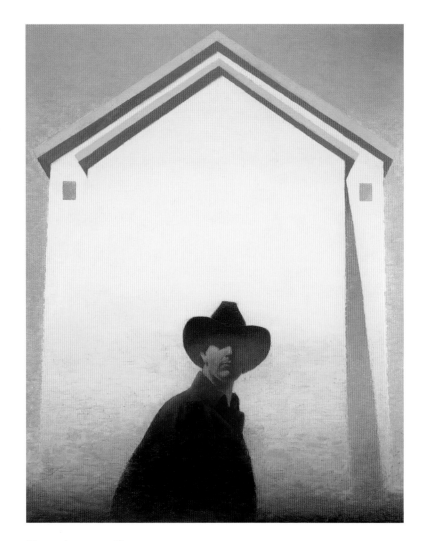

GREAT AMERICAN FARMER
*oil on linen, 60 x 48, 1994*

Familiar icons of this country are expressed in *Great American Farmer* and *Man with Pine Tree* (page 94). The stoic figure of a rancher next to the elegant shape of a Ponderosa pine, and another posed in front of the angular architecture of a barn, reflect images of the rugged individuals who work the land in this region.

Friends and neighbors of Smith's mother and father have also served as models, as in *Ranch Hand* (page 95). This individual is employed on a ranch owned by one of Smith's cousins, and clearly seems possessed with long-term attachment to the ranching profession. Other than a bright blue kerchief and yellow suspenders, the figure of the ranch hand seems practical, plain, humble, almost part of the russet-colored earth. "His sweat-stained hat, the drizzle of tobacco running down his chin, and the fact that he came to work each day in a starched shirt and new neckerchief was typical. That is part of the character I try to express in these people," explains Smith.

With *Common Ground* (page 99), Smith places the figure of a farmer in a freshly plowed field, treating him as an integral part of the cultivated landscape. Unlike the more stylized, anonymous figures in the Solitary Man series, this image is more specific and naturalistic; the farmer's presence in the field is about the harmonious joining of environment and man. "I like to portray the people I paint, such as this individual, as stopped momentarily, to be observed and studied from all angles. The colors are for emphasis and an emotional depth that I hope will be felt by the soul," says Smith.

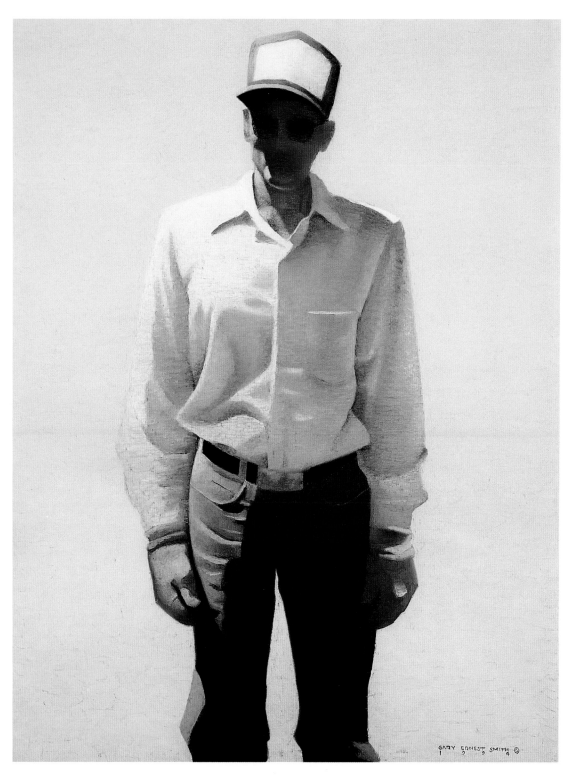

FARMER, *48 x 36, 1994*

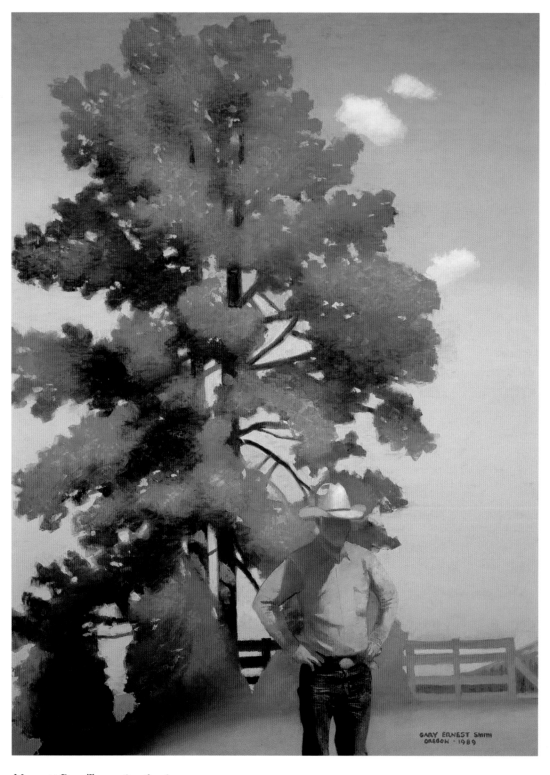

MAN *with* PINE TREE, *48 x 36, 1989*

Gary Ernest Smith returned to Baker County again in 1990. This time people began telling him stories about changes in local ranching traditions. The men on ranches, they informed him, now often sought extra jobs in town to make ends meet, leaving their wives to help conduct the duties involved with maintaining the spreads. Intrigued with the implications of this change, Smith contacted some well-known women in the county, among them a contract cowgirl, a Black Angus cattle rancher, even his own mother, asking if he could use them as subjects for a series of portraits. "I ran into several women who were married with children at home and who worked as contract cowgirls," recalls Smith. "You seldom see contract cowboys in the area any more. I think they have all gone to make a living in the city, working at stores or whatever. But the women are still there, taking care of the children, the animals, and the farms and ranches."

He took photographs of each woman from many different angles before deciding which image suited the concept of the painting he wanted to create. "They were shy

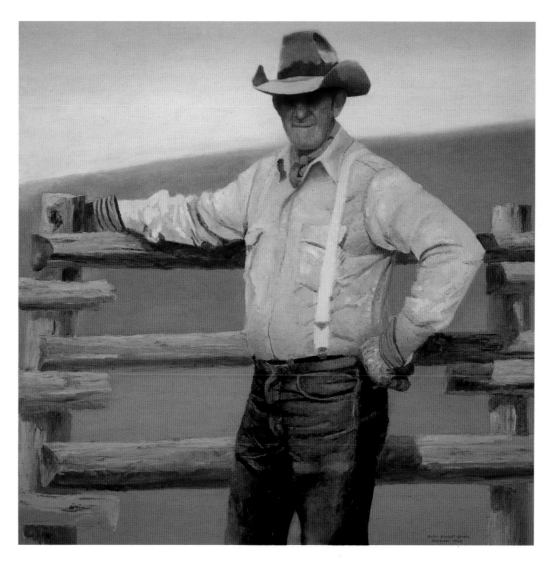

RANCH HAND, *48 x 48, 1989*

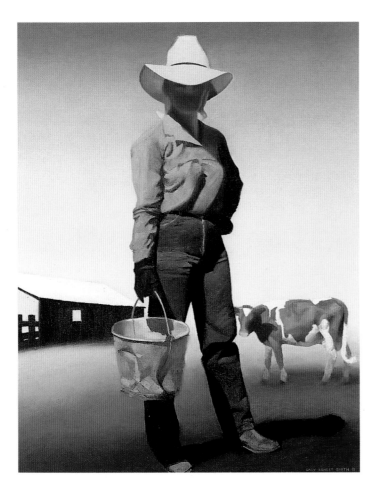

WOMAN *with* BUCKET, *60 x 48, 1990*

about being included because they did not think of themselves as photogenic," Smith says. "I do not want you to be posed," I would tell them. "I want you doing what you do best in your everyday work clothes. I am not trying to glamorize you. I am trying to make it real."

Then, guided by the photographs, he painted large-scale portraits of eighteen different women, such as the confident *Woman with Bucket* or the equally self-sufficient *Sabrina*. All of the subjects are readily identifiable as a local residents, and Smith tried to capture their proud self-reliance and ability in the paintings. "I also attempted to show each woman's character or mood without depending completely on facial expression in an effort to portray them with a slight touch of mystery," explains Smith. In part because of these paintings, and Smith's overall contributions to the understanding of the region's landscapes and people, Baker City declared a "Gary Ernest Smith Day" on March 30, 1991.

Twenty-six of the first northeastern Oregon paintings were gathered together by Vern Swanson for an exhibition at the Springville Museum of Art in Utah with the title, *Journey in Search of Lost Images.* They were then sent on tour to museums in Texas, Washington, Oregon, Kansas, Ohio, Louisiana, Massachusetts, and other places in 1991 and 1992. These paintings were warmly received, one critic declaring in the *Boston Globe,*

> They are less about the physical landscape than about landscapes of the mind, evocations of American myths and a sense of self that may have little to do with complex realities. . . . Smith is exploring our nation's soul, the fictions we spin around ourselves."

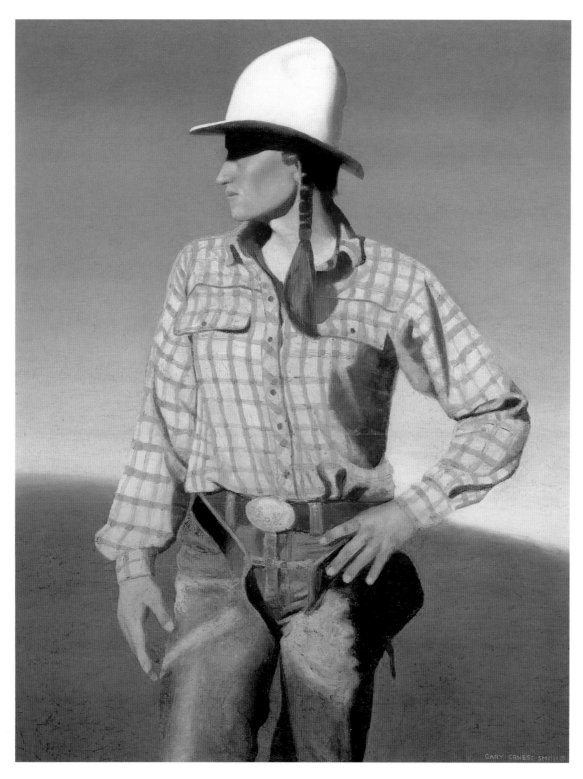

SABRINA, *60 x 48, 1990*

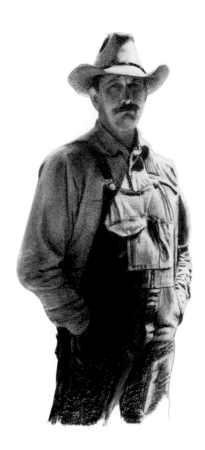

According to Gretel Ehrlich, "To see and know a place is a contemplative act. It means emptying our minds and letting what is in there, with all its multiplicity and endless variety, come in." Northeastern Oregon is such a place for Smith. It remains the center of his identity, the heart and soul of who he is, and the foundation for his expressions in art. Now he often returns there to connect with his past and recharge his vision. William Least Heat-Moon thinks whenever someone enters the land, sooner or later they pick up the scent of their own histories. To truly know a place you must dream it, attempt to enter it, and partake of its distinctiveness, as Gary Ernest Smith has done.

OREGONIAN
*16 1/2 x 11, charcoal on paper, 1995*

*opposite*
COMMON GROUND
*oil on linen, 48 x 60, 1996*

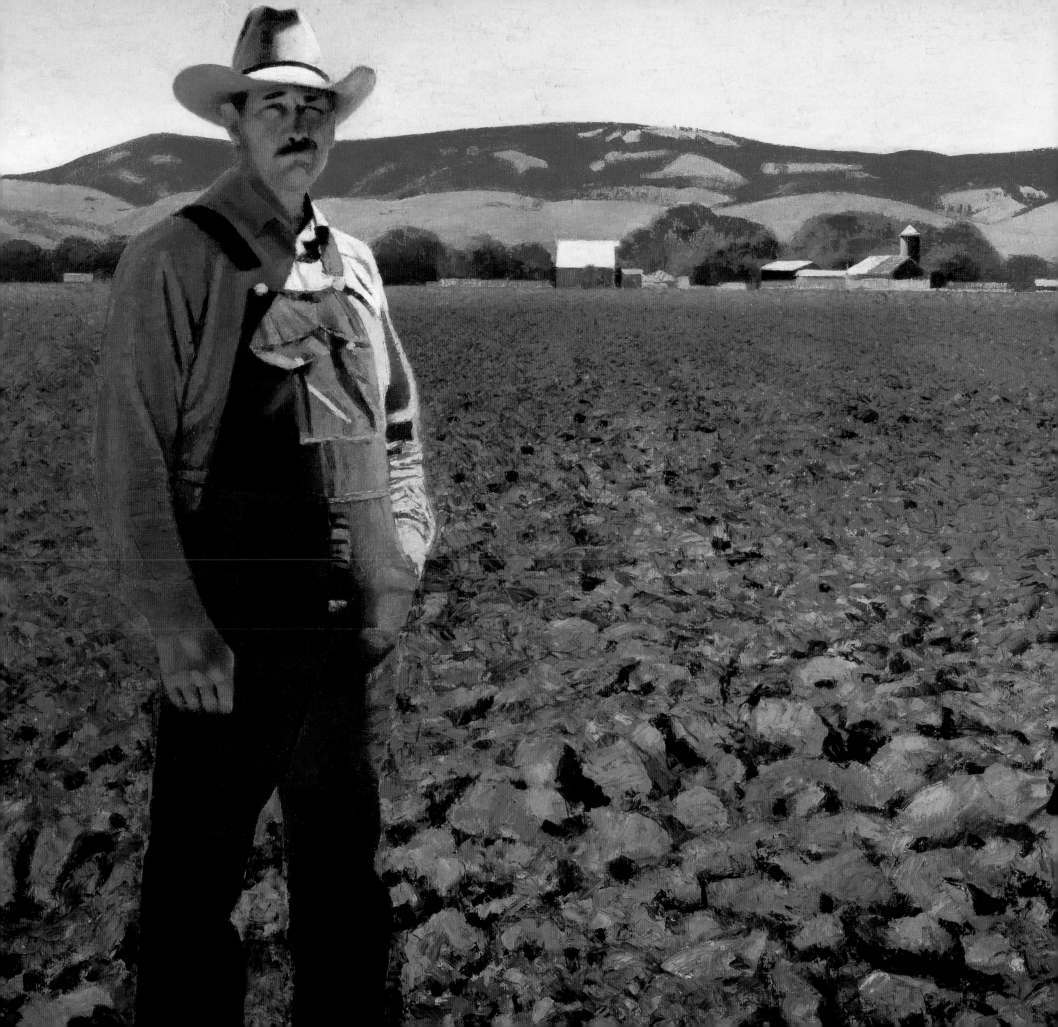

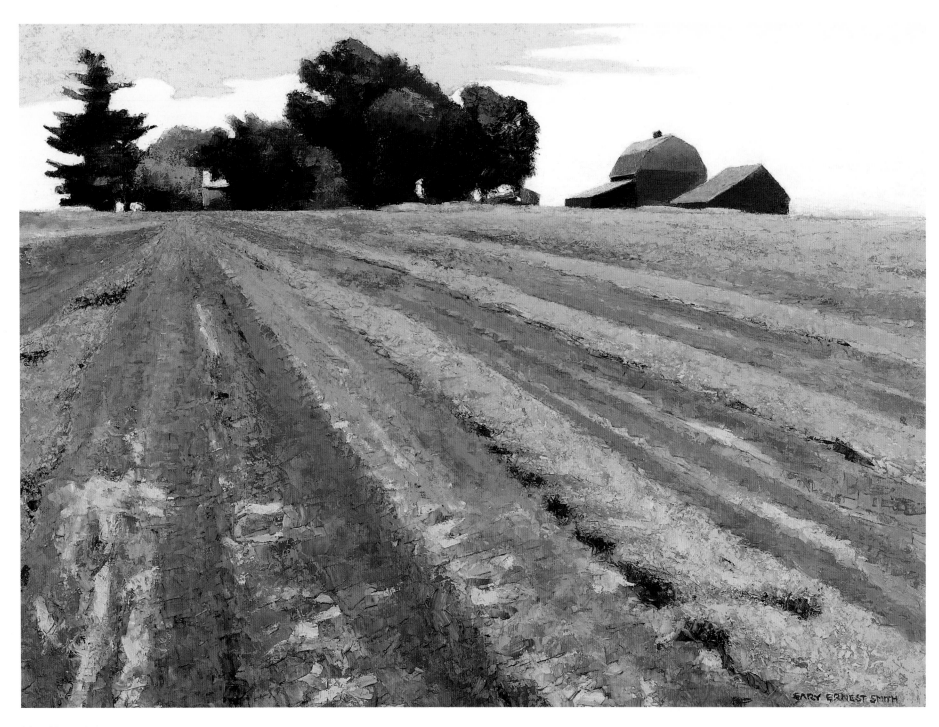

New Hay, *oil on linen, 30 x 40, 1997*

| 5 |

# JOURNEY *through*
# CULTIVATED LANDSCAPES

MARCEL PROUST CLAIMED that the real voyage of discovery lies not in the search for new landscapes, but in having new eyes. Thus in the early 1990s Gary Smith began to look beyond the figures in his paintings in an attempt to see the cultivated landscape with fresh insight, and to find a different direction for his art. Cultivated fields are important to him as symbols for the complex, intertwined relationship between agriculture and land and, ultimately, for American values. Smith approached the agricultural landscape, studied it carefully, then isolated elements to bring about new understanding. As John Brinkerhoff Jackson proposes in *Discovering the Vernacular Landscape*, "I suspect no landscape, vernacular or otherwise, can be comprehended unless we perceive it as an organization of space, unless we ask ourselves who owns or uses the spaces, how they were created and how they change."

Through the efforts of Thomas Jefferson and the Land Ordinance of 1785, the United States government devised a survey system of land division organized around thirty-six-square-mile townships, each defined by a square whose side measured six miles. The Jeffersonian grid converted America west of the Appalachian Mountains into an agrarian landscape, every aspect of land presented as a spatial organization.

FIELD ROWS
*charcoal on paper, 9 x 9, 1997*

CORN *and* SOYBEANS
*oil on linen, 40 x 72, 1997*

*Smith is intrigued by the graphic qualities and expressive forms of farmed landscapes in Minnesota and Iowa—how the corn and soybeans are often laid out in intricate patterns. Other inspiration comes from the practice of harvesting part of a corn crop while leaving adjacent rows intact. Plowed, planted, or fallow fields are measured expressions uniting cultivated sites with a way of life adapted to the landscape and the seasons. "In Iowa, for example, I saw interesting combinations of how the earth is worked and patterns of crops in different stages of growth or harvesting," says Smith. Paintings executed with bold, clear pattern like the rich and ripe beauty of* Corn and Soybeans, Cornfield *(page viii), and* Hay and Corn *(page 3) explore some of these dynamics found in Midwestern fields, intricate and beautifully constructed landscapes based on reciprocity between the environment and the occupant. "The intriguing design patterns of the Midwest fields and crops are an inspiration to me," comments Smith. "Their simple, quiet beauty allows me to explore texture, color, and form in new ways. I think of these landscapes—in fact, all of my landscapes—as being portraits of the land."*

To make parcels available to more people in order for them to purchase land, sections were divided: half-sections first, then quarter sections, half-quarter, and, finally, quarter-quarter sections. The quarter-quarter section, which was legislated into existence by Congress in 1836, is forty acres. This plot size remains the most common in evidence, particularly throughout the Midwestern states. When one flies high above the Midwest or parts of the West, a vast and remarkable mosaic is unveiled by that bird's-eye view, a constructed topography laid out on a grand scale. Squares, strips, circles, straight rows, or curving contours stretch out across the terrain, marking rules of occupancy and a landscape with dynamic relationships.

That view changes on the ground, when the result of the grid pattern is seen from a much different perspective through the eyes of an artist like Gary Smith. In his search for content and context, he wants a close-up, the micro-view of a particular field. In other words, the locale—for each field has its own insistences; each is part of a matrix for his imagination. If space defines landscape, according to Lucy Lippard, then space joined with memory defines the concept of place. All fields have histories, both natural and involving those who have interacted with them. But they are, by and large, unknown places to most Americans. Herman Melville might have had fields in mind when he declared, "It is not on the map, true places never are." Places such as cultivated fields can be read somewhat like stories, then: as outward revelations of an inner spirit.

For most people, agricultural fields make unimpressive landscapes. Few will stop their car in the Midwest, or elsewhere, and take a snapshot of a grain or alfalfa field, or one that is fallow, the way they might stop to photograph Wyoming's Grand Tetons. Scott Russell Sanders, however, writes in a recent issue of *Wild Earth:*

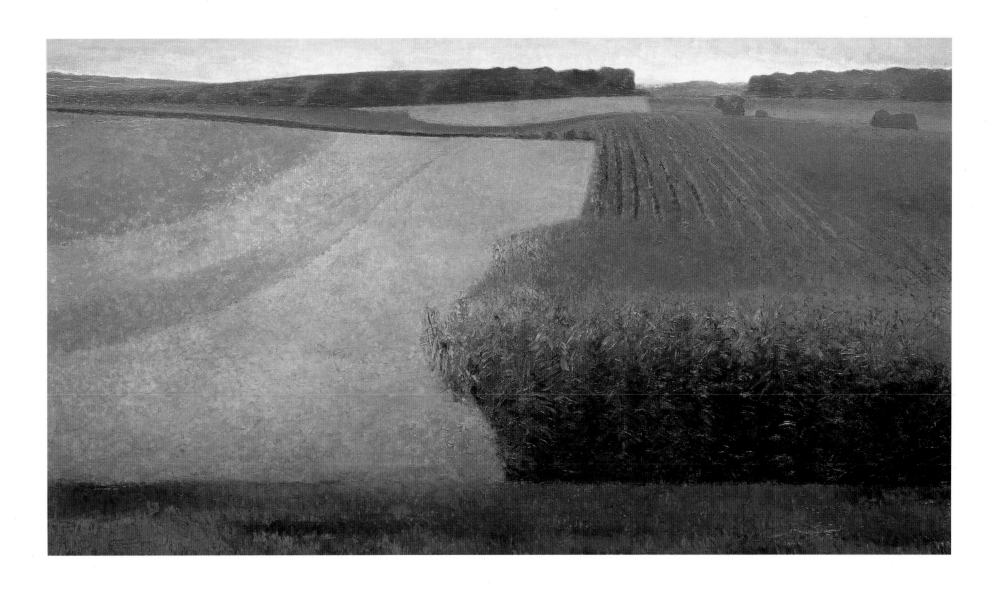

> To know the plainness of an unspectacular landscape . . . requires an uncommon degree of attentiveness and insight. It requires one to open wide all doors of perception. It demands an effort of imagination, by which I mean not what the Romantics meant, a projection of the self onto the world, but rather a seeing of what is already there, in the actual world.

Throughout the first part of his career, Smith painted landscapes, but as backdrops for other issues in his art. One early landscape painting, for example, *Landscape with Harvester*, portrays a wheat combine at work in the rolling hills of northeastern Oregon. The composition is laid out with geometric blocks and horizontal lines indicative of that sparse landscape, the color almost monochromatic. However, the focus of the painting is about the implications of the harvester: people at work, not the landscape itself. In time, though, Smith recognized the significance of looking beyond the surface, the importance of place, an underlying spirituality inherent in cultivated fields. As Vern Swanson speculates:

> There is something spiritual about a well-cared-for farm that is perhaps less visible in the virgin wilderness. Man working in concert with nature is a powerful combination. The corn fields of Iowa, wheat fields of Montana, and melon fields of Utah somehow surpass the rugged sublimity of our national parks. Fields are a harmony man impresses upon nature: the geometry of cornucopia which symbolizes America's abundance.

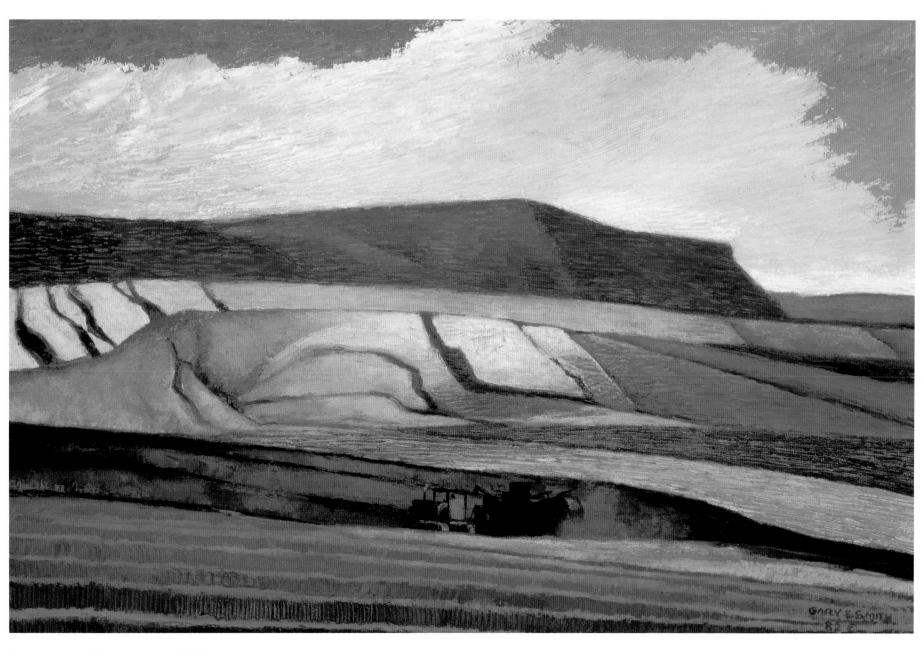

LANDSCAPE *with* HARVESTER, *24 x 36, 1982*

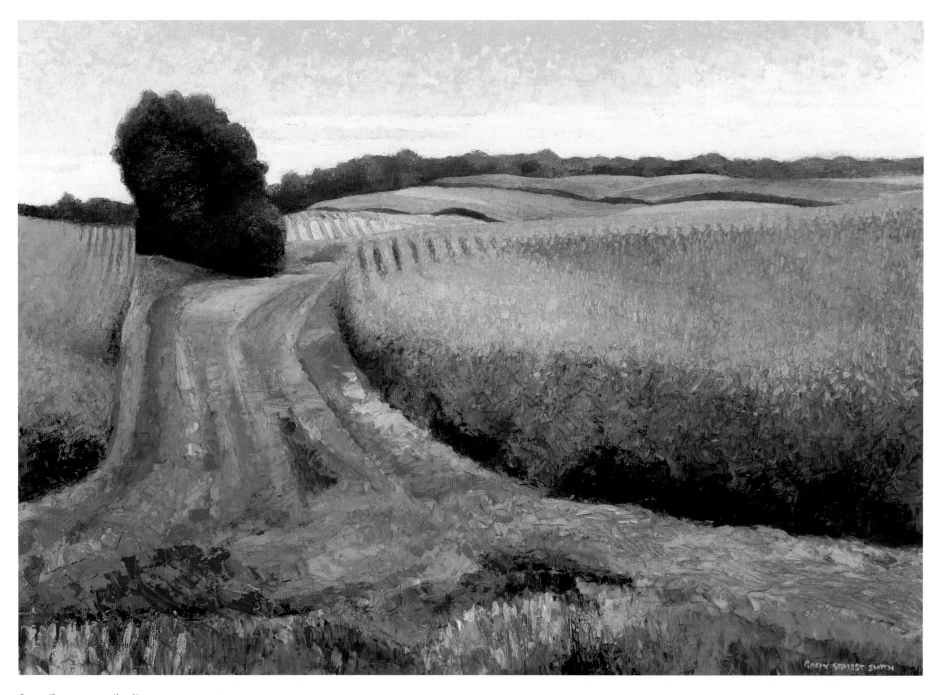

IOWA CORNFIELD, *oil on linen, 30 x 42, 1997*

Smith's paintings of cultivated fields are about reading places; they are stories on canvas about connections between the land and people and what they do there. Cultivated fields are themselves landscapes at work, with day-to-day and season-to-season activities that carry a network of meaning. Smith has connected us to fields, and made them more visible in the process. Gretel Ehrlich suggests:

> Landscape does not exist without an observer, without a human presence. The land exists, but the "scape" is a projection of human consciousness, an image received. It is a frame we put around a single view and ways in which we see and describe this spectacle represent our "frame of mind," what we know and what we seek to know.

There is a feeling of almost Zen-like serenity in the quiet, worked fields expressed in Smith's paintings. Through his sympathy for the cultivated landscape, he has made the ordinary epic and universal. The modest world of a Midwestern or Western field assumes a validity of its own as Gary Ernest Smith probes that ordinary appearance, in search of an elusive reality beyond its surface appearances. These paintings became the precursors of an even deeper insight into the meaning of their existence.

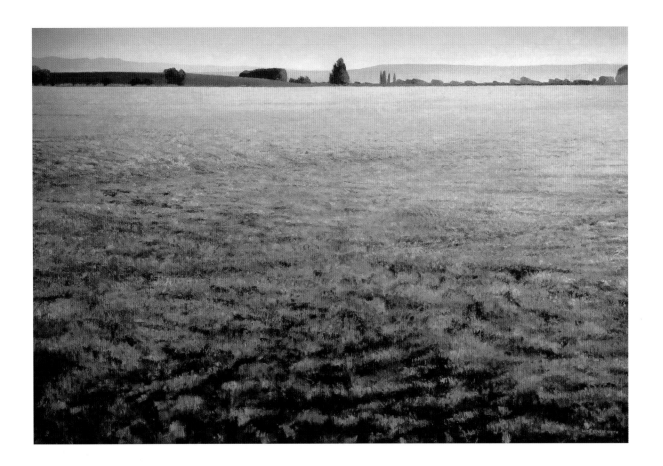

PASTURE
*72 x 108, 1998*

OPPOSITE
COTTON FIELD
*72 x 120, 1998*

*The inviting golden grass and the fullness of ripe cotton in these paintings speak of the lingering days of deep summer. Both hint at Smith's transition between the relatively smaller-scale landscapes and the monumental Field Paintings. The absence of buildings makes* Pasture *unusual, but the trees at the horizon line place it in the landscape category.* Cotton Field, *with its upper and lower visual frames and emphasis on the product of the land, not the land itself, is also unusual, and we can see the progression toward a concentrated focus on fields that is to come.*

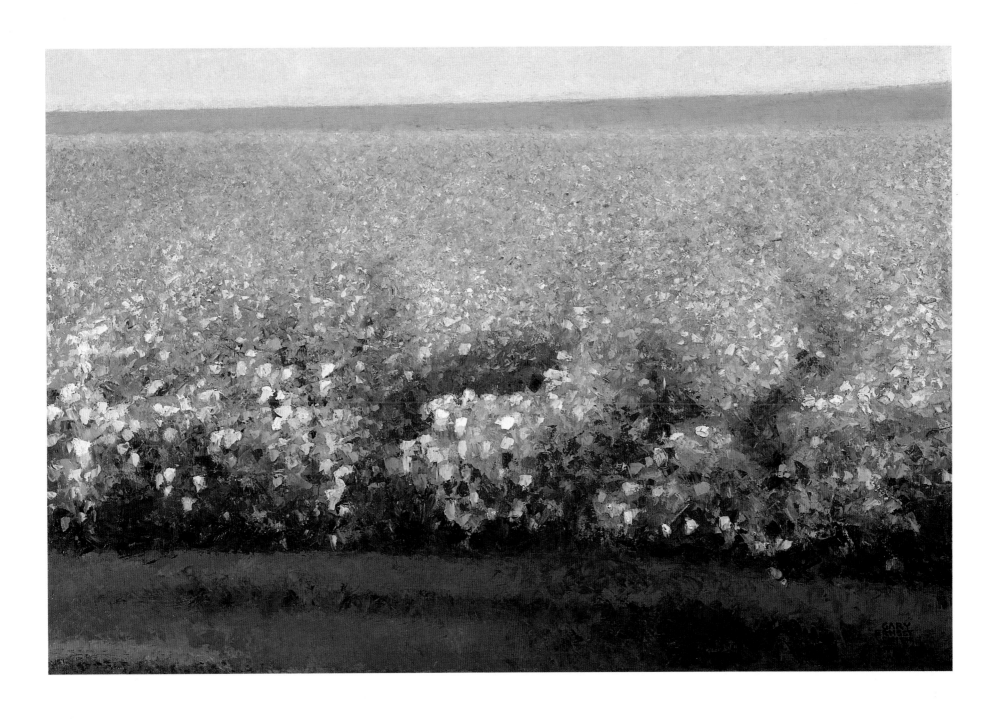

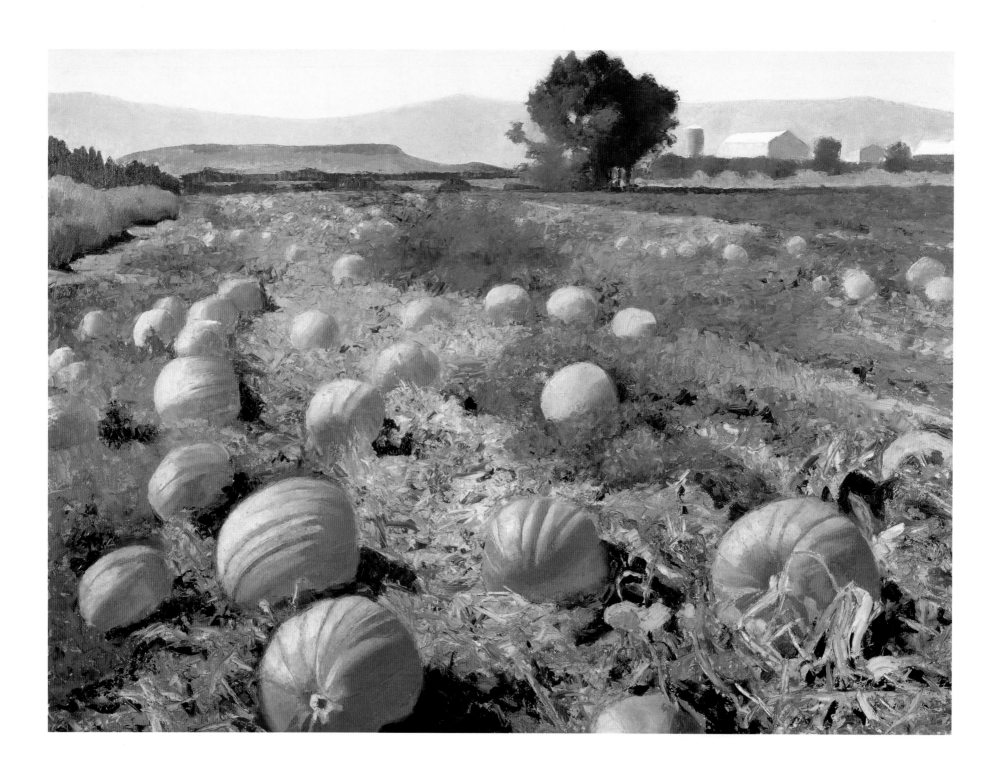

PUMPKIN KING
*oil on linen, 48 x 48, 1996*

OPPOSITE

OCTOBER PUMPKINS
*oil on linen, 36 x 48, 1997*

*Large numbers of pumpkins grow in fields scattered around the small towns north and south of Salt Lake City. They are often a favorite subject for Smith in the early fall; he is attracted by the radiant orange color of pumpkins nestled among the vines. In* Pumpkin King, *he zeroes in on a ripe, plump pumpkin, and has painted it in the tradition of a still life. In* October Pumpkins, *he has created a vivid canvas of fat, round pumpkins in a field awaiting harvest, their luminous hues a counterpoint to the tapestry of green vegetation and brown earth.*

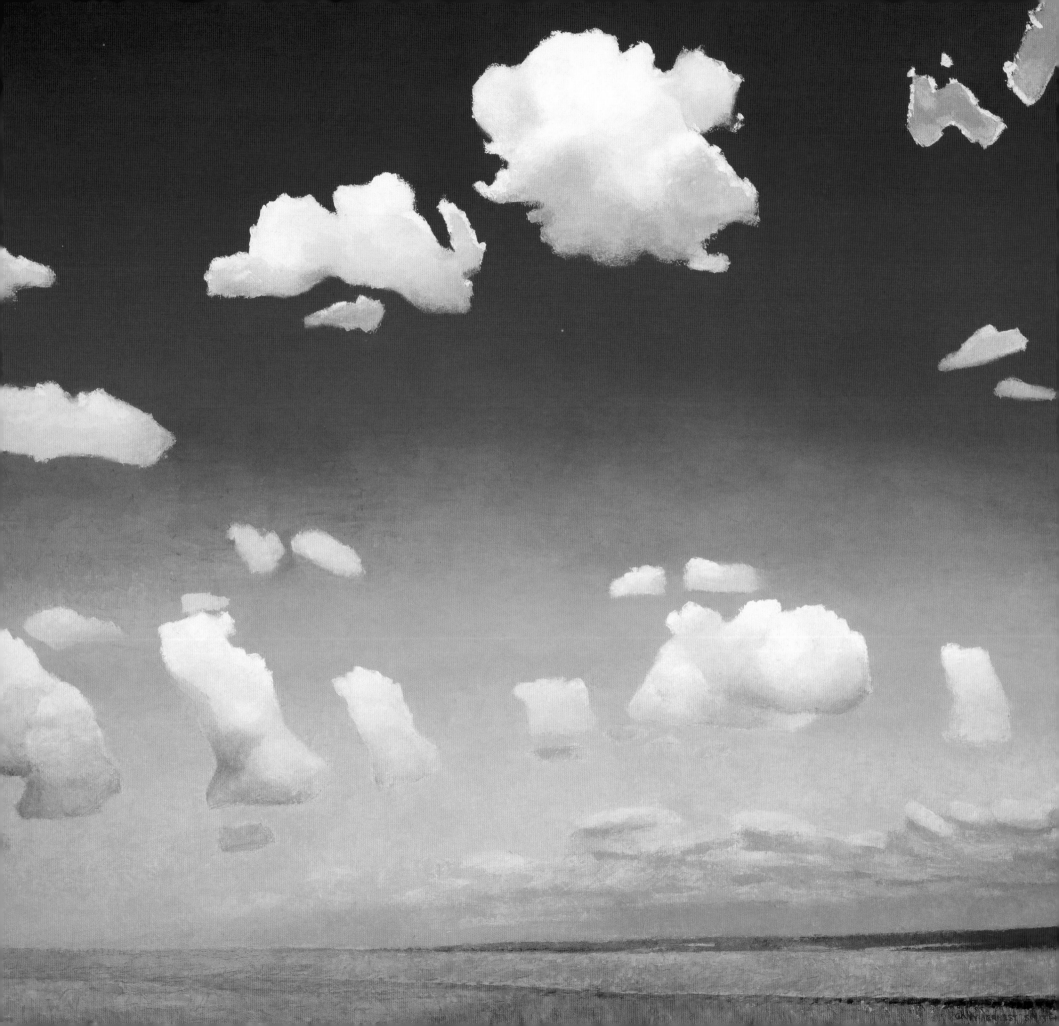

CLOUDS *over* CORN STUBBLE
*oil on linen, 40 x 60, 1998*

OPPOSITE
CLOUDS *and* WHEAT
*oil on linen, 48 x 60, 1997*

*Some paintings address the imprint of the western region's vast space, as in* Clouds over Corn Stubble *and* Clouds and Wheat. *These canvases celebrate the sky as the roof of the land, the change from the lighter, atmospheric blue to the darker blue of limitless space accentuating the vastness of the settings.*

Clouds over Corn Stubble, *an expansive view of amber Iowa fields dotted with gridlike tree lines, cirrus clouds poised lazily overhead, contains hints of fall in the bright red and golden leaves of a few random trees.*

*The lack of structures, natural vegetation, or figures makes* Clouds and Wheat *an unusual landscape for Smith. Architectonic cloud shapes sit above the open Idaho field, and the complementary colors of blue and orange create a striking effect.*

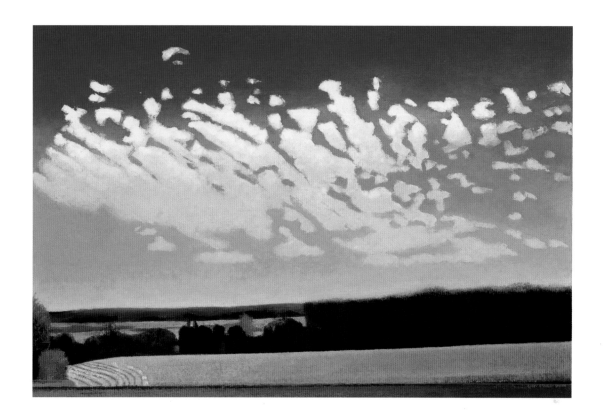

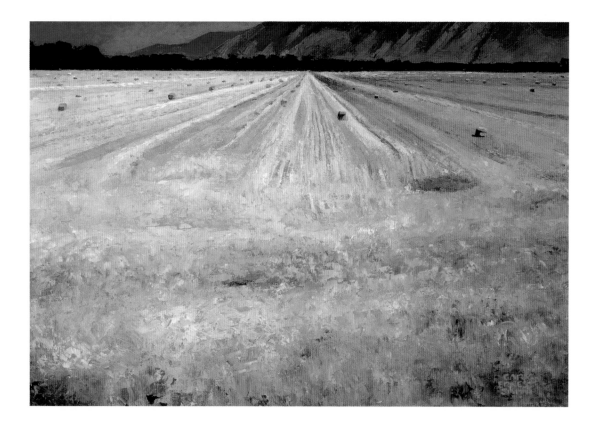

BALES *in* WHEAT FIELD
*oil on linen, 16 x 24, 1997*

OPPOSITE
LONG SHADOWS
*oil on linen, 14 x 20, 1997*

*In* Bales in Wheat Field, *the order of the bales is less obvious than in* Wheat Field *(page 131), though the view down one row, the others meeting its horizon point like an exercise in perspective, again empasizes the order that has been placed on the land. The presence of the mountains behind the field offers contrast to this arrangement, a monument of unusable, untamable nature.*

Long Shadows *focuses on the bales themselves, and their placement appears to be random. The hint of curved, plowed rows in the foreground returns us to the idea of order, however, as does the parallel configuration of the rectangular bales and their aligning shadows. The tops and visible ends of the bales seem to glow in the light as it reflects off them; the sun-kissed plot of land seems to cling to what is left of the day and the season.*

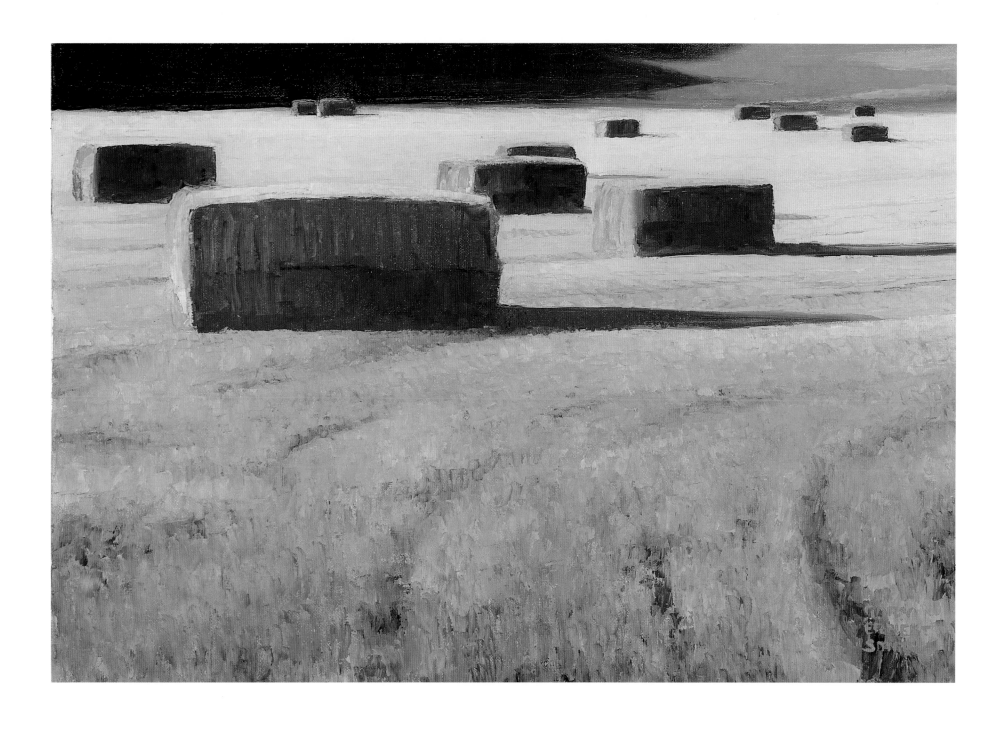

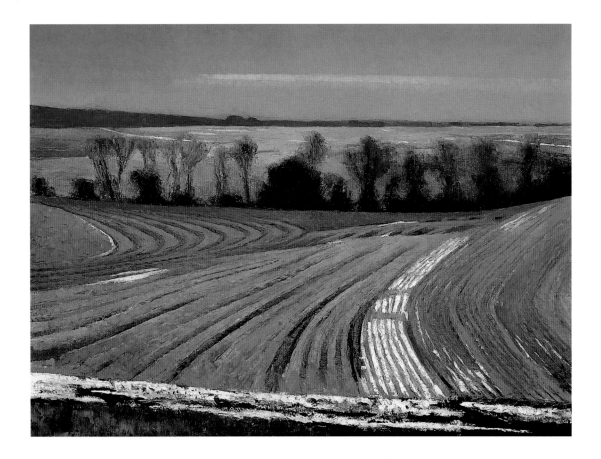

SNOW PATTERN *on* STUBBLE
*oil on linen, 30 x 40, 1997*

OPPOSITE

WINTER CORN STUBBLE
*oil on linen, 16 x 24, 1997*

*The effects of snow on a landscape has led
Smith to paint numerous canvases portraying
the subject. He looks again and again at snow
in the fields, never seeing the same subject
twice because of melting snow's incessant
transformation of form, pattern, and light.
Fields that retain stubble after harvesting
often capture snow in elegant designs, as in*
Snow Pattern on Stubble. *Remnants of a
snowstorm lie between marching ranks of
stubble, illuminating the contrast between
pockets of snow and the straight or curving
earth-tone rows developed with strong
strokes of the palette knife.*

   *In* Winter Corn Stubble, *the rich texture
of the field and the use, again, of complementary
orange and blue bring this painting to life.
"Snow is a blanket that tucks the earth to
winter rest," says Smith. "The texture of the
earth is never as prominent as when the first
snow lies on frozen ground."*

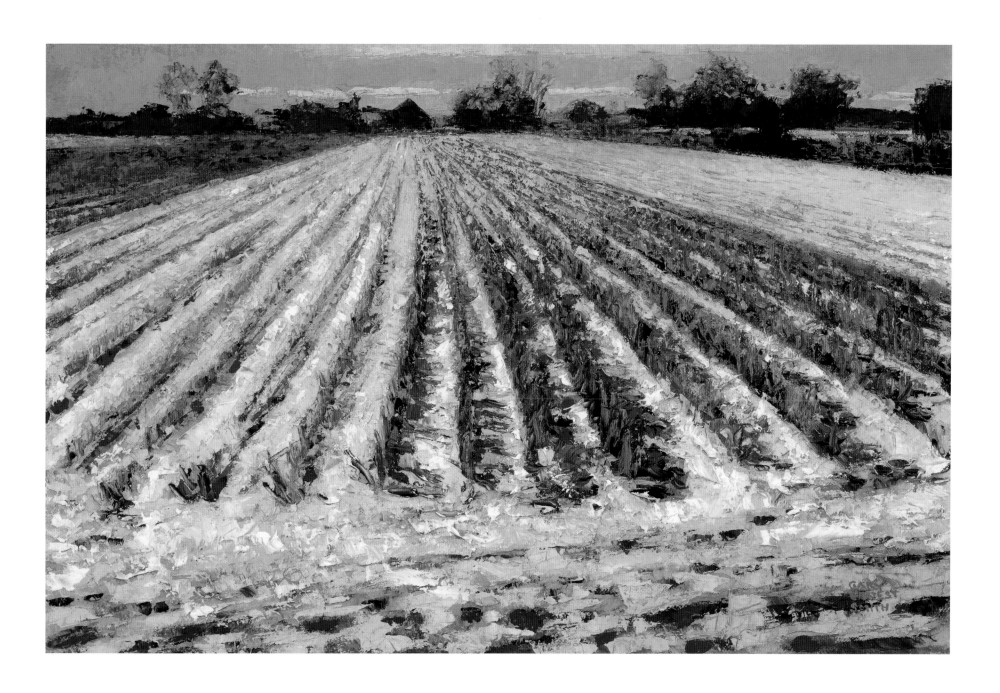

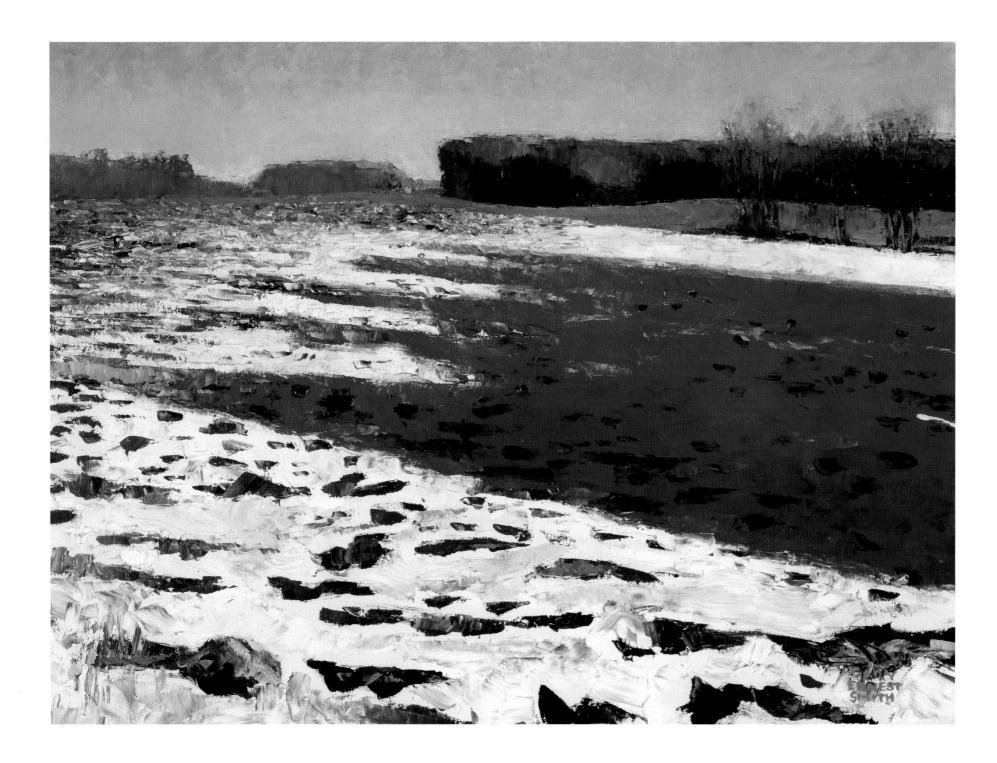

WINTER FIELD
*oil on linen, 30 x 40, 1997*

OPPOSITE
SNOW *and* SHADOW
*oil on linen, 16 x 24, 1998*

*Winter has arrived with arresting quietness in* Winter Field, *the landscape articulated in a kaleidoscope of gray, white, and blue. LeConte Stewart, who painted the Utah landscape from the 1920s to the 1950s, also found beauty in the somber, subtle color relationships in late fall and winter. His approach was to place a structure, perhaps a pioneer brick home, or an old barn, for example, within a bleak winter landscape, painted with contrasting light and shadow. Like Smith, Stewart found personal expression in the peaceful, quiet mood of winter, when colors in the landscape are muted and mysterious.*

*In* Snow and Shadow, *a long blue shadow from nearby trees marches over a Minnesota field. The thawing patches of snow and angular shadow project a wild, almost primitive feel to the scene.*

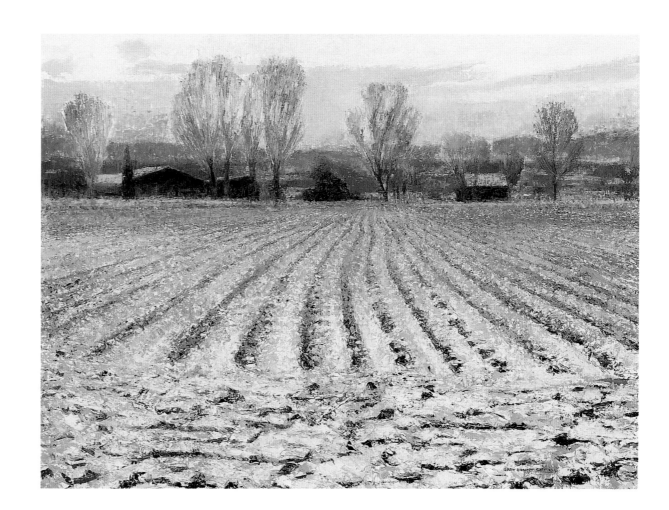

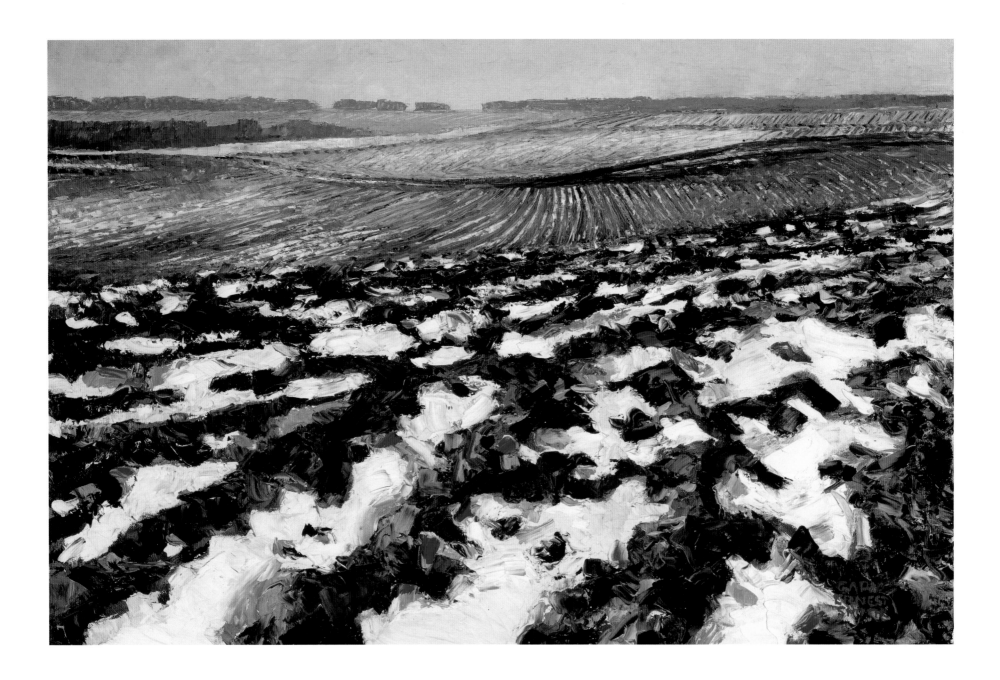

WINTER FURROW DESIGN
*oil on linen, 36 x 48, 1997*

OPPOSITE

SNOW *and* EARTH
*oil on linen, 16 x 24, 1997*

*Like the painter Andrew Wyeth, who selected fragments of bleak winter-swept terrain for his canvases, Smith prefers late fall and winter. Then he can envision the bare structure, loneliness, and quiet chill of winter in the fields, such as he has done on several visits to Minnesota. Still, the whole story does not appear until he attempts to capture it on canvas.* Winter Furrow Design, *for example, illustrates a farmer's adaptation of plowing strategies to a particular field, with furrows executed at right angles to preserve runoff and minimize erosion. In* Snow and Earth, *pockets of snow reside in deep furrows stretching to the shelterbelt of trees on the horizon, the patches of brown and white contributing to the feel of crisp, cold daylight.*

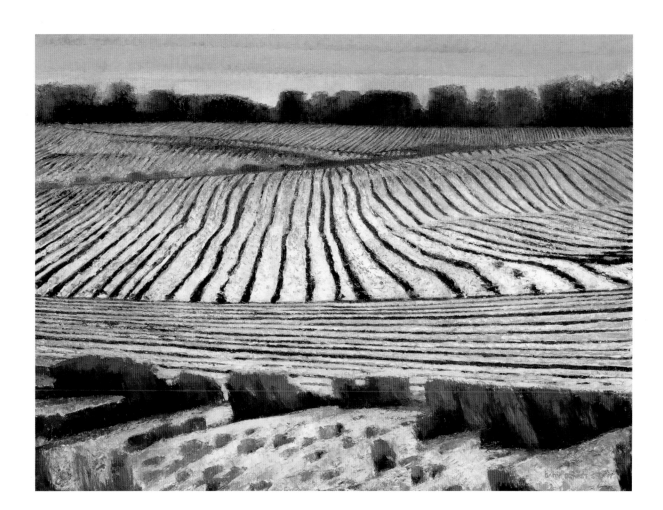

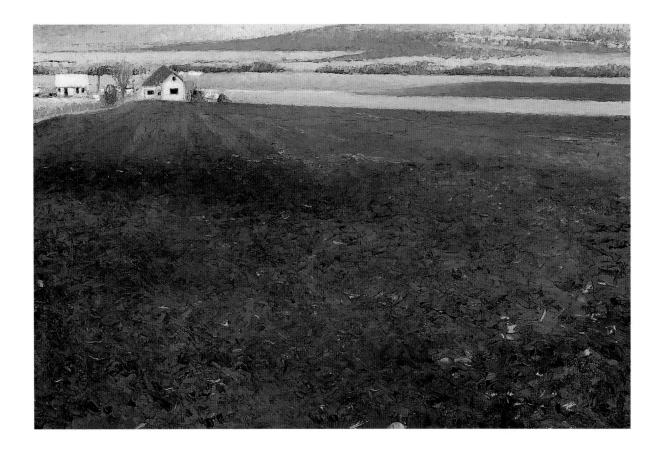

FALL EARTH
*oil on linen, 16 x 24, 1997*

*In early autumn the fields are quiet, the harvest completed, as Smith depicts in* Fall Earth. *Gray skies gather together on the horizon, again, harbingers of change. The colors used to paint the buildings accentuate the cool greens and blues that envelop it in the chill of coming winter. The house seems to be placed as the focal point of the field, the center of operations on the farm.*

OPPOSITE

AUTUMN DRY FARM
*oil on linen, 30 x 40, 1997*

*In Smith's section of Utah, dry farming is often practiced, as he indicates in* Dry Farm. *The placement of the buildings seems to speak of the dependence of this small human settlement on the mercy of the land. With no irrigation, dry farming relies mainly on rainfall, run-off, and drought-resistant crops.*

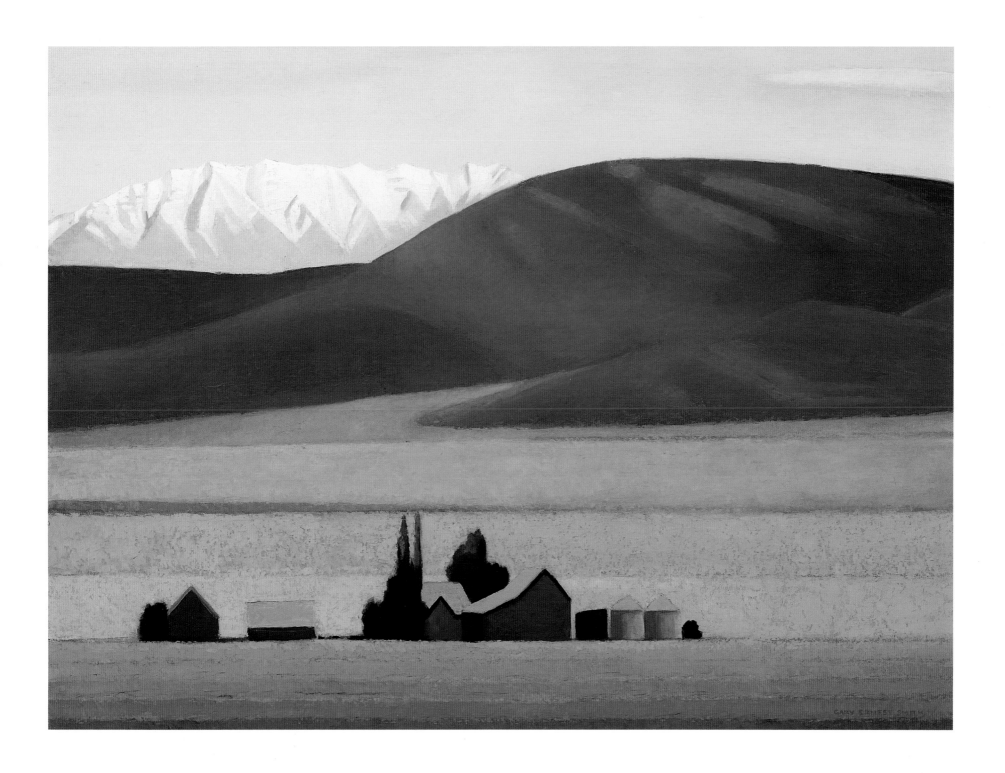

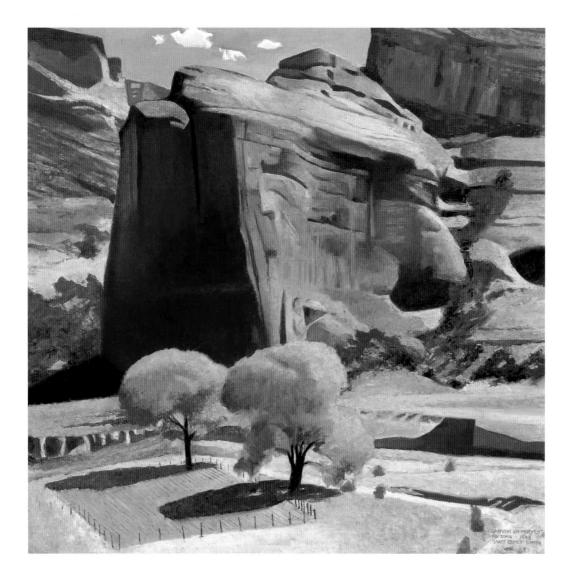

NAVAJO FARMING
*oil on linen, 48 x 48, 1998*

*On a visit to northeastern Arizona's Canyon de Chelly, Smith spotted a Navajo cornfield in Canyon del Muerto, its major tributary. Whereas his paintings of cultivated fields elsewhere are often framed by vast space,* Navajo Farming *celebrates a modest agricultural universe. A small plot, enclosed by a fence to repel wandering sheep and horses, sits adjacent to the sandy canyon floor. It is October, and the corn has been harvested. Two cottonwood trees, ablaze with golden foliage, stand watch over the quiet field.*

*Perhaps no area in the Southwest possesses the sacred feel that Canyon de Chelly has, where centuries whisper from the vertical red sandstone walls, sometimes towering a thousand feet above the narrow canyon floor.*

*Throughout the canyon area, wherever there is level ground and sunlight, the Navajo plant small cornfields—tucked into an alcove, or situated on a terrace above the canyon streambed—as they have year after year for nearly three centuries.*

OPPOSITE

HORIZON
*oil on linen, 24 x 36, 1997*

*Sometimes Smith sees the more direct human presence in the landscape, as in* Horizon. *The gambrel-designed barn and nearby windmill are stark against the waning light of an Iowa day, and the structures' shapes intensified by the angular shadows in the afternoon light. "There is a big sky in the Midwest. The flatness of the land emphasizes it. I wanted to create the feel of open spaces by keeping the farmscape low, just as you see it while passing through," says Smith.*

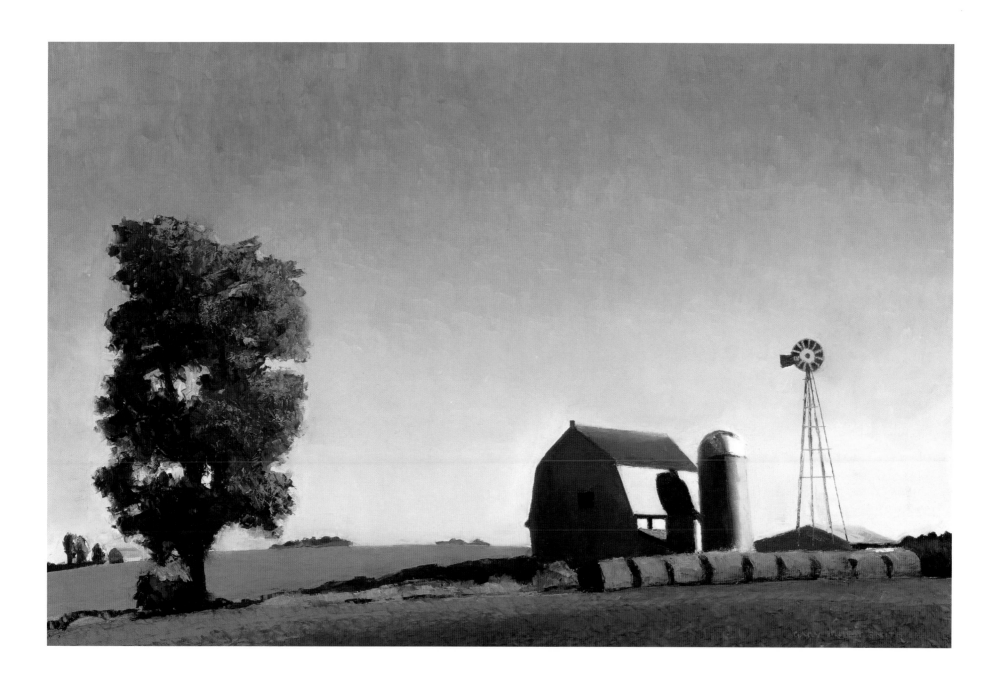

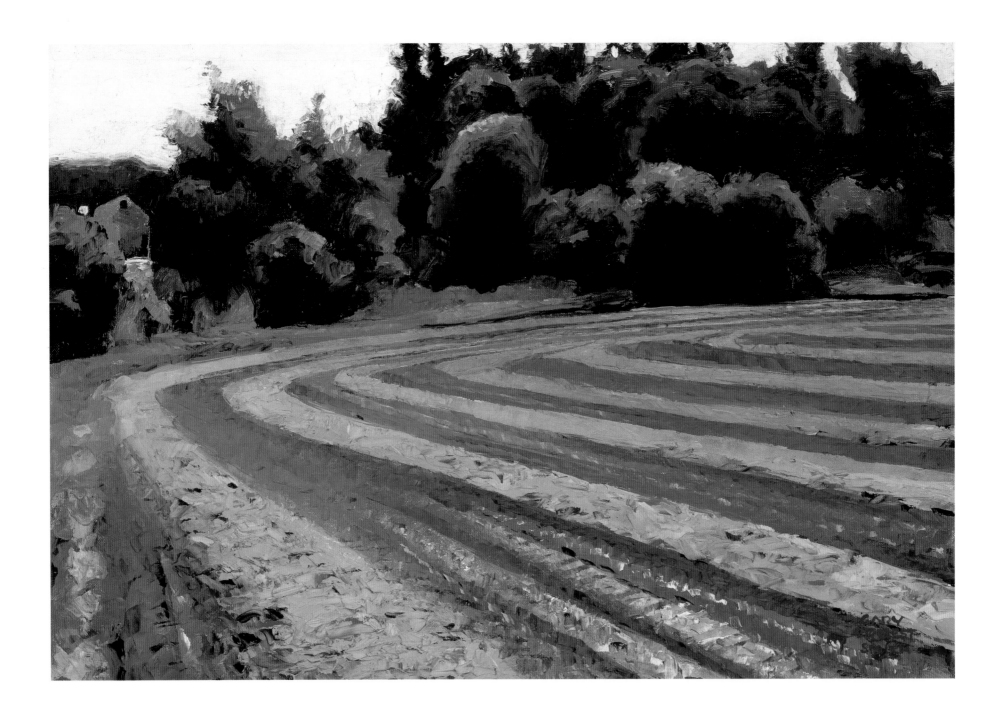

Spring
*oil on linen, 30 x 40, 1996*

OPPOSITE
Windrows
*oil on linen, 14 x 20, 1997*

*Smith is a painter not only of place, but of the seasons. Each change of season offers insight, and he likes to document the transformations in cultivated fields, particularly those near his Utah home. His walks in fields reveal the results between event and the soil, between the rhythms of the farmer and the rhythms of the land.*

*In* Spring, *for example, winter's grip has lessened or retreated altogether, and the stark outlines of Lombardy poplars against an empty sky begin to show emerging green leafage. The heavy trunks of the trees and feathery growth on the branches promise full protection for the little buildings by the time full summer comes. The field is plowed and planted, its barrenness also full of promise. A chill lingers in the air, indicated in the low, gray-blue clouds, another emblem of this time of transition.*

Windrows, *a close-up view of how a plow creates interesting designs when it pivots and turns at the edge of a field, celebrates the readiness of the earth in early summer. The full growth of green leaves on the trees stand in contrast to the luxuriant brown of the prepared field.*

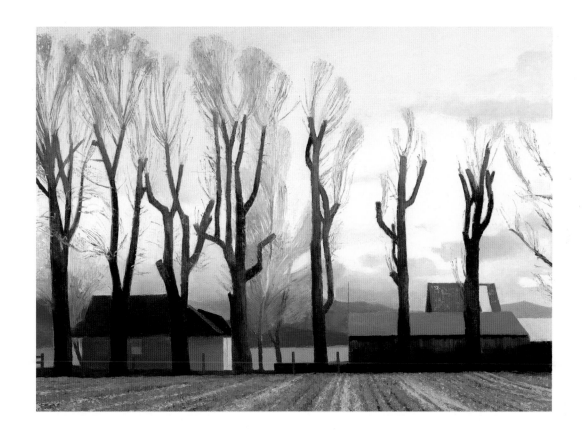

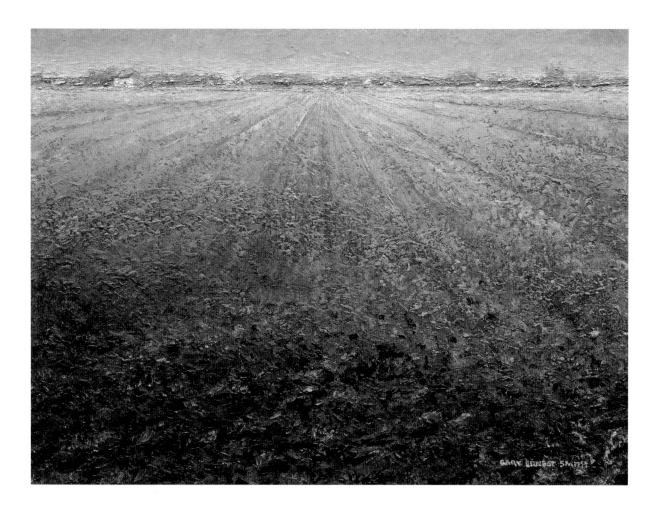

SPRING FIELD
*oil on linen, 18 x 24, 1997*

Spring Field, *a portrait of a field recently plowed and ready for planting, is an example of Smith's use of texture to show depth. The field's foreground is a jumble of earth and budding growth; as the eye travels the distance to the dwelling on the horizon, the rows lose their bulky texture to become flat, elongated strokes of the palette, true to perspective. The contrast of the green field and cold blue on the horizon is a distinct and familiar sign of the transition from dormancy to rebirth.*

OPPOSITE
RIPE CORN
*oil on linen, 24 x 36, 1997*

Ripe Corn *is a rare image for Smith, for in this painting he portrays the actual crop: in this case corn growing in an Iowa field. Painted with scintillating brushstrokes, he has found an interplay of colors—violet, purple, gray, yellow—among the tassels of mature cornstalks. Farmers in the West and Midwest say you can hear corn growing when the wind rustles the tassels. The stalks sway back and forth and the cornfield seems to give off constant murmurs.*

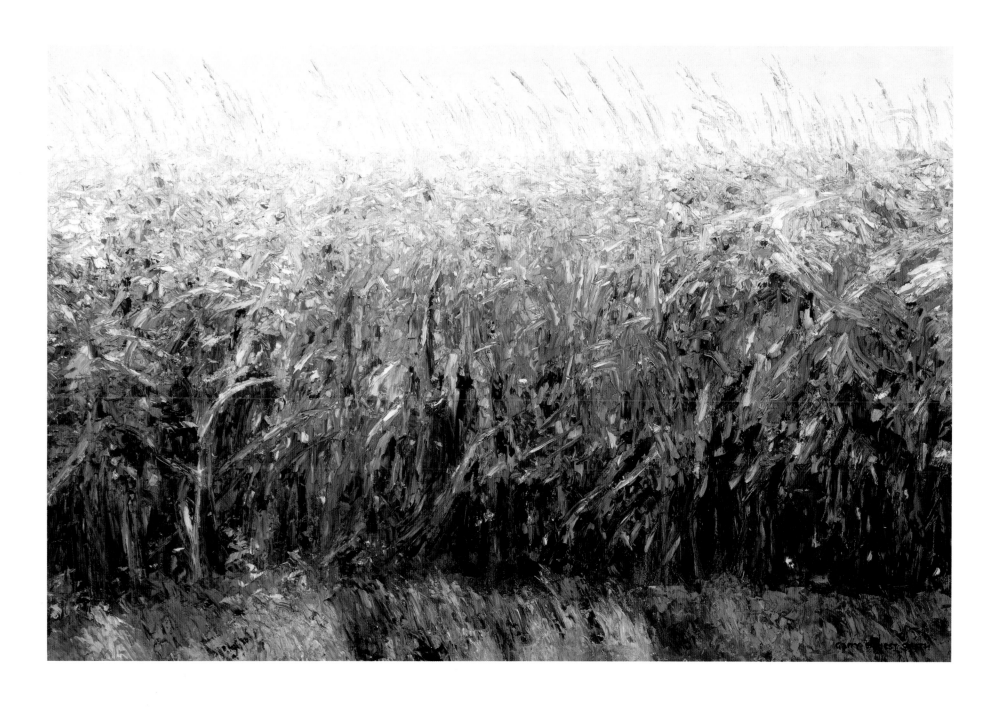

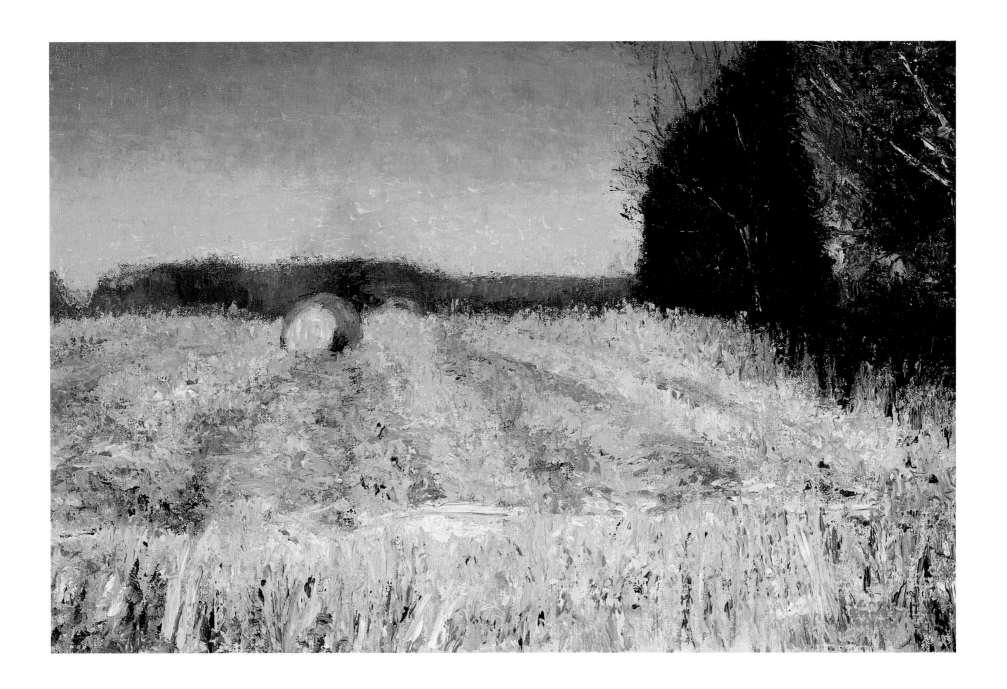

WHEAT FIELD
*oil on linen, 24 x 24, 1998*

OPPOSITE

SPRING STUBBLE *with* BALES
*oil on linen, 16 x 24, 1998*

*Wheat and other grains are planted in the valleys and rolling foothills of Utah, snow and rain the sole irrigators. Straw is an important byproduct of grain farming here and in Iowa, and Smith finds fascination with the aftermath of harvesting, when straw bales litter the fields with neat precision, their shadows casting bold designs.*

*The perfect squares of the bales in* Wheat Field, *and the order with which they have been laid out, speaks of the mechanical means that was necessary to accomplish such an arrangement. Yet two bales—one of them, in fact, placed prominently in the foreground, just out of the viewer's reach—have fallen a little to the left or right of the pattern as if to say that even with machinery nature can never be made to comply fully with programmed order.*

*In* Spring Stubble with Bales, *rolled bales parked on the yellow and blue expanse of an Iowa field are the reminders of order in an otherwise naturally chaotic scene. Remnants of cultivated rows peek through the stubble, which nonetheless seems to sprout from the ground in a disordered jumble that has more to do with nature than with mechanics.*

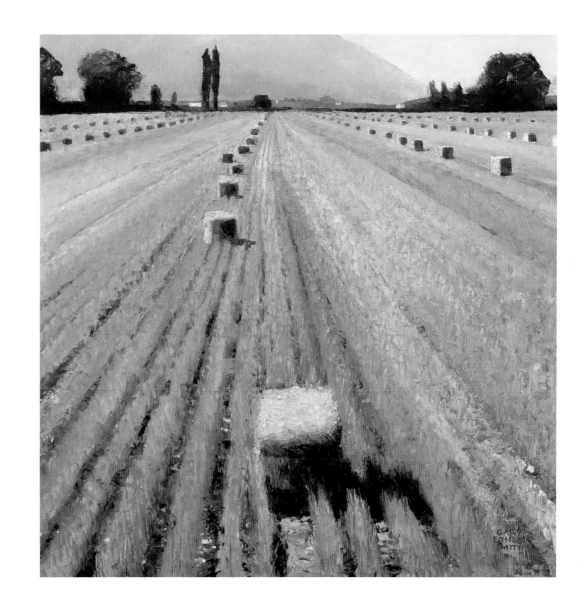

Fields, and all cultivated places, are human landscapes of fabricated construction, and for most people their paramount importance lies in their commercial real estate. But they are also a repository of the sublime, the uncontrollable. The geometric rows of stubble or sweeping contours of plowed ground are, in effect, the joining of the natural

TURNED, *72 x 96, 1996*

and the artificial. Yet while nature has been tamed in them, it has not completely abdicated the domain. Fields are landscapes without apparent high drama, but they harbor long-term change and consequences often ignored or overlooked.

In his own fashion, perhaps as a requiem, Gary Ernest Smith found a way to preserve for posterity the openness and vitality of farm fields through his art. As an outgrowth of painting cultivated landscapes in the West and Midwest during the mid-1990s, he eventually created a series of large-scale paintings focusing on cultivated fields through the seasons, without theatrics, concentrating on the ideas prompted by form, color, light, and space. These monumental canvases, which he calls the "Field Paintings," emerged from the initial landscape painting efforts and his concern about the disappearance of cultivated fields. "Part of the inspiration for these big paintings is watching these broad, beautiful open spaces gobbled up by development," says Smith. Partly, too, the fermentation for the Field Paintings leads back to Smith's childhood: the song of the seasons, patterns in the soil as he walked over it, and how beautiful they all were.

A number of important contemporary American landscape painters probe the ambiguities of the human imprint on the land. Some, like Wolf Kahn, Jane Freilicher, and Neil Welliver concentrate on familiar places in the eastern United States, painting their own gardens, or the countryside adjacent to their homes. In Nebraska, Keith Jacobshagen celebrates the beauty of that state's sweeping skies and back roads punctuated by a grain elevator or silo. Others, like Arizona artist Ed Mell, travel further distances to find their pictorial places. Mell, for example, often uses a helicopter to give him a bird's-eye view of the Colorado Plateau's rugged topography. Andrew Wyeth searched for years to discover those small patches of ground that symbolize his work. Like most of these artists, Smith views landscape painting as a spiritual quest, the search for a more intimate union with the land—and like them he sees the fragility and vulnerability of earth. Ultimately Smith's Field Paintings possess a common theme—his faith in their importance. They are an exultant "yes" to that most irreducible visual element in the landscape—dirt. "The soil is the great connector in our lives, the source and destination of all," reflects ecologist Wendell Berry. To Vern Swanson:

> These are not paintings about farmers, not about crops and modern farming techniques and technology, but about fields of dirt in their own right. With high horizons so the fields themselves can be honored, we see plowed fields, disked fields, fallow fields, and stubble fields. Mother Earth gives of her abundance if men will scratch her mantle just right. No short-term plundering of our resources in these paintings, but a conscientious symbiotic alliance, a true environmental relationship with nature.

SOD
*8 x 8 1/2, charcoal on paper, 1997*

For six months during 1994, Smith experimented with four-by-four-foot canvases, then made a quantum leap to six-by-eight-foot, thinking this might create a stronger presence and impact the smaller ones would not project. He hoped to capture the sense of peace, order, and space he experiences while walking through fields. "I wanted the paintings to be large and spacious, with the emphasis on the dirt itself," he says. "But I also wanted to give the impression that man has been here before." Somehow, then, these larger canvases might encourage the viewer to experience his reverence for the earth. "Smith has always been in love with the land, and man's part in it," says Ray Johnson. "Now, in these paintings, he wants to get closer."

The shift to a larger scale was successful, for these monumental works surprise people into taking time to look at them. "I wanted to recreate the feelings of well-being I get when I am out in these fields, and to have other people feel the way I do: to have a respect for the earth, the dirt. These fields are a basic pattern on the earth, and most people do not see it."

Some of the Field Paintings, at first glance, seem rather barren, an ordinary here and now, but on closer look appear almost ancient, nearly hallucinatory. Their topography transplants us to a realm that exceeds their prosaic appearance, literally a paradise of the senses. The specifics, real or imagined, of a particular place mark each painting. But these images of fields are also universal, for they can serve as places anywhere and every-where—Oregon, Idaho, Utah, California, Iowa, Nebraska, Indiana, or New York. With rare exception, they evoke the before, the after, the in-between. They are images that reflect the eternal forces of germination, growth, and death: the cycles of life and season.

One of the hallmarks of the new work became the unbroken horizon line. Usually situated high up in the frame, it is the first element Smith places on a canvas. When he

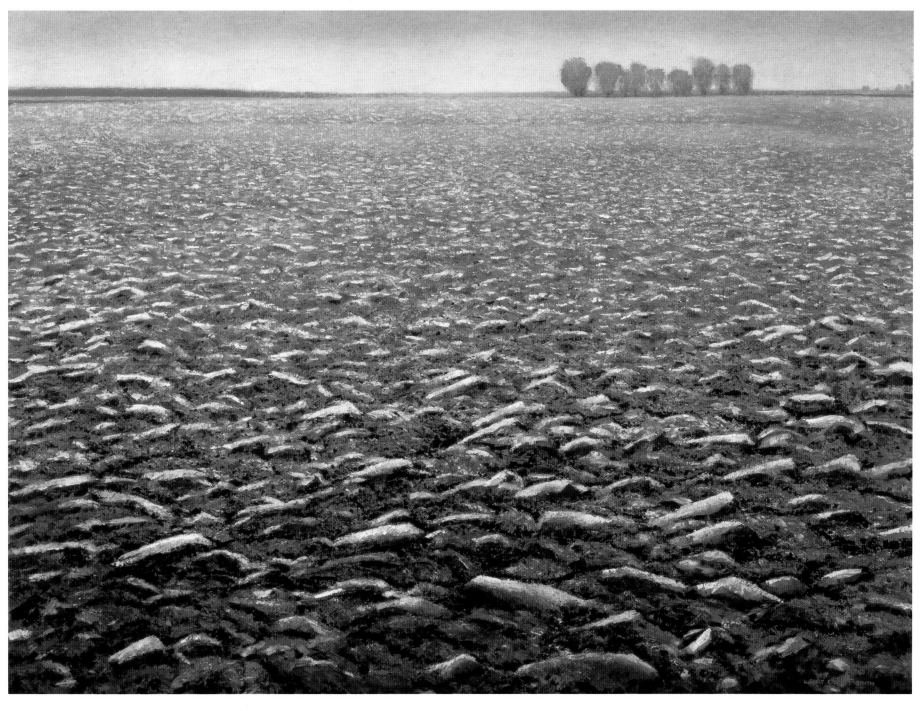

PLOWED, *72 x 96, 1996*

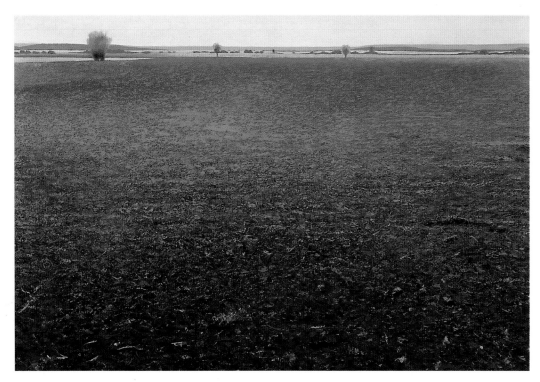

FALLOW
*72 x 96, 1996*

*Unlike the vibrant colors in his earlier works, many of the Field Paintings, such as* Pattern *(page 139), drawn from a field Smith spotted near Burley, Idaho, and* Fallow, *outside Richfield, Utah, border on monochromatic, infused with a subtle range of dark and light tones. Diffuse and hazy, the translucent glow washes over the stark beauty inherent in the filigree of melancholy in temporarily abandoned fields. Furthermore, the images give the appearance of an earthly world without movement, still and quiet, on the edge of disappearance as described through the conduit of paint with selective brevity.*

first experimented with the Field Paintings, Smith tried to focus on earth itself, but quickly discovered that this line serves as an important reference, in effect a picture-widening device, giving visual release.

The less obvious, overlooked elements in a field are what Smith strives to discover. "I never see myself as a traditional landscape painter. I never look for the obvious beauty other people see," he explains. "For me, it is the beauty in ordinary things that most people overlook." Indeed, the sculptor and painter David Smith felt one could never look at a landscape without seeing other landscapes within it. That specific beauty centers on something unusual, a special quality, places Gary Smith may have passed by hundreds of times before. All of a sudden, in a rush, he sees it in a new light. The pungent odor of burnt, wet, or decaying plant life in a late autumn field may become the catalyst for a subject. Or it might be clumps, scraps, shavings, and fragments of earth and grass, mangled into masses of clods and furrows that can strike him as an interesting design. "Gary Smith took something so ordinary, even mundane, and created paintings with a design and texture you can walk into," reflects Ed Mell.

If he does not find a specific field out there, Smith will create one, discovering, isolating, inventing, and composing strategic elements, compositional devices used to construct a painting. The nineteenth-century French painter Gustave Courbet once said,

"An artist ought to be able to render something—a distant pile of sticks, say, in a field—without actually knowing what it was." Whatever the sources, real or imagined, Smith wants these subjects, basic as life itself, grafted as his feelings for the soil on the monumental canvases.

Always attracted by the dynamics of pattern, Smith lets the forms in a field interact or merge with another, creating provocative designs on the canvas. He wants the paintings to project instant impact, so there is little question in the viewer's mind about what it is. While within the larger space exists a panoramic vision, numerous subtle, intricate details occur, little parts which on balance make the composition whole. "Smith's Field Paintings are almost totally devoid of narrative, with almost 80 percent of a canvas portraying dirt," says Neil Hadlock. "He makes a conscious decision what not to show, and what to elaborate." Often the immediate foreground pattern is abstract—low and foreshortened—becoming more coherent when the viewer moves away. Friend David Hunt remembers the time he first saw one of the Field Paintings. "I walked up to it and felt dizzy, then moved back and the scene became calm and peaceful."

Broader effects are never sacrificed to detail, however. Smith might place a building, for example, on the edge of the horizon line, but then creates the feeling of space in the middle. There is only a narrow strip of empty sky above the horizon, and often, the angle of vision is low, as if the viewer is standing or kneeling at the edge of a field. When Smith begins a Field Painting, he models the whole image quickly by building it with the palette knife, wet on wet, without finishing any one part first, letting the painting grow together organically. The physicality of the paint on the canvas adds to the structure of the composition.

These spare, meditative paintings probe man's imprint on the tilled landscape. They

offer the viewer a sensation of somehow having seen them many times before. While they portray an intimate union of land and culture, few man-made objects, except for the hint of a structure or two on the horizon, intrude upon the scene: The presence of man is imbedded through the rearrangement of shape and line upon the earth. Toil on the land, to Smith, does not deface the environment. Subtle shapes of furrows, stubble texture, and the mystery of shadow in a plowed field celebrate the careful tending of the earth.

By any definition, Smith's Field Paintings stand apart. Nothing like them, either in scale or number, is being attempted in contemporary American art. As James Ballinger comments in the publication for the Fields exhibition at Brigham Young University:

> This series of pictures may create a new challenge for the artist, his collectors, and the critic. Here is an artist who for years has been comfortably described as a "regionalist." Yes, these new pictures are of the West, but they transcend the traditional qualities of western American artists who are generally known for the documentary and narrative nature of their work. . . . Here are dramatic paintings which express a portion of western lands as they really are today. And, though contemporary, Smith's new work does not meet the criteria normally applied to the term. . . . One can only hope that these subtle but beautiful paintings will get the attention they deserve. Such quality work should not be ignored for lack of a proper label. It should, on the other hand, be applauded for what it is, an insight to part of the American experience which is in or near each one of us.

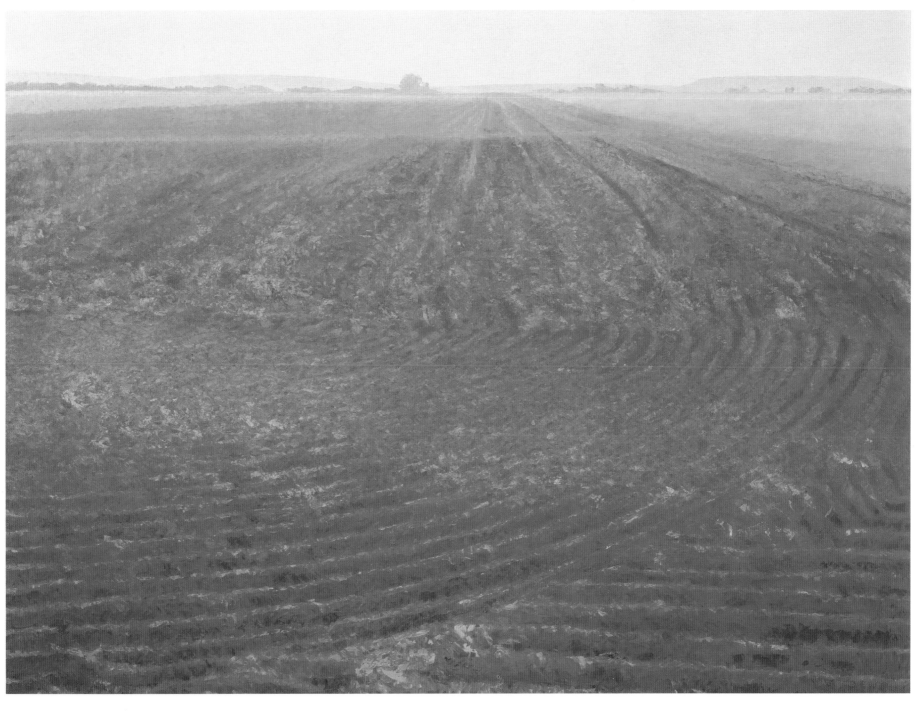

PATTERN, *72 x 96, 1996*

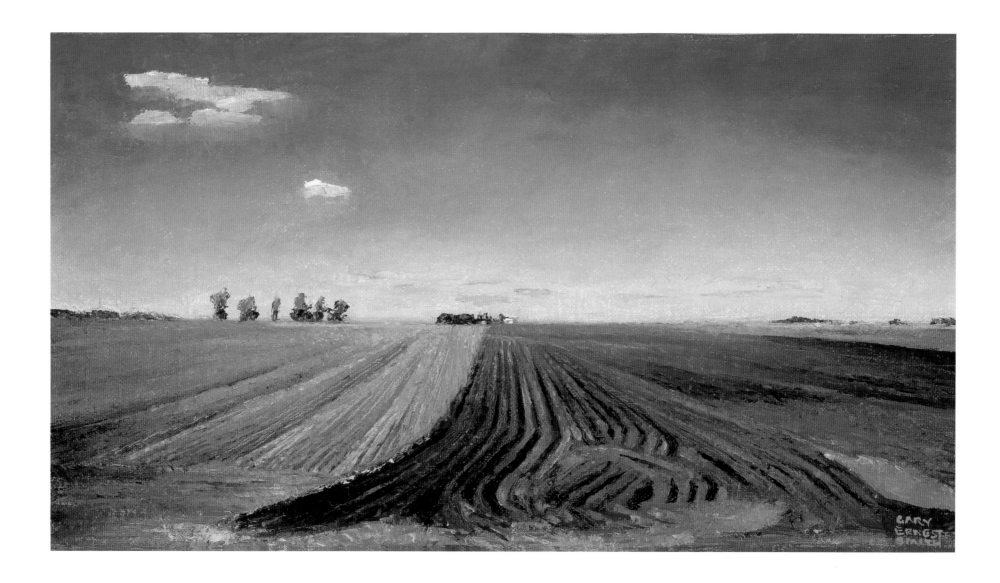

The writer N. Scott Momaday suggested in his book, *The Way to Rainy Mountain:*

> Once in his life a man ought to concentrate his mind upon the remembered earth, I believe. He ought to give himself up to a particular landscape in his experience, to look at it from as many angles as he can, to wonder about it, to dwell upon it. He ought to imagine that he touches it with his hands at every season and listens to the sounds that are made upon it. He ought to imagine the creatures there and all the faintest motions of the wind. He ought to recollect the glare of noon and all the colors of the dawn and dusk.

Thus the cultivated fields of Gary Ernest Smith are never static. There are always new landscapes in any field throughout a year. Cultivation, growth, harvest, even inactivity constantly lend changing dimensions to the agricultural landscape, and to his vision. These transformed fields, painted with a personal voice and lyric concentration, simultaneously reveal and urge us to ponder what he, and we, have seen.

PLOWED STUBBLE
*oil on linen, 11 x 20, 1997*

*Residue of stubble left upon a field as the aftermath of harvest is another attraction for Smith. The patterns created by stubble, and its bleached, worn, golden color finds its way into paintings like* Plowed Stubble. *Smith has documented newly plowed earth on one side of a field, while the other side remains unplowed, the wet and dry soil creating impressions of texture and sensation.*

SERENE
*72 x 96, 1996*

OPPOSITE
HARVESTED
*72 x 96, 1996*

*Low-lying fields near Flagstaff, Arizona, yearn for the horizon in* Serene, *a panoramic, sensuous march toward what seems a remote void. A simple, nearly unbroken horizon line conveys a feeling of tranquillity. Perhaps in the faraway intersection between sky and ground in a Utah field depicted in* Harvested *is a glimmer of the divinity. Indeed, the writer Annie Dillard thinks there are angels in agricultural fields. Smith walks the intersection between the realities of what he sees in a manipulated landscape and his art, the difference between empirical representation and abstraction. His vision has translated these fields into some spiritual view of rearranged earth on canvas.*

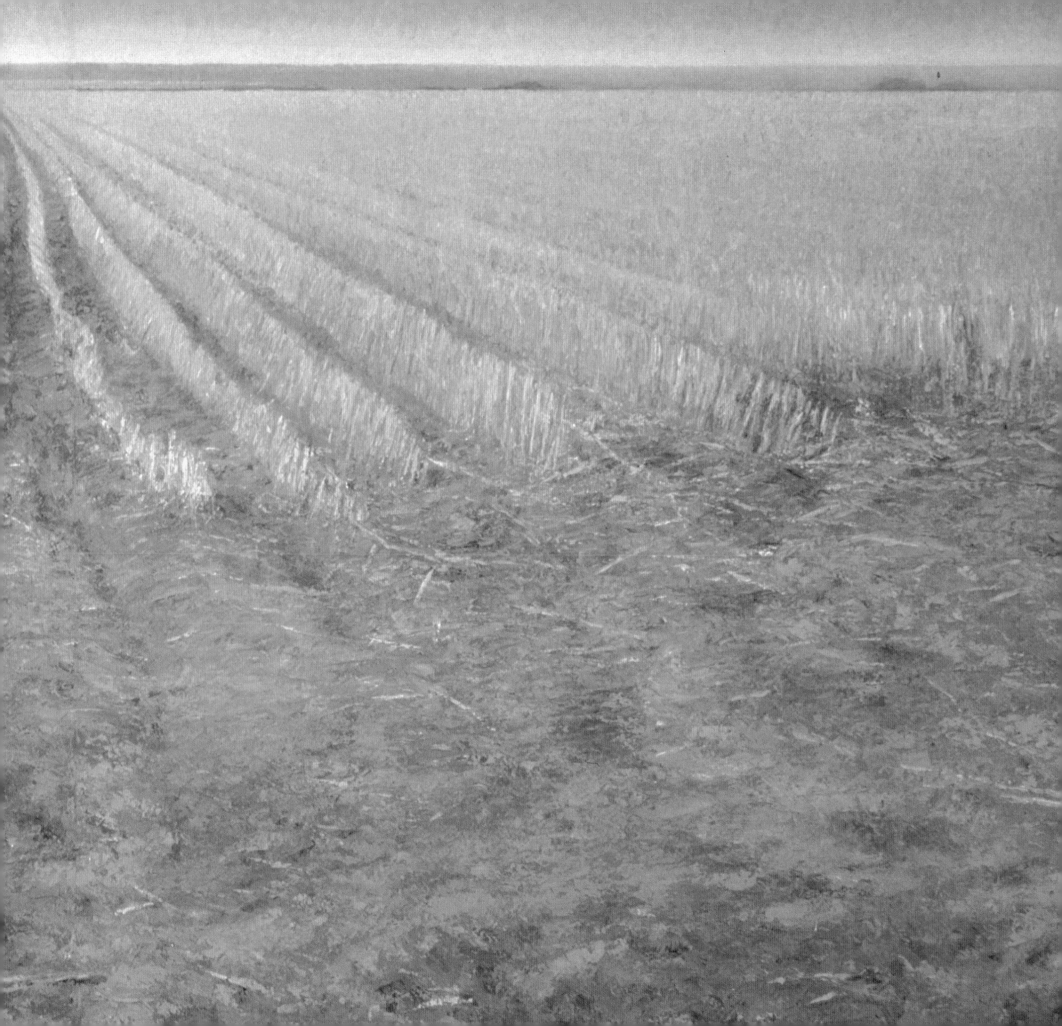

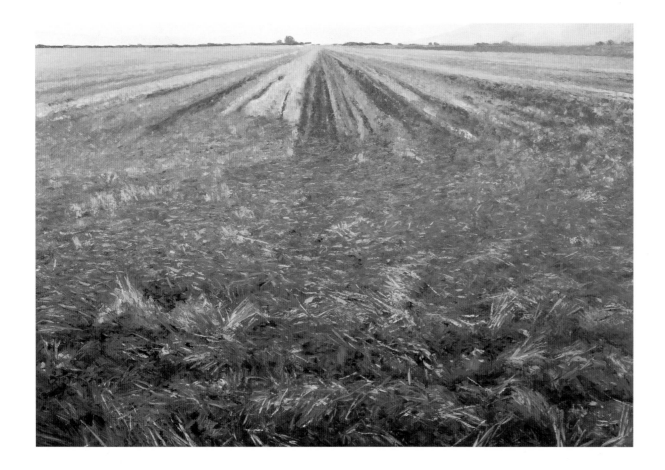

STUBBLE
*72 x 192, 1996*

GOLDEN
*72 x 96, 1996*

OPPOSITE
GOLDEN STUBBLE
*72 x 120, 1998*

Stubble, *a six-by-sixteen-foot canvas,*
Golden, *and* Golden Stubble *explore the
aftermath of harvested grain, the clipped stalks
lined up in brilliant golden rows to the horizon.
Smith used sixty large tubes of paint to cover
the surface of the sixteen-foot painting. "It was
like sculpting the field, as if the paint was
earth itself." Through the use of a reductive
painting vocabulary, Smith stresses unity over
diversity, repose over activity, and the spiri-
tual over the physical in these works. Charles
Burchfield once said, "An artist must paint not
what he sees in nature, but what is there."*

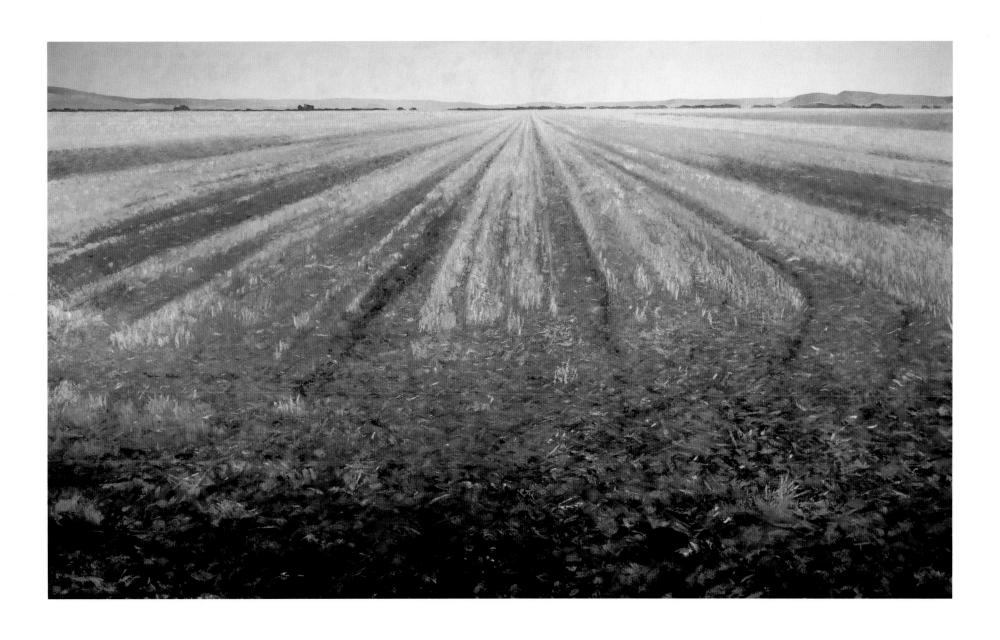

BALED

*72 x 96, 1996*

*In* Baled, *hay bales appear to float above the far recesses of a field two miles from Smith's home, a reconciliation of poetry and geometry. The composition elaborates upon the beaming warmth of texture and density through strategically placed shadows.*

*The architectural shapes of the hay bales seem reflective of the machines which created them. "These hay bales, arbitrarily placed in a vast hayfield, look like man and nature working in design harmony, and have moved me," says Smith.*

OPPOSITE

BURNT

*72 x 96, 1996*

*Sometimes Smith uncovers dramatic events in the life of a field, as he presents in* Burnt, *which depicts a field near Baker City, Oregon. Field fires are often set by farmers in the fall after a crop has been harvested to reduce old growth, return nutrients to the soil, and facilitate easier plowing. After the flames have swept across the field, the blackened remnants of the crop seem surreal. "This is a painting of a field recently burned over, a wet field with black embers and soot embedded in it," explains Smith.*

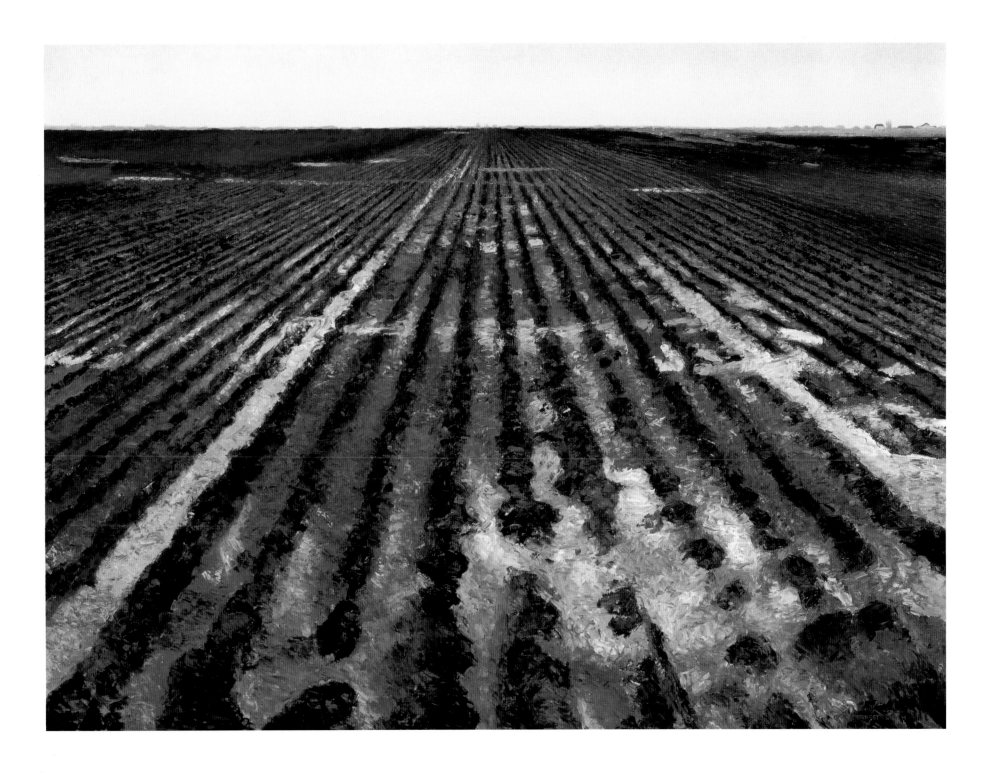

OPPOSITE

SNOW

*72 x 96, 1996*

WINTER

*72 x 96, 1996*

*A number of paintings drawn from various locations in Utah, such as* Snow, *explore the effects of a light dusting of snow on a plowed field. Upon first glance, the composition appears to be arranged in a random fashion, but coalesces into an abstract mosaic of pattern and shadow honed by the artist. In* Winter, *the air seems to crackle under the onslaught of frigid temperature.* Snow *is often viewed as a friction between man, machine, and earth, but in these paintings there is the quiet, peaceful calm of a land at rest.*

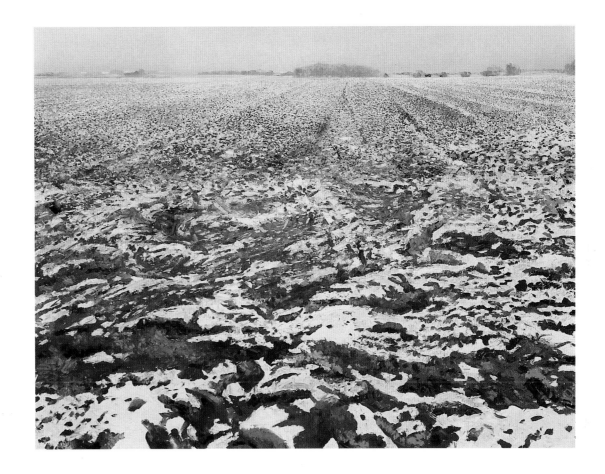

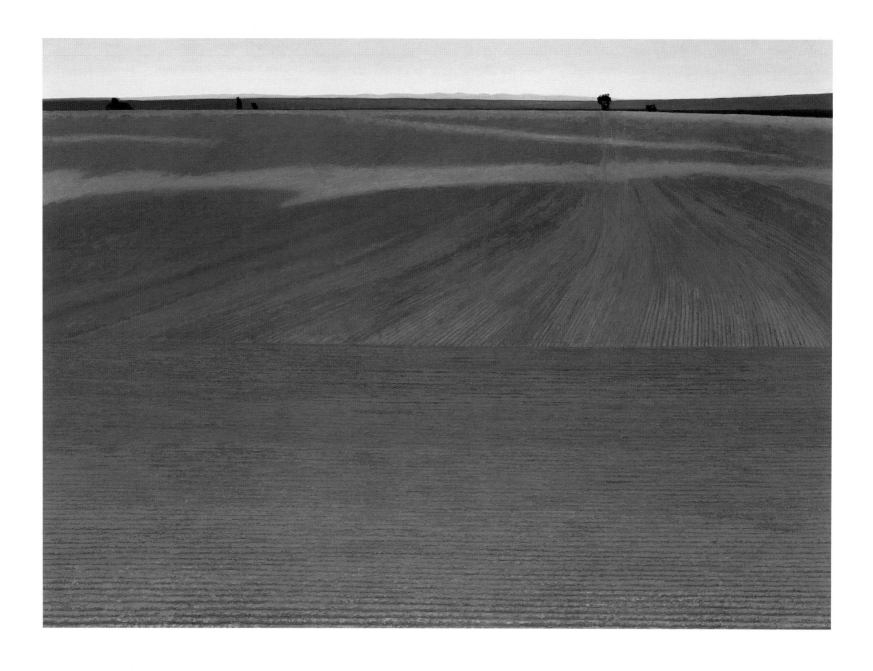

PLANTED
*72 x 96, 1996*

Planted *is an example of the artist's understanding of how farming strategies are designed to fit closely the particular dimensions of the landscape. With this image, he describes the ability of a farmer to gauge and plot cultivation approaches to the circumstances of the land, the result of long-term experiences with weather, soil, and terrain over time.*

OPPOSITE
GROWTH
*72 x 96, 1996*

*Eventually, the cycle of seasons arrives and departs; thus, as in* Growth, *rejuvenation makes an appearance, the cosmic secrecy of seeds embarking upon their process of germination, thrusting out of the ground toward the light, spreading a delicate green veneer of life over the field.*

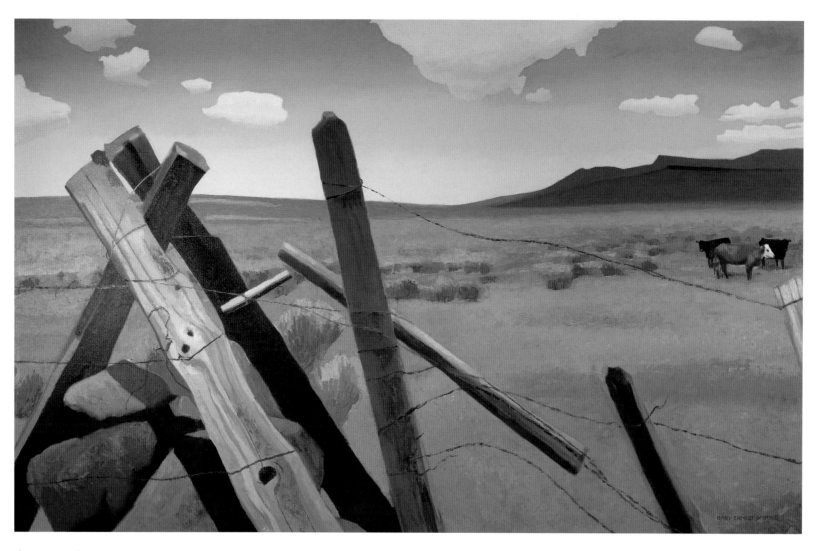

CATTLE *with* FENCE, *48 x 78, 1989*

# CHRONOLOGY *of* EVENTS

1942    Born June 29 in Baker City, Oregon. Named Garold Ernest Smith.

1946    Shows early interest in drawing cartoons and people.

1947–50  Parents recognized a gift for drawing and encouraged it by making supplies and time available.

1951–57  Begins painting with watercolors and tempera. Takes Famous Artists correspondence art course.

1958–60  Paints landscapes on commission. Takes summer classes at great aunt's art center in Lincoln Beach, Oregon. Meets Dr. Robert Banister, a watercolorist and educator, while attending summer art class in Lincoln Beach.

1959    First painting lessons at St. Francis Academy in Baker City, Oregon.

1960    Graduates from Baker High School. Recipient of state arts awards.

1961    Works on father's ranch and continues to paint.

1963    Leaves the ranch. Starts college at Eastern Oregon College, LaGrande, Oregon. Works nights at a gas station. Continues drawing and painting.

1964    Commutes to school from Baker City. Majors in art.

1965    Best friend, David Hunt, convinces Smith to transfer to Brigham Young University, Provo, Utah.

1966–67  Attends Brigham Young University in BFA program. Accepts assistantship and teaches as an undergraduate. Meets fellow artists and forms lasting friendships. Discovers dynamic symmetry and golden section techniques and studies them seriously. Marries music student Judy Asay.

1968    One-artist show in Riverside, California. Is drafted during Vietnam War and serves eighteen months in Alabama and Korea. Does many drawings of military people and life.

1969    Daughter Andrea born.

1970    Discharged from military. Continues school at Brigham Young University, graduates with BFA. Exhibits widely in local and state art exhibitions. One-artist show in Hobbs, New Mexico.

1971    Accepts position as gallery director at Brigham Young University. Teaches and paints in spare time. Begins showing paintings at the F. Weixler Gallery, Salt Lake City, Utah. Group show, Tempe, Arizona. Meets artist Joseph Hirsch.

1972    Begins doing commission illustrations and paintings. Son Christopher is born. Accepts mural commission in Upland, California. Moves there and works on mural for six months.

1973    Begins career as full-time artist. Paints for galleries and accepts major mural commissions for banks and commercial buildings. Two-artist show at Stable Gallery, Salt Lake City.

1974    Paints a series of metaphysical family portraits, landscapes, and introspective self-portraits. Continues with commissions. Moves to Alpine, Utah, with fellow artist friends. Starts North Mountain Artists Cooperative.

1975    Paints murals and historical paintings for Copper State Bank, Salt Lake City. Son Nathan born.

1976    Paints mural for Dixie State Bank, St. George, Utah.

1977    Experiences severe illness with what is believed to be paint poisoning.

1978    Moves to Highland, Utah, and starts construction of new home. Paints murals for Murray Thrift and Brighton State Bank. Works with Tivoli Gallery, Salt Lake City. Exhibits in group shows.

1979    Daughter Julia is born. Moves into new home and studio. Begins work with Meyer Gallery, Park City, Utah. One-artist show. Does mural for Deseret Bank.

1980    Realizes his career is stagnant with commissions. Makes decision, after visit to home ranch in Oregon, to reduce commission work and produce a body of work based on own experiences. Does *Red Ryder* comic strip.

1981    Begins to explore images of his rural America background. Group show at Brigham Young University with college artist friends. Commission to travel to Israel and Middle East to paint biblical subjects for LDS church.

1982    Travels to Europe to visit museums and study art. Continues to develop ideas and paint rural subjects. One-artist shows. Group show with North Mountain artists. Does mural for Utah State Bank.

1983    Does first of solitary man paintings. One-artist show at Brigham Young University. Ray Johnson visits studio. Smith agrees to be represented by him. Exhibits with Ten Utah Painters, Nora Eccles Harrison Museum, Logan, Utah.

1984    One-artist show, Meyer Gallery, Park City, Utah. Feature article on his art in *Southwest Art.*

1985    One-artist show, Meyer Gallery, Park City, Utah. One-artist show, Brigham Young University. Group show of Utah painters at Sundance. First one-artist show at Overland Gallery, Scottsdale, Arizona.

1986    One-artist show, Wooden Bird Gallery, San Diego, California. Selected to participate in the Third Western States Traveling Exhibition curated by the Brooklyn Museum of Art. Painting included in Sotheby's auction at Hard Rock Cafe in New York.

1987    One-artist show, Overland Gallery.

1988    One-artist show, Overland Gallery. Prompted by a visit to his home in Oregon, he decides to do a series of paintings based on images he remembers about the country he grew up in.

1989    Returns to Oregon to paint *Journey in Search of Lost Images.* One-artist shows at Springville Museum of Art, Springville, Utah; Sangre de Cristo Art Center, Pueblo, Colorado; and Overland Gallery. Does first bronze sculpture.

1990    *Journey in Search of Lost Images* goes on tour to twenty-two museums for a period of three years. Travels to Oregon to paint a series on rural women. Completes life-size bronze of farmer with sack. One-artist show, Overland Gallery. Assists Ray Johnson in acquiring art from Russia.

1991    "Gary Ernest Smith Day" declared in Baker City, Oregon. Cover and feature article in *Southwest Art.* Begins a series of stone lithographs on rural images. One-artist show, Overland Gallery.

1992    Travels to Russia to assist Ray Johnson in acquiring Russian realist art. One-artist show, Overland Gallery.

1993    Creates fifteen-foot-tall sculpture of Superman for Metropolis, Illinois. One-artist show, Overland Gallery. Returns to Russia with Ray Johnson.

1994    Changes start to enter his work, more emphasis on landscape painting. Begins to do field paintings. One-artist show, Overland Gallery. Bronze sculpture of Krazy Kat included in Barnum Museum exhibition.

1995    Invited to participate in traveling exhibition, *Covering the West.* North Mountain Group Show, Bountiful, Utah. One-artist show, Overland Gallery.

1996    One-artist show, Overland Gallery. Begins to paint large-scale canvases of fields.

1997    One-artist show, Overland Gallery. Exhibition of Field Paintings at Brigham Young University. Sculpture of Krazy Kat included in exhibition at Musée de la Bande Dessinée, Angoulême, France. One-artist show, Eckert Gallery, Indianapolis, Indiana.

1998    Further explores landscape paintings, including large earth canvases. Does life-size bronze sculpture of Owen Bradley, Nashville, Tennessee. One-artist shows, Overland Gallery and Denise Roberge Gallery, Palm Desert, California. Group exhibition, Colorado Springs Fine Arts Center.

1999    Exhibition of "Fields Paintings" at Eiteljorg Museum, Indianapolis, Indiana. One-artist show, Overland Gallery.

# EXHIBITION HISTORY

## ONE-ARTIST EXHIBITIONS

GARY E. SMITH. Moreno Valley Art Center, Riverside, CA. March–April, 1968.

GARY SMITH. B. F. Larsen Gallery, Brigham Young University, Provo, UT. October–November, 1972.

GARY E. SMITH. Barn Banking Gallery, Kaysville, UT. March, 1978.

GARY E. SMITH, RECENT WORK. Tivoli Gallery, Salt Lake City, UT. November–December, 1979.

GARY E. SMITH, MASTER OF GENRE PAINTING. Harris Fine Arts Center, Brigham Young University, Provo, UT. October–November, 1982.

GARY E. SMITH, PAINTINGS OF THE NEW TESTAMENT. Secured Gallery, Harris Fine Arts Center, Brigham Young University, Provo, UT. November–December, 1982.

GARY E. SMITH. Meyer Gallery, Park City, UT. March–April, 1985.

GARY ERNEST SMITH, IMAGES OF RURAL AMERICA. Harris Fine Arts Center, Brigham Young University, Provo, UT. December, 1985–January, 1986.

GARY E. SMITH. Wooden Bird Gallery, San Diego, CA. February–March, 1986.

GARY ERNEST SMITH. Overland Gallery, Scottsdale, AZ, 1986–present.

JOURNEY IN SEARCH OF LOST IMAGES. University of Kentucky Art Museum, Lexington, KY, 1990; Concord Art Association, Concord, MA, 1990; Art League of Manatee County, Bradenton, FL, 1990; Sheldon Swope Art Museum, Terre Haute, IN, 1990; Desert Caballeros Western Museum, Wickenburg, AZ, 1991; Wichita Falls Museum, Wichita Falls, TX, 1991; Kerns Art Center, Eugene, OR, 1991; Monmouth Museum, Lincroft, NJ, 1991; Meridian Museum of Art, Meridian, MS, 1991; Butler Institute of American Art, Youngstown, OH, 1991; Rogue Valley Art Association, Medford, OR, 1992; Oregon State University, Corvallis, OR, 1992; Allied Arts Council, Yakima, WA, 1992; Nicolaysen Art Museum, Casper, WY, 1992; Springfield Museum of Art, Springfield, OH, 1992; Anglo-American Art Museum, Baton Rouge, LA, 1992; Birger Sandzen Memorial Gallery, Lindsborg, KS, 1992.

GARY ERNEST SMITH. Springville Museum of Art, Springville, UT. September, 1989.

GARY ERNEST SMITH. Sangre de Cristo Art Center, Pueblo, CO. September–October, 1989.

GARY ERNEST SMITH. Springville Museum of Art, Springville, UT. December, 1995–January, 1996.

FIELDS. Museum of Fine Art, Brigham Young University, Provo, UT. August–November, 1997.

WORKS BY GARY ERNEST SMITH. Eckert Fine Art Galleries, Indianapolis, IN, October–November, 1998.

GARY ERNEST SMITH REVEALED: LANDSCAPE OF THE HEART, LANDSCAPE OF
THE MIND. Denise Roberge Gallery, Palm Desert, CA. November-December, 1998.

FIELDS. Eiteljorg Museum. Indianapolis, IN, October, 1999–January, 2000.

## GROUP EXHIBITIONS

GARY SMITH AND DENNIS SMITH. The Stable, Salt Lake City, UT. November, 1973.

NORTH MOUNTAIN ARTISTS. Kimball Art Center, Park City, UT. January, 1982.

THE CAVE: SIX ARTISTS AND THEIR FRIENDS. Harris Fine Arts Center, Brigham
Young University, Provo, UT. January–February, 1982.

TEN UTAH PAINTERS. Nora Eccles Harrison Museum of Art, Logan, UT. October–
November, 1984.

UTAH ARTISTS AT SUNDANCE. Sundance, UT. September, 1985.

IMAGES OF THE ARTIST: PORTRAITS AND SELF-PORTRAITS OF UTAH ARTISTS.
Springville Museum of Art, Springville, UT. November, 1986–January, 1987.

THIRD WESTERN STATES TRAVELING EXHIBITION. The Brooklyn Museum,

Brooklyn, NY, 1986; New Orleans Contemporary Art Center, New Orleans, LA,
1986; Art Museum of South Texas, Corpus Christi, TX, 1987; Colorado Springs
Fine Arts Center, Colorado Springs, CO, 1987; Yellowstone Art Center, Billings,
MT, 1987; Palm Springs Desert Museum, Palm Springs, CA, 1987-1988; San Jose
Museum of Art, San Jose, CA, 1988.

CAVE DWELLERS REUNITED. Harris Fine Arts Center, Brigham Young University,
Provo, UT. August–September, 1988.

COVERING THE WEST: THE BEST OF SOUTHWEST ART. Colorado Springs Fine Art
Center, Colorado Springs, CO, 1995; Tucson Museum of Art, Tucson, AZ,
1995–1996; National Cowboy Hall of Fame and Western Heritage Center,
Oklahoma City, OK, 1996; Autry Museum of Western Heritage, Los Angeles,
CA, 1996; Albuquerque Museum of Art, Albuquerque, NM, 1996.

WHOOPI TI YI YO: COWBOY CULTURE IN UTAH. Hippodrome Gallery, Salt Lake
City, UT. April–July, 1994.

INDIANA COLLECTS THE WEST. Eiteljorg Museum, Indianapolis, IN. July–
November, 1994.

NORTH MOUNTAIN ARTISTS. Bountiful Art Center, Bountiful, UT. September, 1996.

ARTISTS OF AMERICA. Colorado History Museum, Denver, CO. September–
November, 1997.

LEADING THE WEST. Munson Gallery, Santa Fe, NM. February, 1998. Group of
Eight. St. George Museum of Art. St. George, UT. March, 1998.

ARTISTS OF AMERICA. Colorado History Museum, Denver, CO. September–
November, 1998.

LAND AND WATER: THE ARTISTS POINT OF VIEW. Colorado Springs Fine Arts
Center, Colorado Springs, CO. September, 1998–January, 2000.

# BIBLIOGRAPHY

*American Icons: The Art of Neo-Regionalist Gary Ernest Smith*. Scottsdale, Arizona: Overland Gallery, 1994.

Beer, Ralph. "All the Way Home." *Big Sky Journal,* summer 1998, 16–18.

Berry, Wendell. *The Unsettling of America: Culture and Agriculture*. San Francisco: Sierra Club Books, 1977.

Corner, James. *Taking Measures Across the American Landscape*. New Haven and London: Yale University Press, 1996.

Critchfield, Richard. *Trees, Why Do You Wait? America's Changing Rural Culture*. Washington/Covelo, California: Island Press, 1991.

Davis, Robert O. *LeConte Stewart: The Spirit of Landscape*. Salt Lake City: Museum of Church History and Art, 1985.

Dillard, Annie. *Teaching a Stone to Talk: Expeditions and Encounters*. New York: HarperPerennial, 1992.

Egan, Timothy. *Lasso the Wind: Away to the New West*. New York: Alfred A. Knopf, 1998.

Ehrlich, Gretel. *The Solace of Open Spaces*. New York: Viking, 1985.

Ehrlich, Gretel. "Surrender to the Landscape," *Harper's,* September 1987, 24–27.

*Fields*. Foreword by Donald J. Hagerty. Essays by Michael Duty and James Ballinger. Scottsdale: Overland Gallery, 1997.

*Form, Color and Symbol: The Art of Gary E. Smith*. Scottsdale, Arizona: Overland Gallery, 1988.

Hagerty, Donald J. *Desert Dreams: The Art and Life of Maynard Dixon*. Layton, Utah: Gibbs Smith, 1993.

Hagerty, Donald J. *Leading the West: One Hundred Contemporary Painters and Sculptors*. Flagstaff: Northland Publishing, 1997.

Heat-Moon, William Least. *PrairyErth*. Boston: Houghton Mifflin Company, 1991.

Hooley, Renee. "Gary E. Smith." *Western Art Digest,* July/August, 1986, 96–97.

Hughes, Robert. *American Visions: The Epic History of Art in America*. New York: Alfred A. Knopf, 1997.

Jackson, John Brinkerhoff. *Discovering the Vernacular Landscape*. New Haven: Yale University Press, 1984.

Johnson, Michael L. *New Westers: The West in Contemporary American Culture*. Lawrence: University Press of Kansas, 1996.

*Journey in Search of Lost Images*. Scottsdale: Overland Gallery, 1989.

*Just Beyond the Merging of Mind and Memory: The Art of Neo-Regionalist Gary Ernest Smith*. Scottsdale: Overland Gallery, 1995.

Kaplan, Robert D. *An Empire Wilderness: Travels Into America's Future*. New York: Random House, 1998.

Kittredge, William. *Hole in the Sky: A Memoir*. New York: Alfred A. Knopf, 1992.

Kittredge, William. Owning It All. Saint Paul, Minnesota: Graywolf Press, 1987.

Knoblock. Frieda. "Agriculture and Nostalgia." *Wild Earth,* fall 1998, 32–34.

*The Landscape in Twentieth-Century American Art: Selections from the Metropolitan Museum of Art*. Introduction by Robert Rosenblum, catalog texts by Lowery Stokes Sims and Lisa M. Messinger. New York: Rizzoli International Publications and the American Federation of Arts, 1991.

*Land and Water: The Artists Point of View*. Essays by Ann Zwinger and David Turner. Colorado Springs, Colorado: Colorado Springs Fine Arts Center, 1998.

Levin, Gail. *Hopper's Places*. Berkeley and Los Angeles: University of California Press, 1998.

Lippard, Lucy R. *The Lure of the Local: Senses of Place in a Multicentered Society.* New York: The New Press, 1997.

Matrone, Michael, ed. *A Place of Sense: Essays in Search of the Midwest.* Iowa City: University of Iowa Press, 1988.

Momaday, N. Scott. *The Way to Rainy Mountain.* Albuquerque: University of New Mexico Press, 1969.

Preston, Sandy. "Gary E. Smith." *Art Gallery International,* July/August 1986, 22–29.

Pyne, Lynn. "Fields." *Southwest Art,* February 1998, 74–79.

Pyne, Lynn. "Gary Ernest Smith." *Southwest Art,* March 1991, 60–66, 131.

Raban, Jonathan. *Bad Land: An American Romance.* New York: Vintage Books, 1996.

Robbins, William G. "Creating a New West: Big Money Returns to the Hinterland." *Montana: The Magazine of Western History,* Summer 1996, 66–72.

Russell, Sharman Apt. *Kill the Cowboy: A Battle of Mythology in the New West.* New York: Addison-Wesley, 1993.

Sanders, Scott Russell. "Landscape and Imagination." *Wild Earth,* fall 1998, 29–31.

Swanson, Vern G., Robert Olpin, and William Seifert. *Utah Art.* Layton, Utah: Gibbs Smith, 1991.

Swanson, Vern G. "Gary E. Smith: Rooted Substance and Surface." *Southwest Art,* August 1984, 42–48.

Thornton, James. "Gary E. Smith: Visions of Yesterday." *Midwest Art,* July/August 1985, 18–25.

Twain, Mark. *Roughing It.* Hartford, Connecticut: American Publishing Company, 1872.

West, Elliott. "Stories: A Narrative History of the West." *Montana: The Magazine of Western History,* summer 1995, 64–76.

Wilson, Ann. "Gary E. Smith: The Melding of Body and Soul." *Art Today,* winter 1987/98, 38–42.

# INDEX

# ABOUT *the* AUTHOR

DONALD J. HAGERTY is an independent scholar and consultant on the art and culture of the American West.

In 1981, Hagerty organized the first important exhibition of the art of Maynard Dixon, *Images of the Native American*, held at the California Academy of Sciences. His biography of Dixon, *Desert Dreams: The Art and Life of Maynard Dixon*, was published in 1993. In conjunction with the book, Hagerty served as guest curator for a major retrospective exhibition of Dixon's work, also called *Desert Dreams*, which originated at the Museum of New Mexico in Santa Fe and traveled to six other museums.

Hagerty's *Leading the West: One Hundred Contemporary Painters and Sculptors* (Northland) "surmounts dismissive stereotyping and popularization with its informed and substantial text," according to *Library Journal*, and his *Beyond the Visible Terrain: The Art of Ed Mell* (also from Northland), was "highly recommended" by *The Bookwatch*, and called "one of the best new art books of the year" by *Bookviews*. He is also the author of *Canyon de Chelly: One Hundred Years of Painting and Photography*, as well as articles on art and artists for *Arizona Highways, Southwest Art, Pacific Historian, El Palacio, Russell's West, Art of California, American Art Review, Crosswinds*, and the Book Club of California. In addition, he has given numerous lectures for museums and other institutions.

Don J. Hagerty retired from the University of California, Davis, in 1993 after twenty-two years as a faculty member. Since 1981, he has also been a research associate in anthropology at the California Academy of Sciences in San Francisco. He lives in Davis, California, with his wife and two children.